P9-AQT-067

PORTFOLIO

Swimsuit: Paradise Found

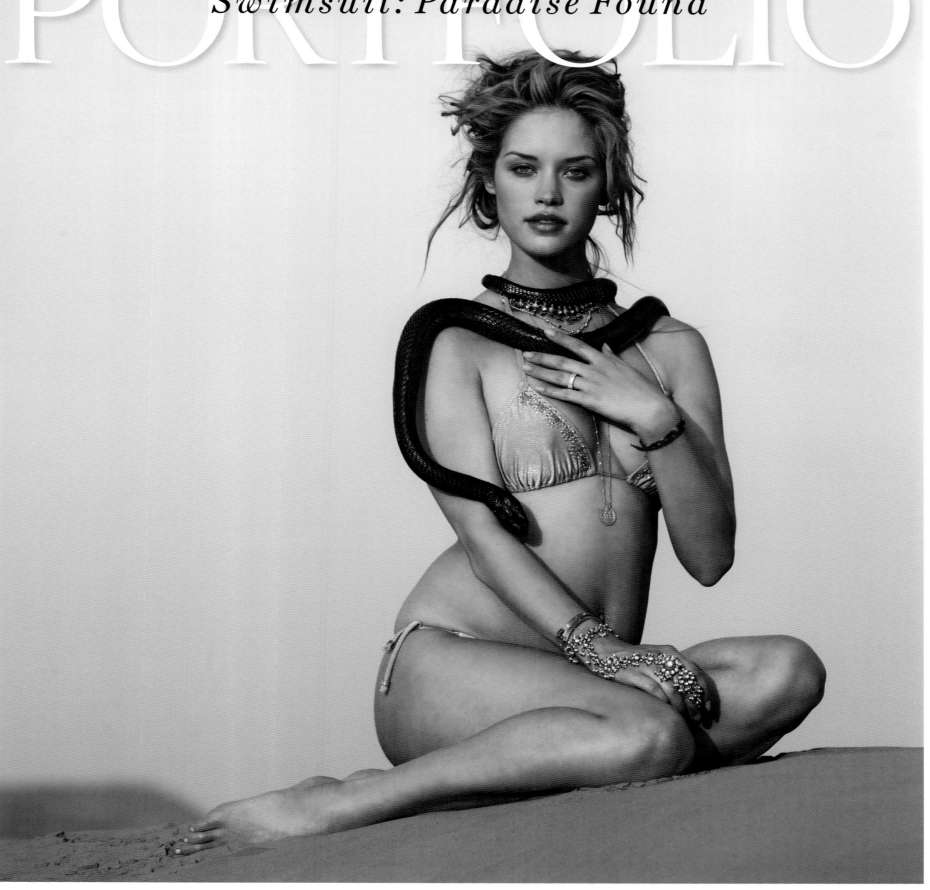

RICCARDO TINELLI

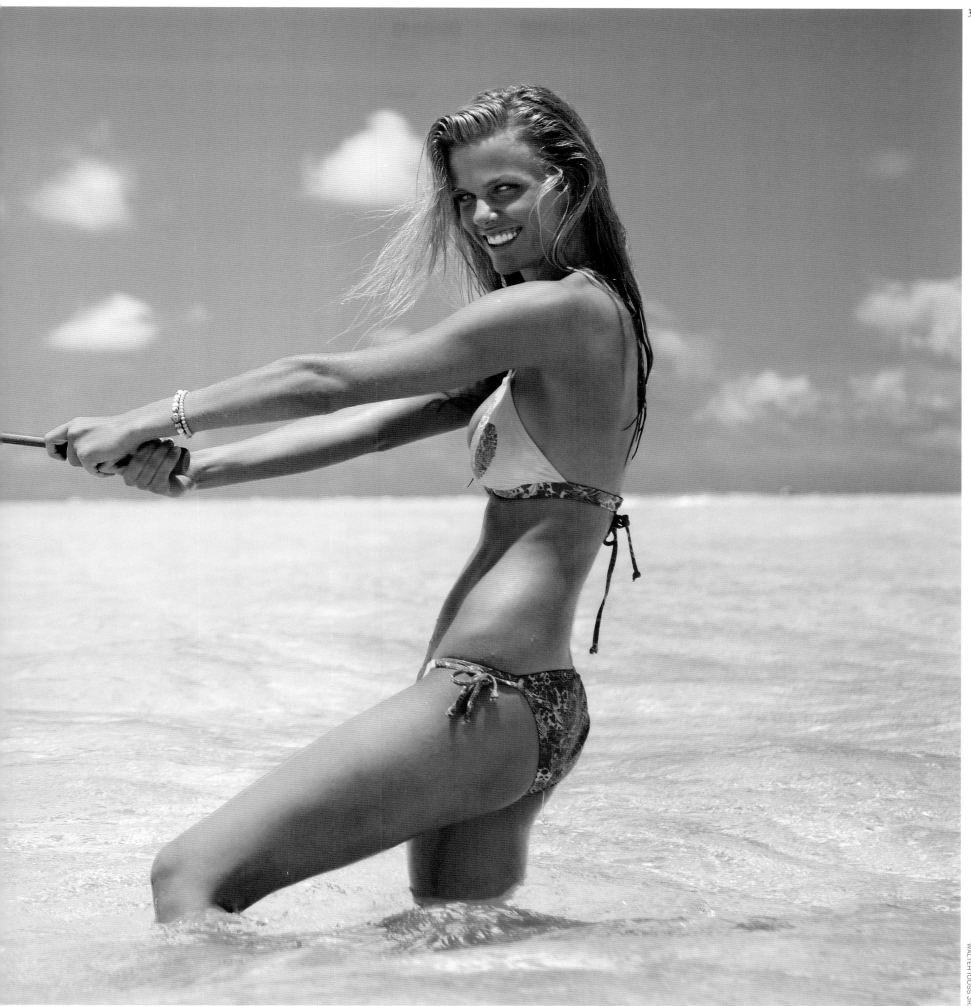

WALTER IOOSS JR.

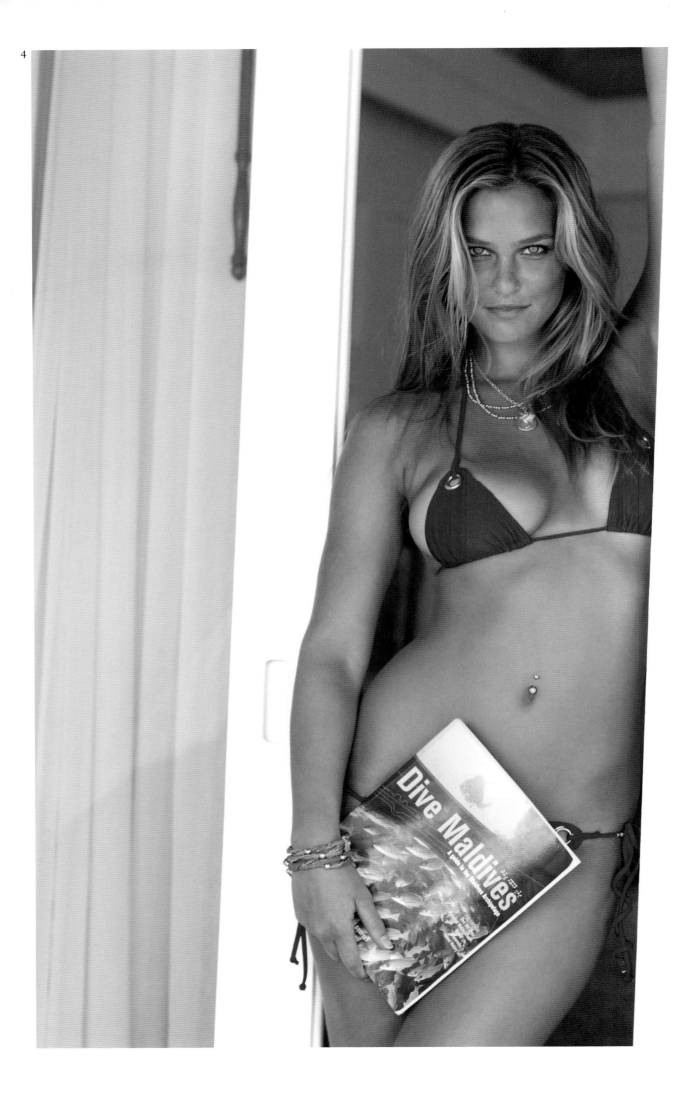

WALTER IOOSS JR.

The Portfolios

INTRODUCTION – 6

photographer + swimsuit model

Stewart Shining + Anne V – 10

Walter Iooss Jr. + Christine Teigen – 20

Riccardo Tinelli + Esti Ginzburg – 30

Raphael Mazzucco + Irina Shayk – 40

Stewart Shining + Jessica White – 50

Walter Iooss Jr. + Bar Refaeli – 60

Walter Chin + Genevieve Morton – 70

Riccardo Tinelli + Hilary Rhoda – 80

Raphael Mazzucco + Julie Henderson – 90

Stewart Shining + Jessica Gomes – 100

Walter Iooss Jr. + Dominique Piek – 110

Riccardo Tinelli + Sonia Dara – 120

Raphael Mazzucco + Daniella Sarahyba – 130

Walter Chin + Damaris Lewis – 140

Stewart Shining + Cintia Dicker – 150

Raphael Mazzucco + Zoe Duchesne – 160

Riccardo Tinelli + Julie Ordon – 170

Walter Iooss Jr. + Brooklyn Decker – 180

Creative Director
STEVEN HOFFMAN

Art Director
SUZANNE NOLI

Swimsuit Editor
DIANE SMITH

Associate Editor
MJ DAY

Assistant Editor
DARCIE BAUM

Copy Editor
KEVIN KERR

Writers
MARK BECHTEL
RICHARD DEITSCH
CHRIS MANNIX

Project Manager
STEFANIE KAUFMAN

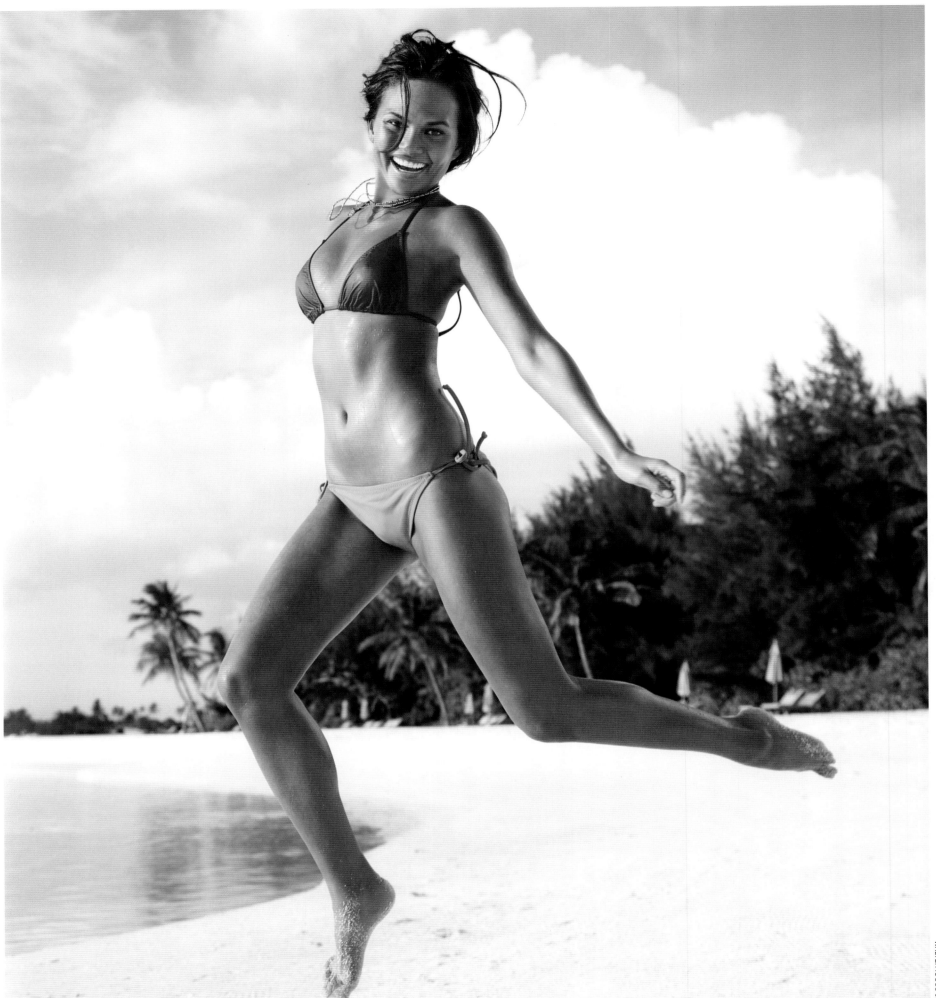

WALTER IOOSS JR.

AH, PARADISE.
FOR CENTURIES ARTISTS HAVE WRITTEN ABOUT ITS ELUSIVENESS

and offered their visions of what it might look like. John Milton devoted countless years and countless words to man's loss and subsequent pursuit of it in *Paradise Lost* and *Paradise Regained*. As for its appearance, well, if nothing else, the Renaissance painter Tintoretto clearly thought it was big. At 74' × 30', his *Paradise* is believed to be the largest painting rendered on canvas. (That's enough canvas to construct 5½ boxing rings, or a straitjacket large enough to subdue the Statue of Liberty.) But for the best representation of paradise—its definitive definition, as it were—we turn (where else?) to rock and roll. No, not to whatever it was Meatloaf found by the dashboard light. Instead, we're talking about Guns N' Roses's *Paradise City*, a place with but two simple characteristics: The grass is green and the girls are pretty. Indeed, every year SPORTS ILLUSTRATED embarks upon a Miltonian quest to find a paradise that's true to the song's ideal, a place that allows us to combine that pair of essential elements: a verdant setting and a gaggle of good-looking gals. Frankly, it's never as hard to find as Milton made it seem. (Though, in his defense, he didn't have Trip Advisor.) Take, for instance, our shoot in the Maldives. Beauties? Check. Brooklyn Decker, Bar Refaeli, Christine Teigen (*left*) and Dominique Piek were on hand. Lush environs? Check. Maldivian sand is as white and fine as powdered sugar, the grass and ubiquitous coconut palms were impossibly green and the ocean there is so clear you could read a copy of *Paradise Lost* underwater with no problem. Of course the Maldives weren't the only Eden-like setting out there. We found them all over the world, in Portugal, India, Chile and California. So as you look at the pictures on these pages and take in the staggering beauty of the subjects and their surroundings, keep in mind that in the right company, and with the right travel agent, paradise is not so hard to find after all.

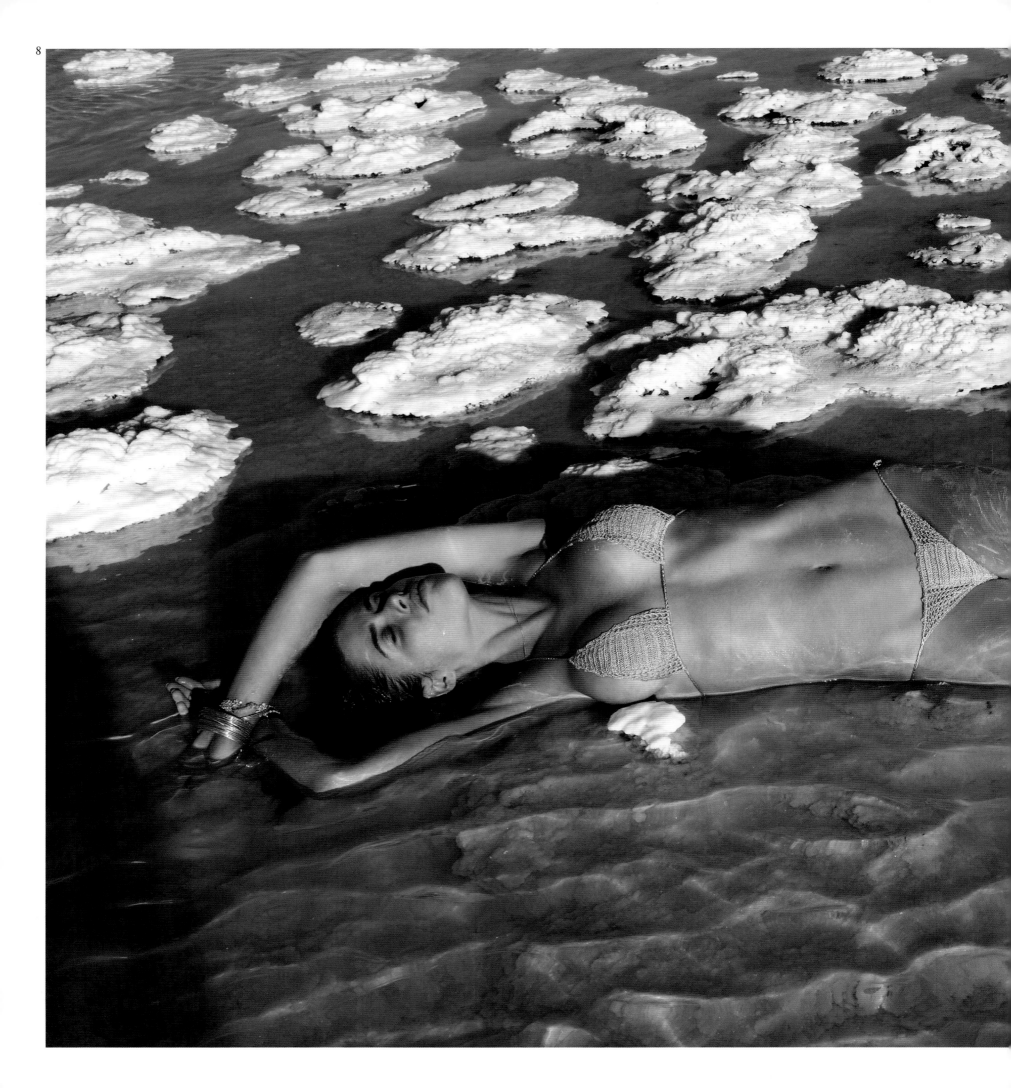

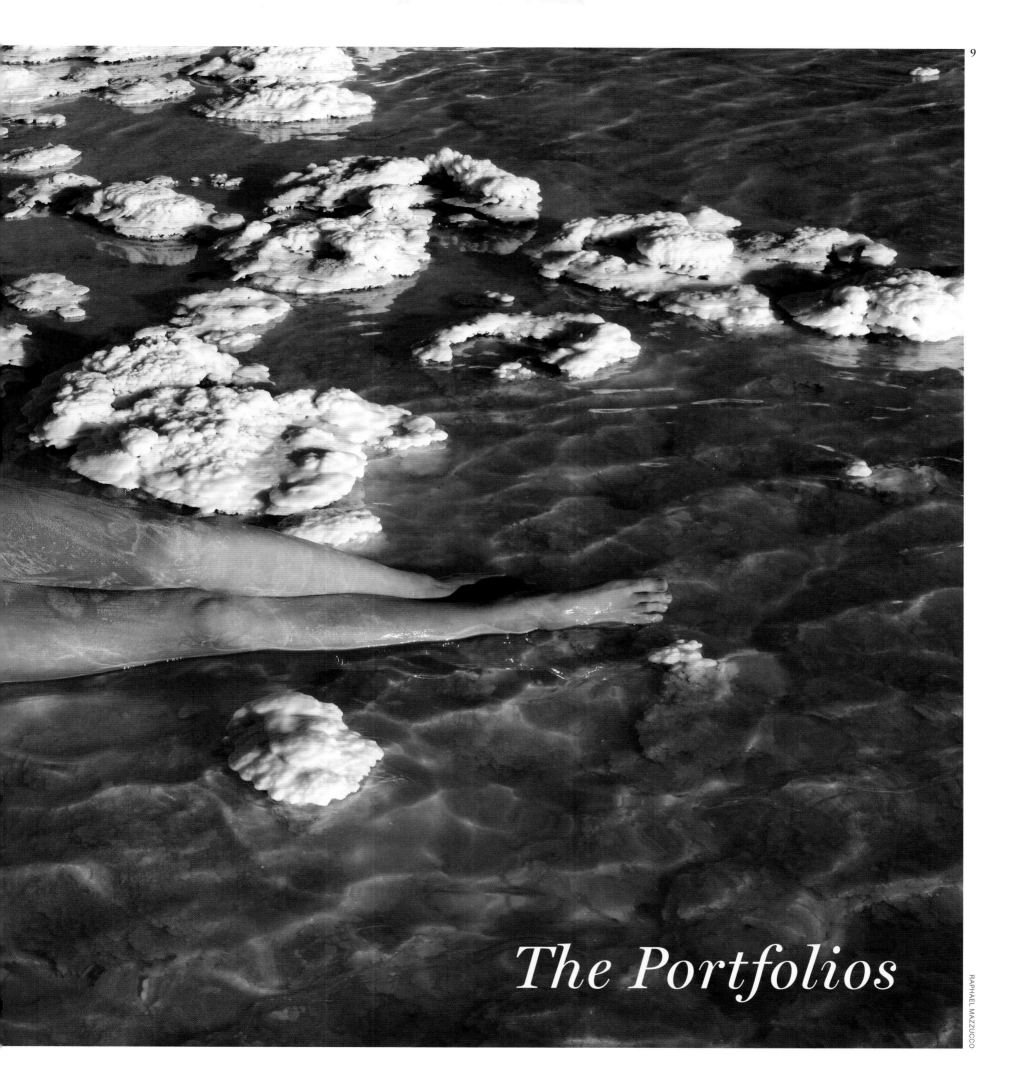

The Portfolios

RAPHAEL MAZZUCCO

ANNE V | LISBON, PORTUGAL

ANNE V

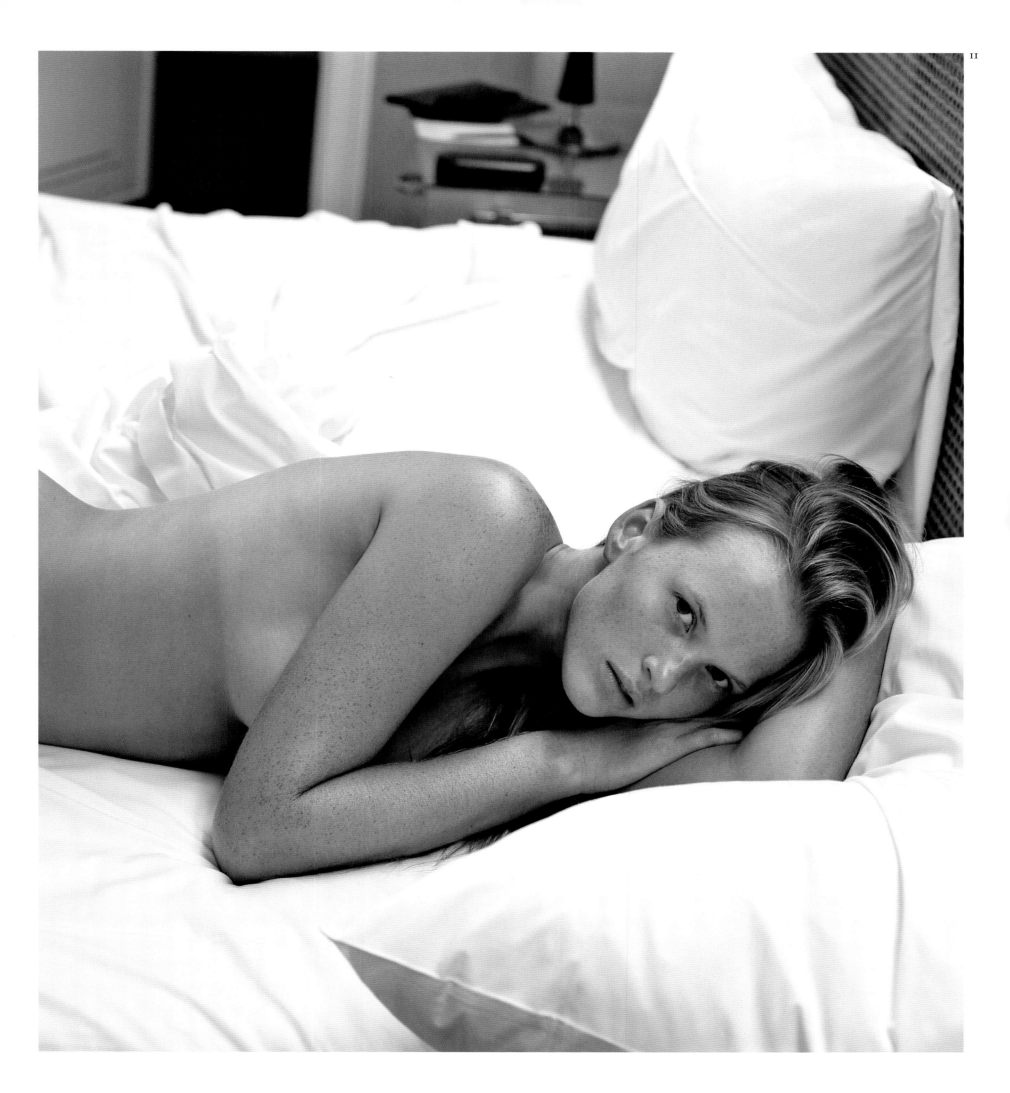

PORTFOLIO PHOTOGRAPHED ON LOCATION IN PORTUGAL BY

STEWART SHINING

" The two words I think best describe Anne V are effervescent and all-American, which is ironic, of course, because she's Russian. But when you're looking through the camera, you'd swear you were shooting a girl from Southern California. It's a great little mindbender. On the set Anne was totally playful, fun and upbeat, kind of an Energizer Bunny–type. For one shot on the beach, her hair was in pigtails and I thought, 'Oh my God, she looks like a young Marilyn Monroe when she was still Norma Jeane Baker.' Anne totally conveyed the innocence of that time. I thought she was channeling Marilyn. It was pretty cool. "

—STEWART SHINING

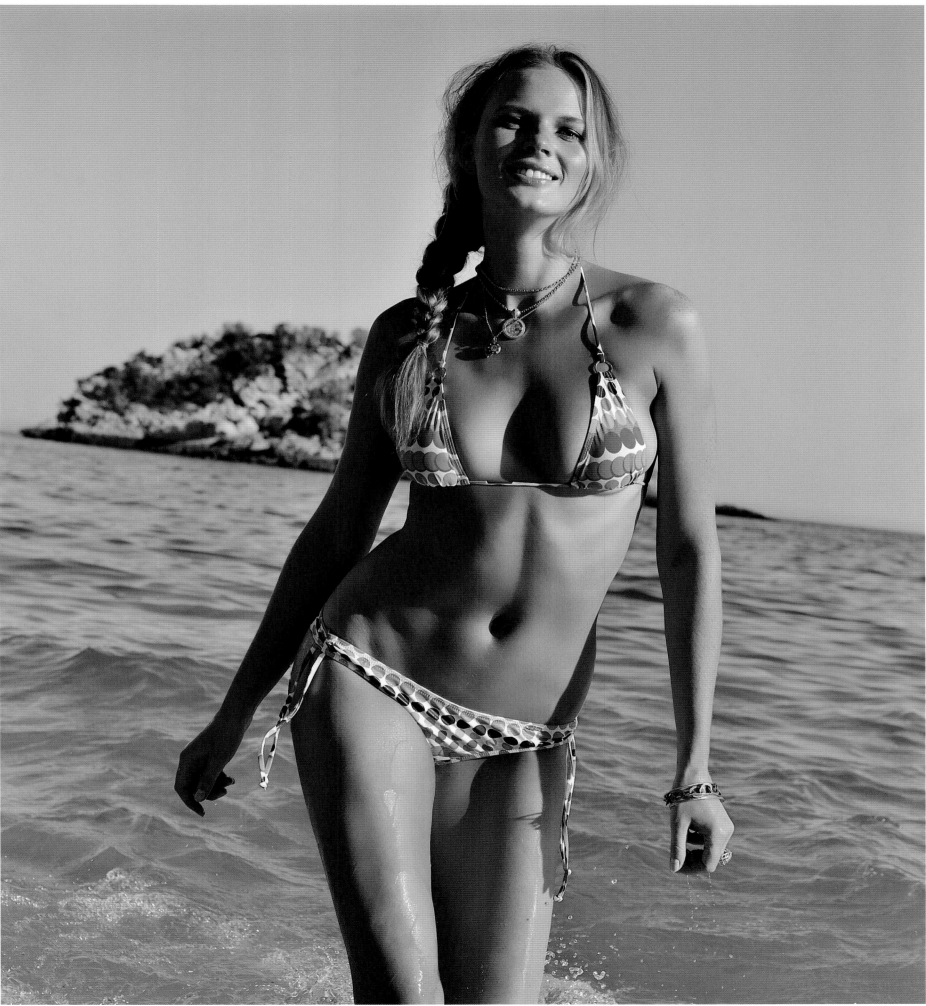

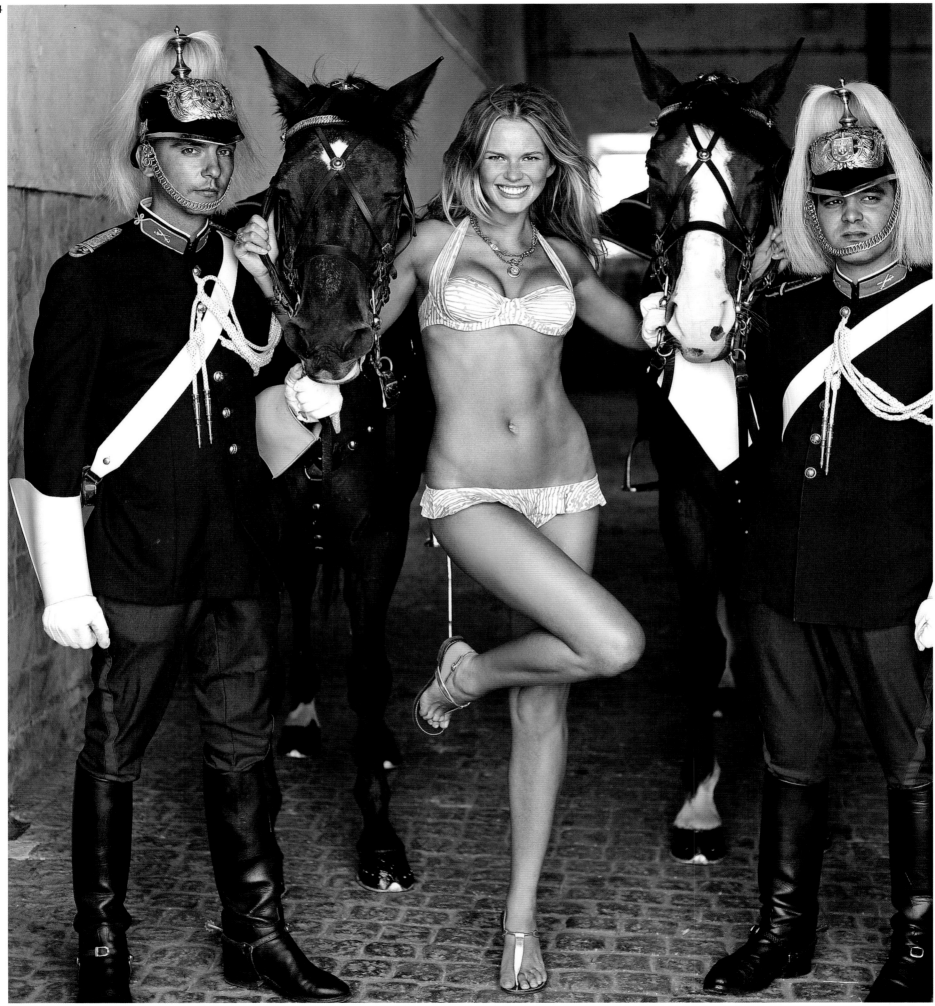

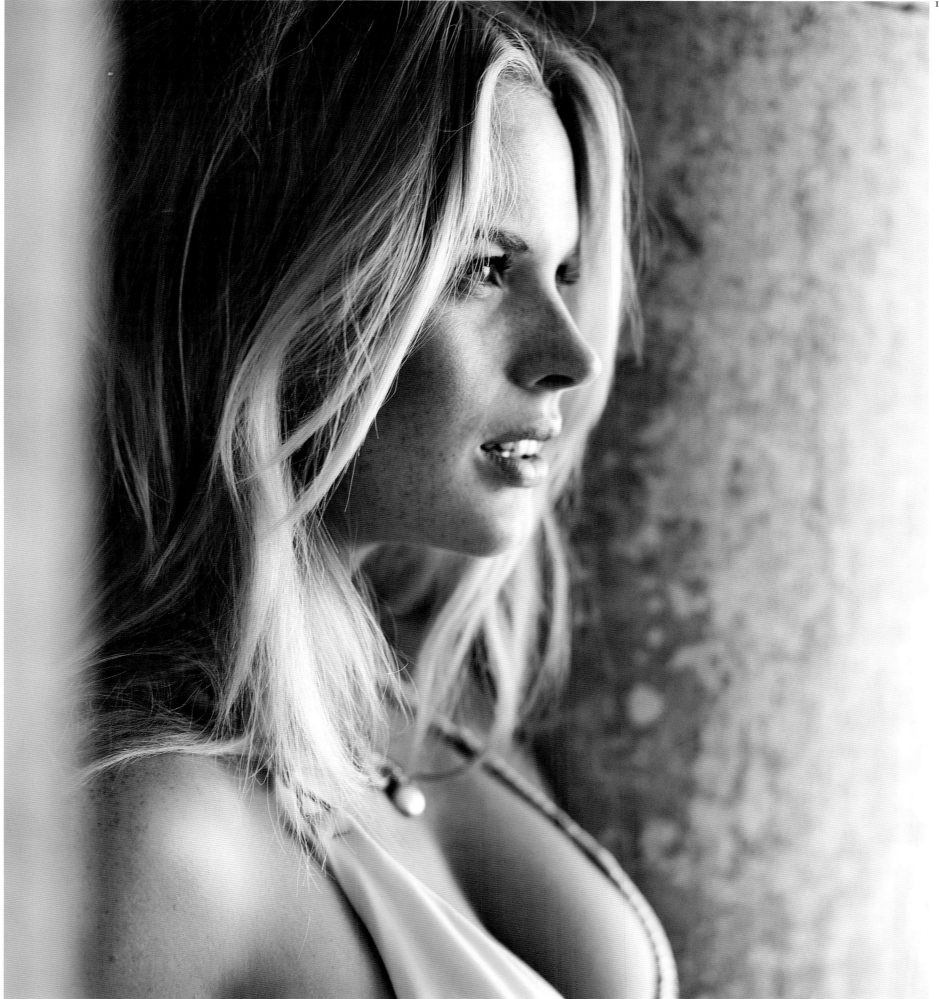

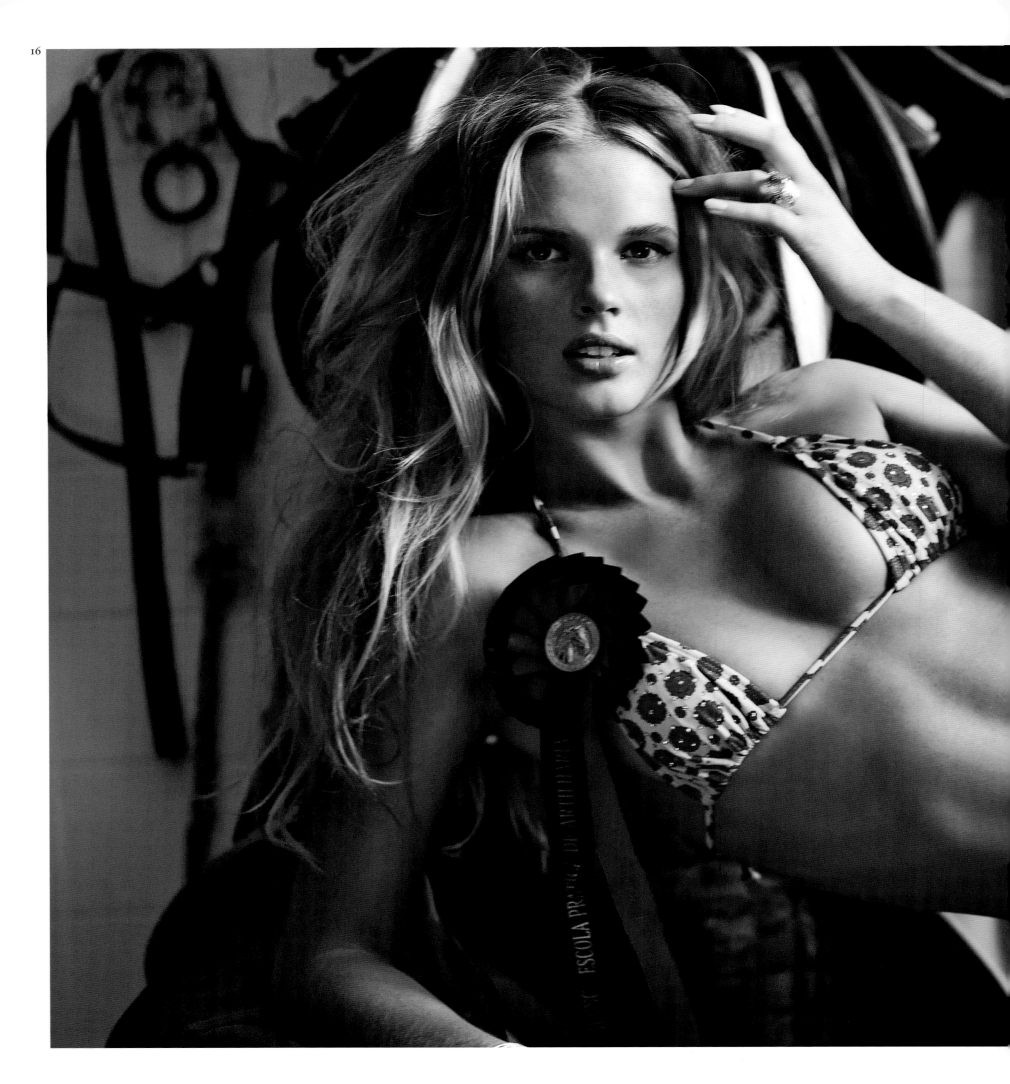

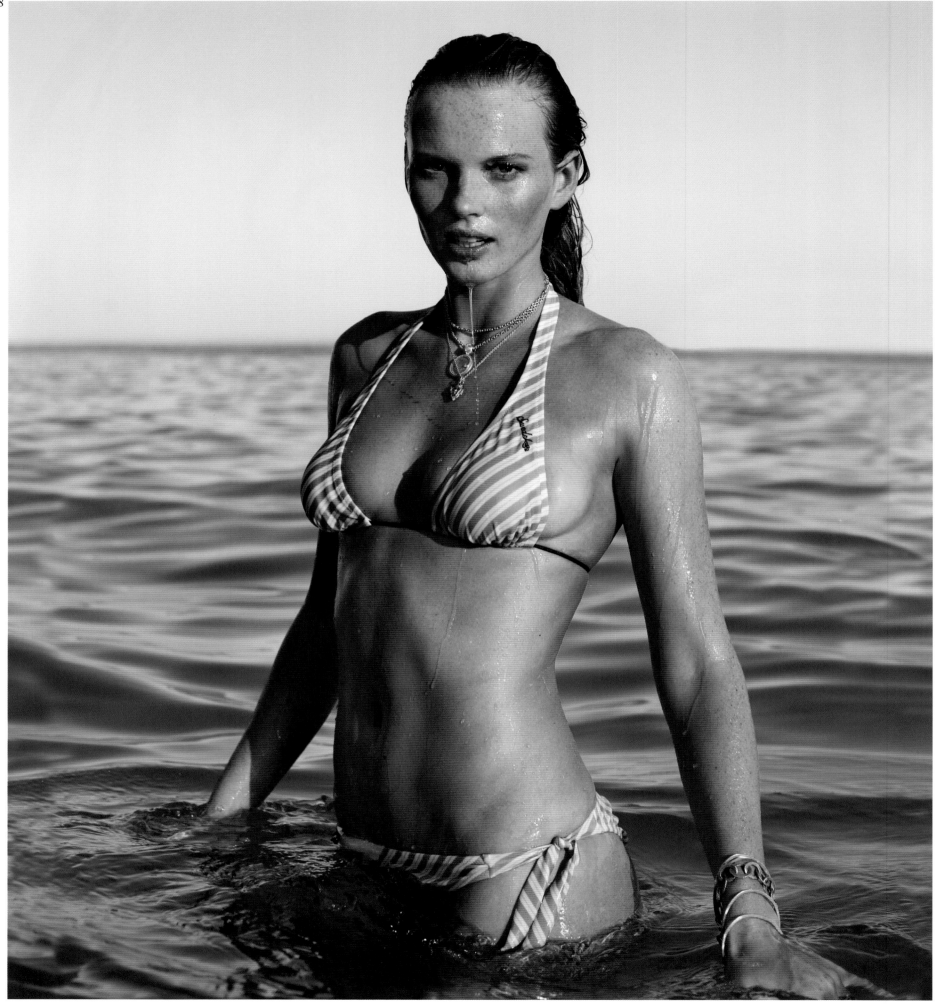

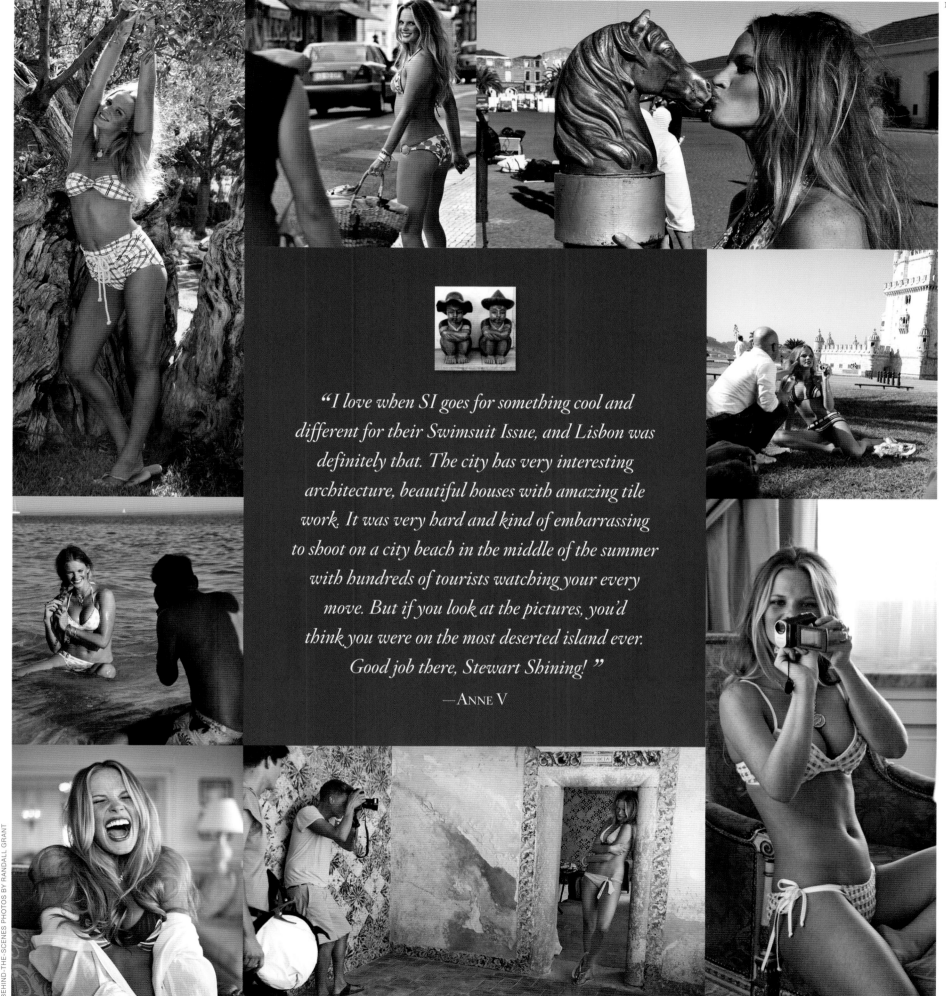

"*I love when SI goes for something cool and different for their Swimsuit Issue, and Lisbon was definitely that. The city has very interesting architecture, beautiful houses with amazing tile work. It was very hard and kind of embarrassing to shoot on a city beach in the middle of the summer with hundreds of tourists watching your every move. But if you look at the pictures, you'd think you were on the most deserted island ever. Good job there, Stewart Shining!* "

—ANNE V

CHRISTINE TEIGEN | SOUTH MALÉ ATOLL, MALDIVES

CHRISTINE

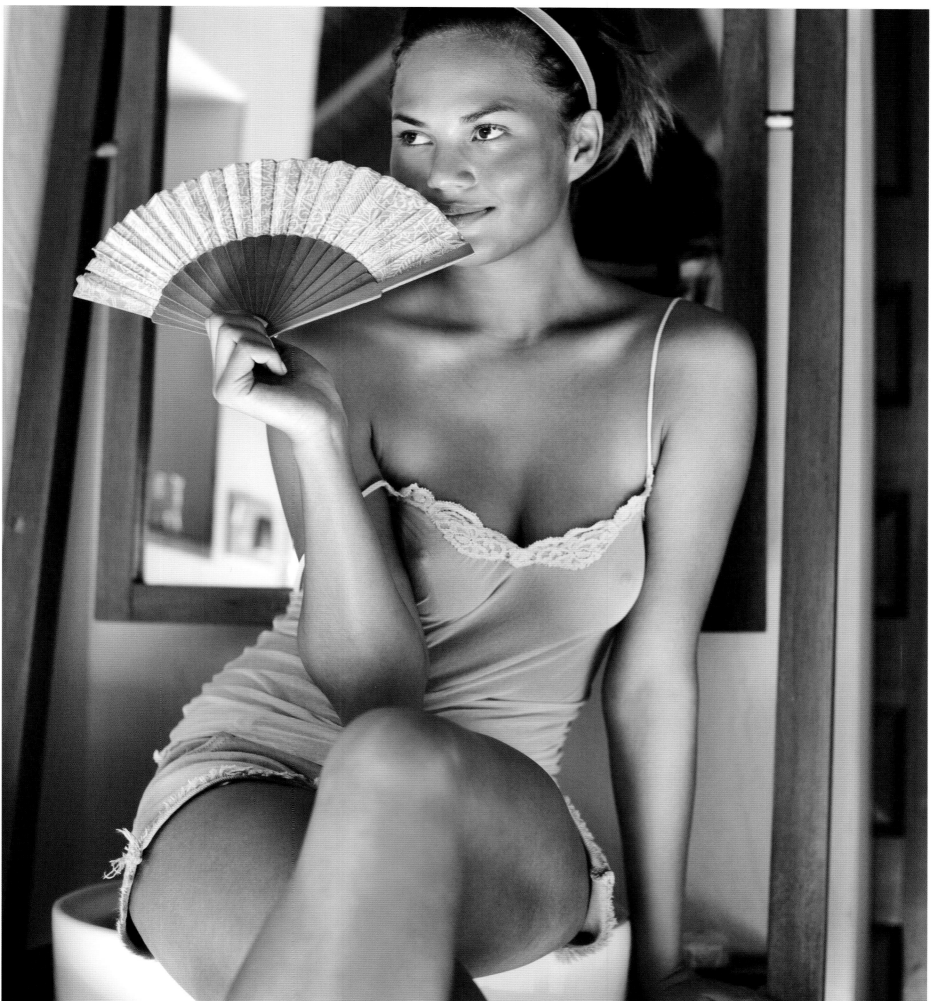

PORTFOLIO PHOTOGRAPHED ON LOCATION IN THE MALDIVES BY

WALTER IOOSS JR.

*"Chrissy was very bubbly, always giggly. She had a
nervous laugh that ended almost every one of her sentences.
I will say, though, that she was willing to try and do
anything. She's very open—I'm sure she is one wild girl.
I mean, some of the stories we heard from her, wow.
She's uninhibited, I think that's the right word. In a model,
that is a great attribute to have. Chrissy isn't that tall
but she has a good body and a special smile. She worked
hard at it and got better as the shoot went along. Her
pictures were terrific. I think she could be really something.
I'd love to shoot her again next year. She reminded me of
Ashley Richardson in one sense: Anything goes."*
—WALTER IOOSS JR.

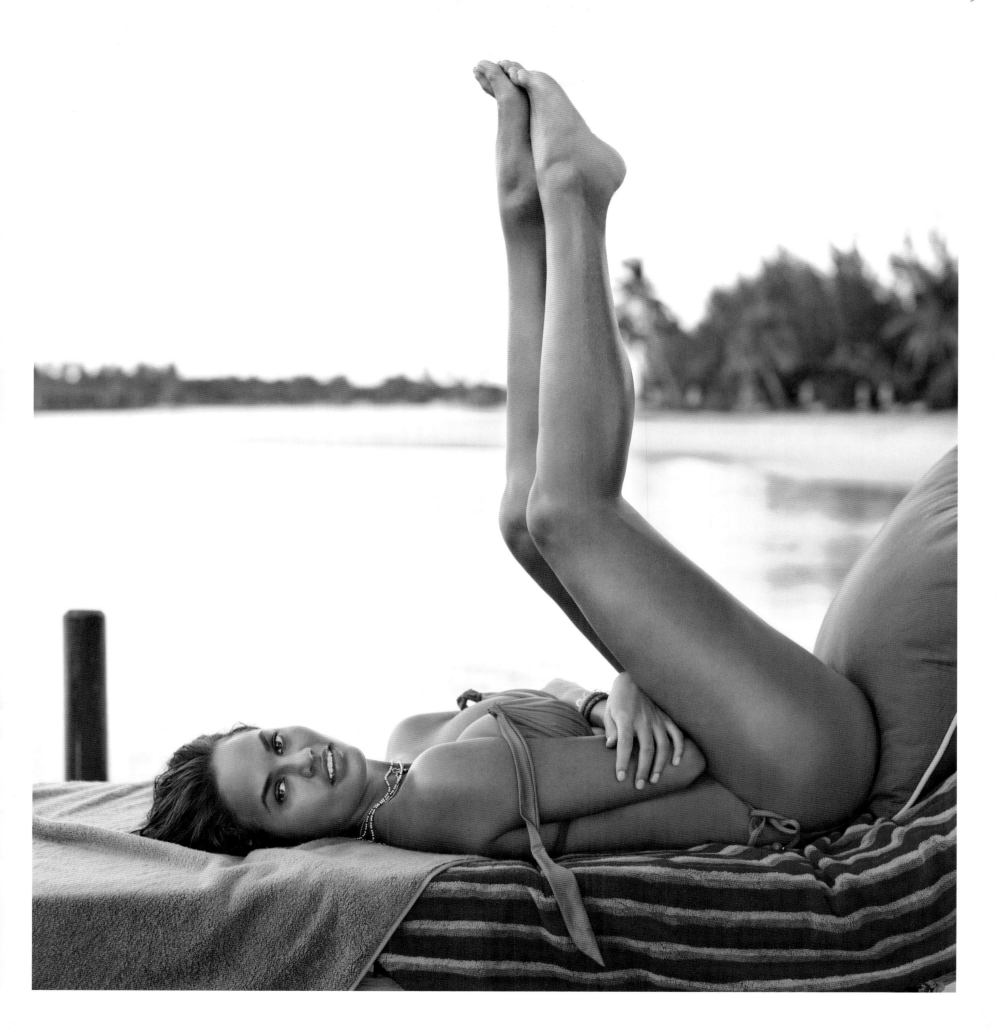

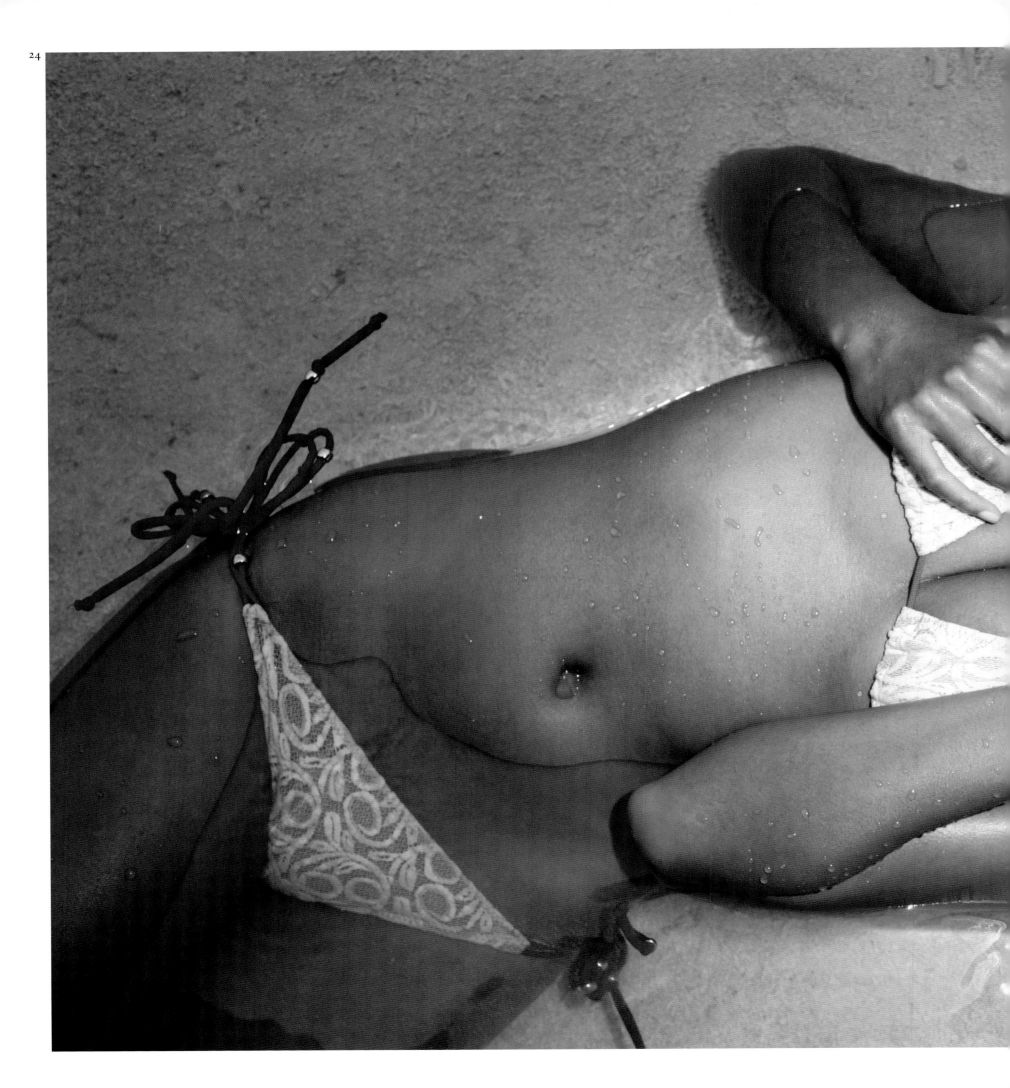

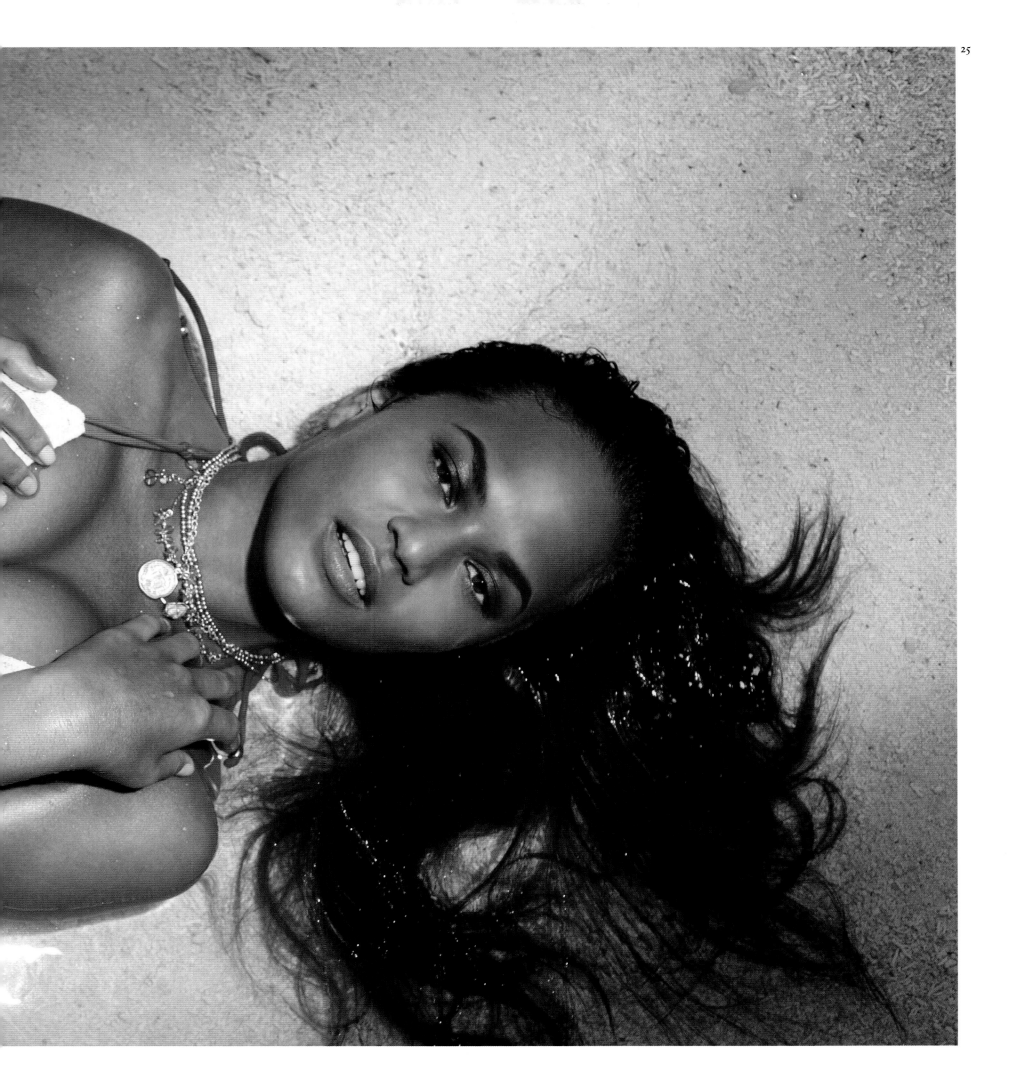

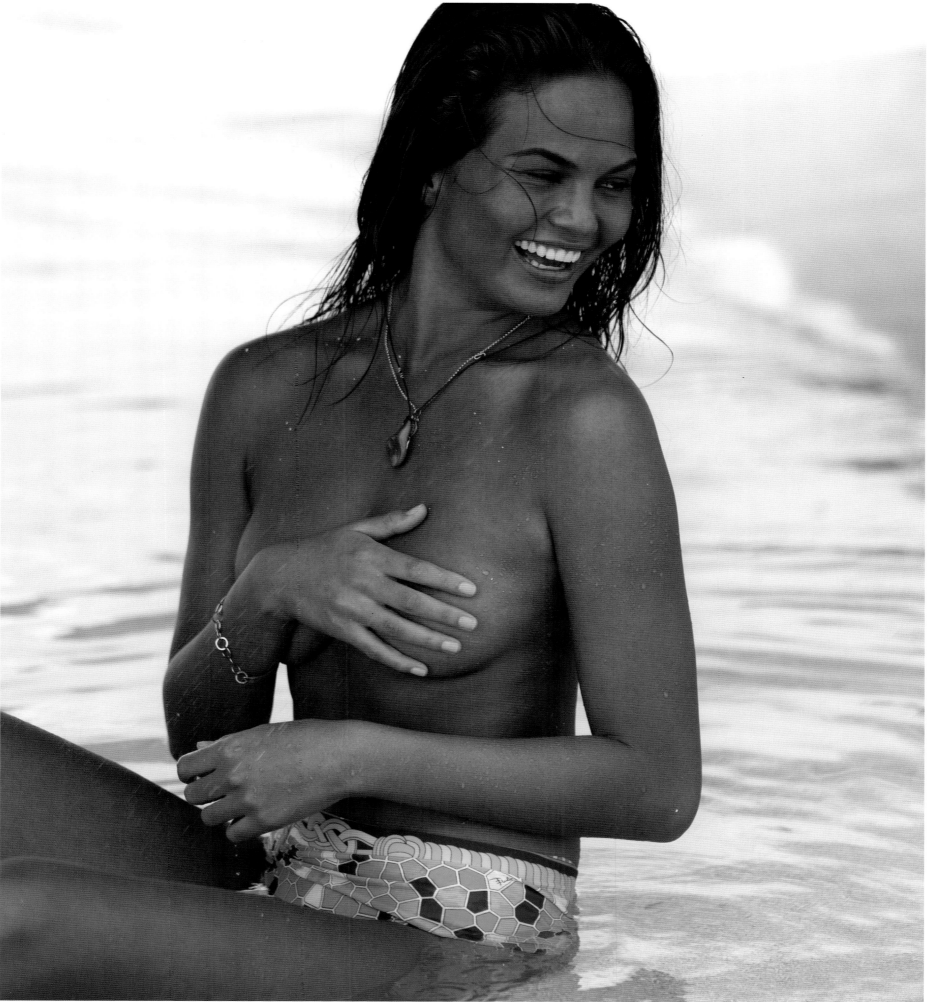

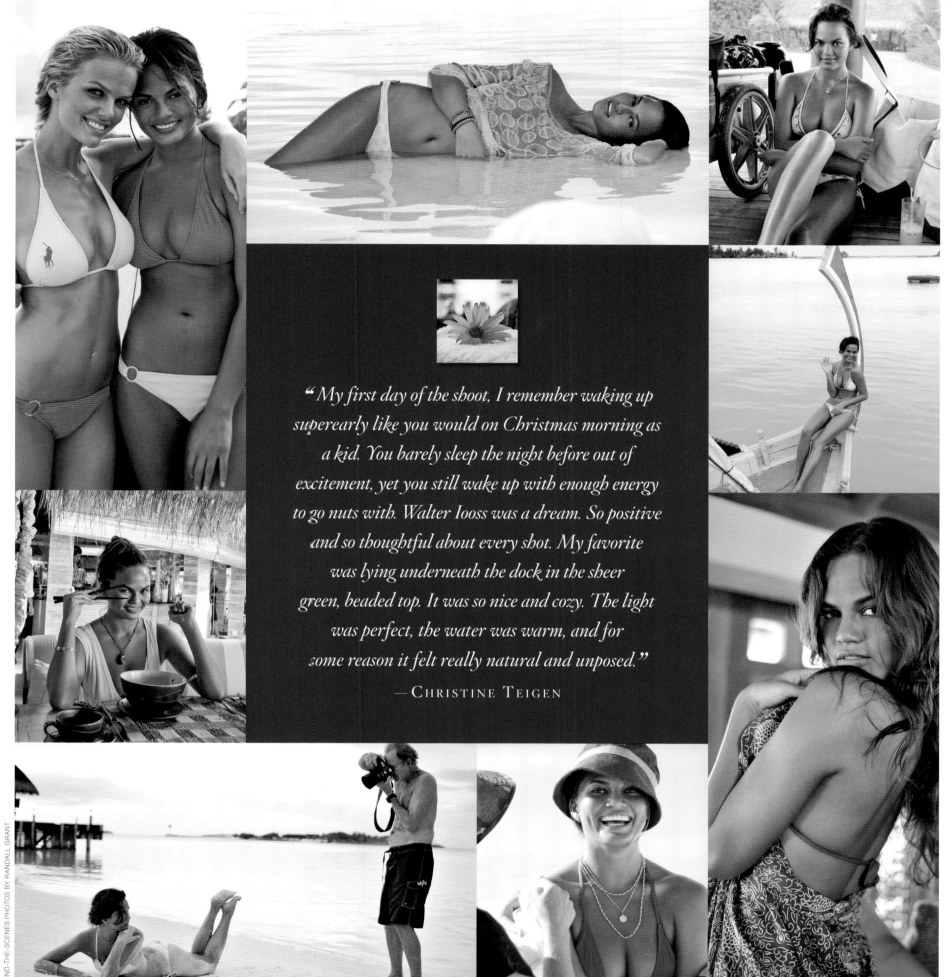

BEHIND-THE-SCENES PHOTOS BY RANDALL GRANT

"*My first day of the shoot, I remember waking up superearly like you would on Christmas morning as a kid. You barely sleep the night before out of excitement, yet you still wake up with enough energy to go nuts with. Walter Iooss was a dream. So positive and so thoughtful about every shot. My favorite was lying underneath the dock in the sheer green, beaded top. It was so nice and cozy. The light was perfect, the water was warm, and for some reason it felt really natural and unposed.*"

—CHRISTINE TEIGEN

ESTI GINZBURG | RAJASTHAN, INDIA

ESTI

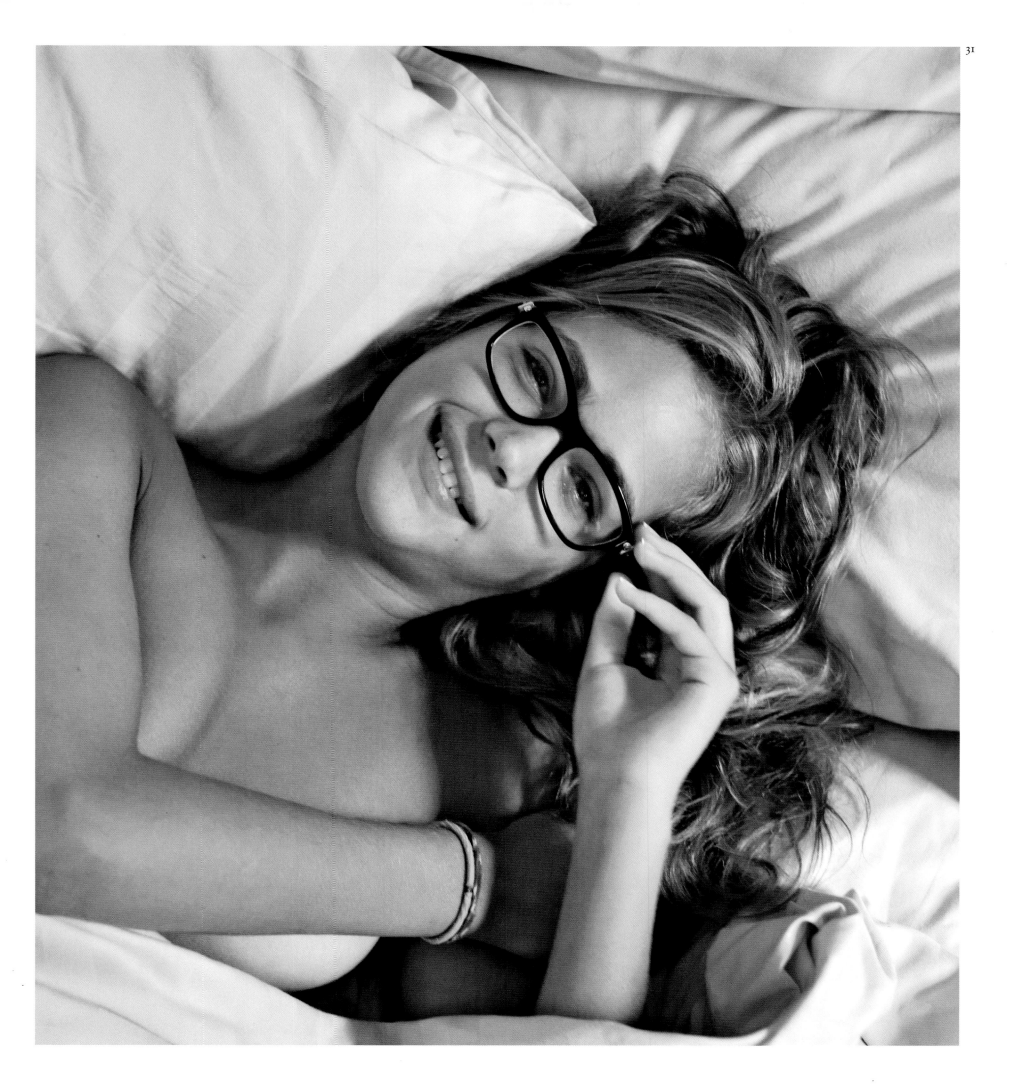

PORTFOLIO PHOTOGRAPHED ON LOCATION IN INDIA BY

RICCARDO TINELLI

*" I liked being around Esti. She is such a cute girl, such
a nice spirit. She is so polite. She's not one of these girls where
it's always 'Me, Me, Me.' She is so friendly and so
enthusiastic. She has such an attractive character; I think
this shows up a lot in her photos. We had two llamas in
one shot and all of a sudden they started kissing each other.
This would only happen with Esti—nice things happen
around her. Esti is this pretty Israeli thing with thick,
unbelievable hair who is just naturally beautiful. Sometimes
you have a girl who is too natural and you lose a little
bit of the glamour of the situation. You need to pull out the
glamour. But not with Esti. She has it all."*
—RICCARDO TINELLI

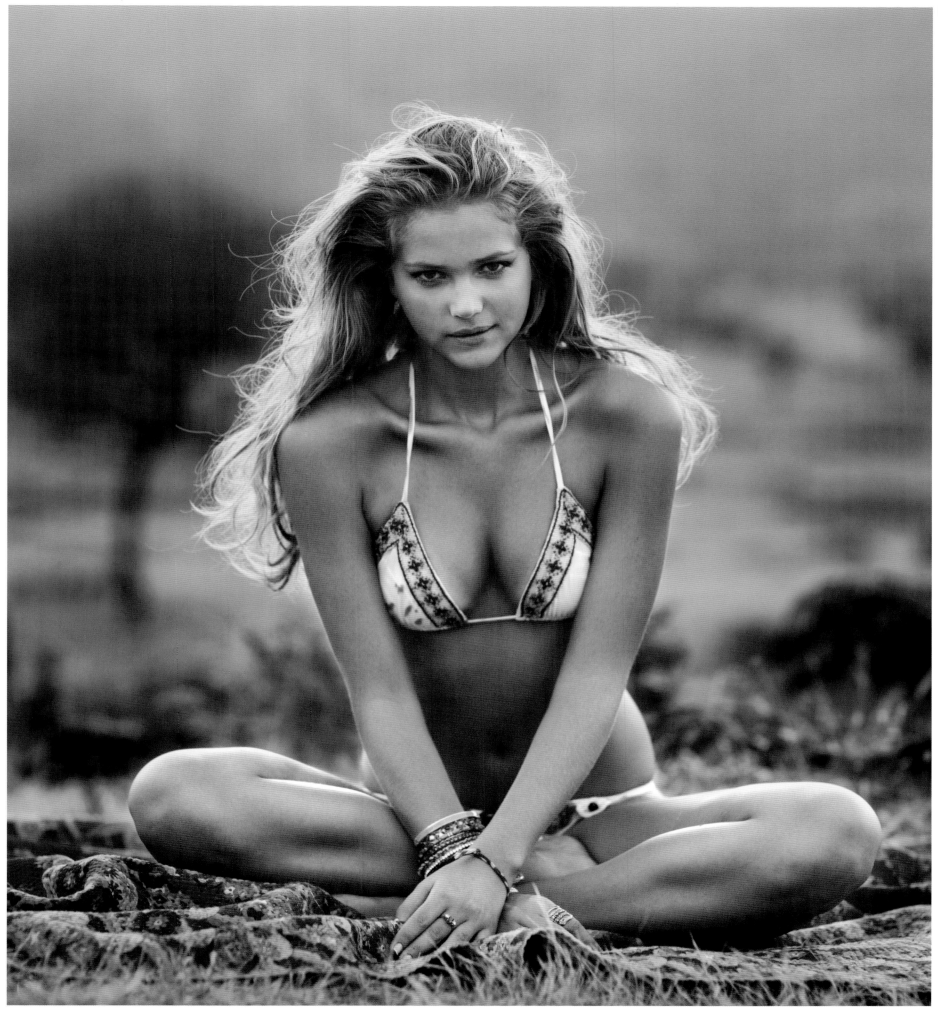

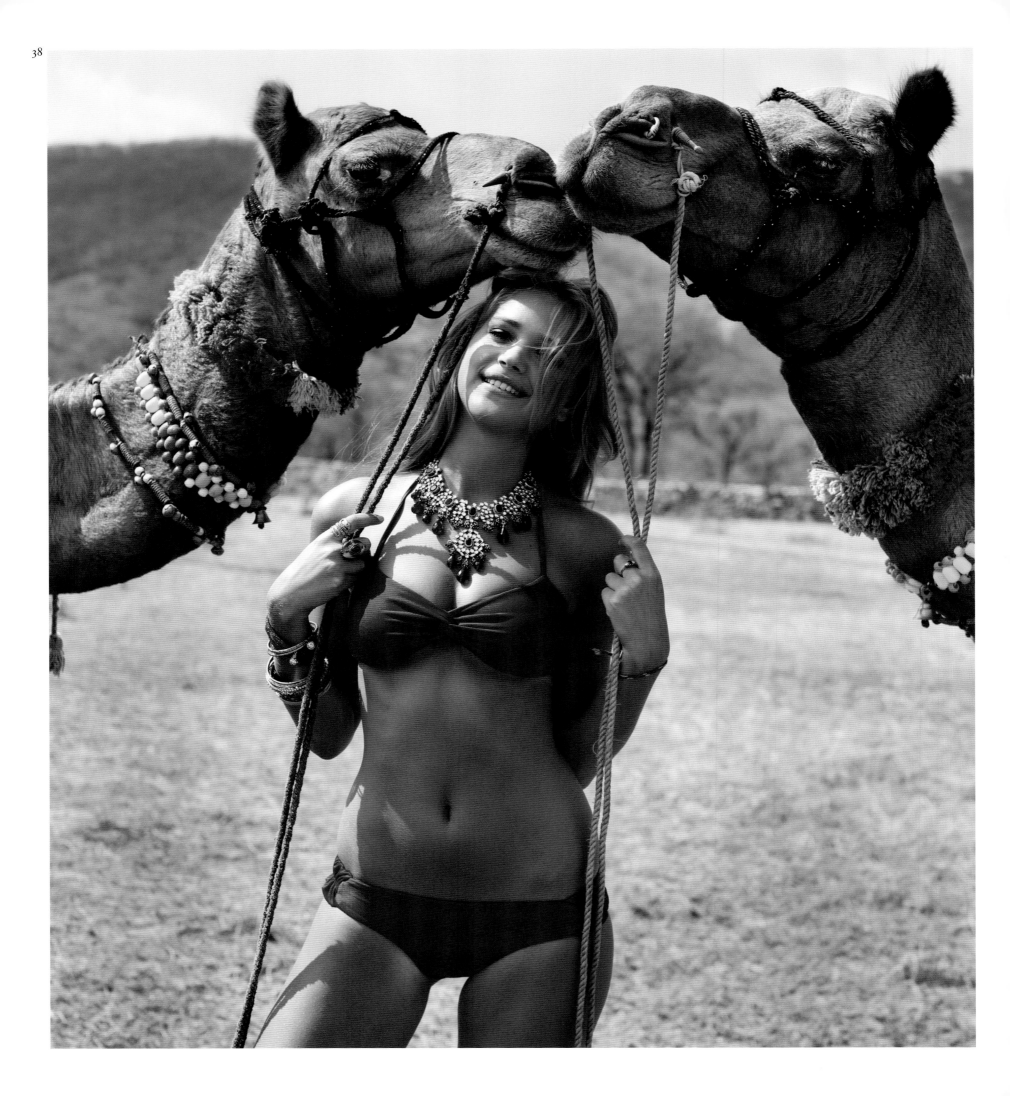

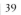

"The people of India were amazing. I've never met such warm, respectful, kind, polite, welcoming, generous, good-hearted people. The local women with whom I shot were so sweet and patient. Even though they barely spoke any English we managed to understand each other. I got such energy from them. As we drove through small towns, little kids would look into our vans as if we were aliens. They were so curious and innocent. And whenever we shot monkeys followed us around everywhere!"

— ESTI GINZBURG

BEHIND-THE-SCENES PHOTOS BY RANDALL GRANT

IRINA SHAYK | SAN PEDRO DE ATACAMA, CHILE

IRINA

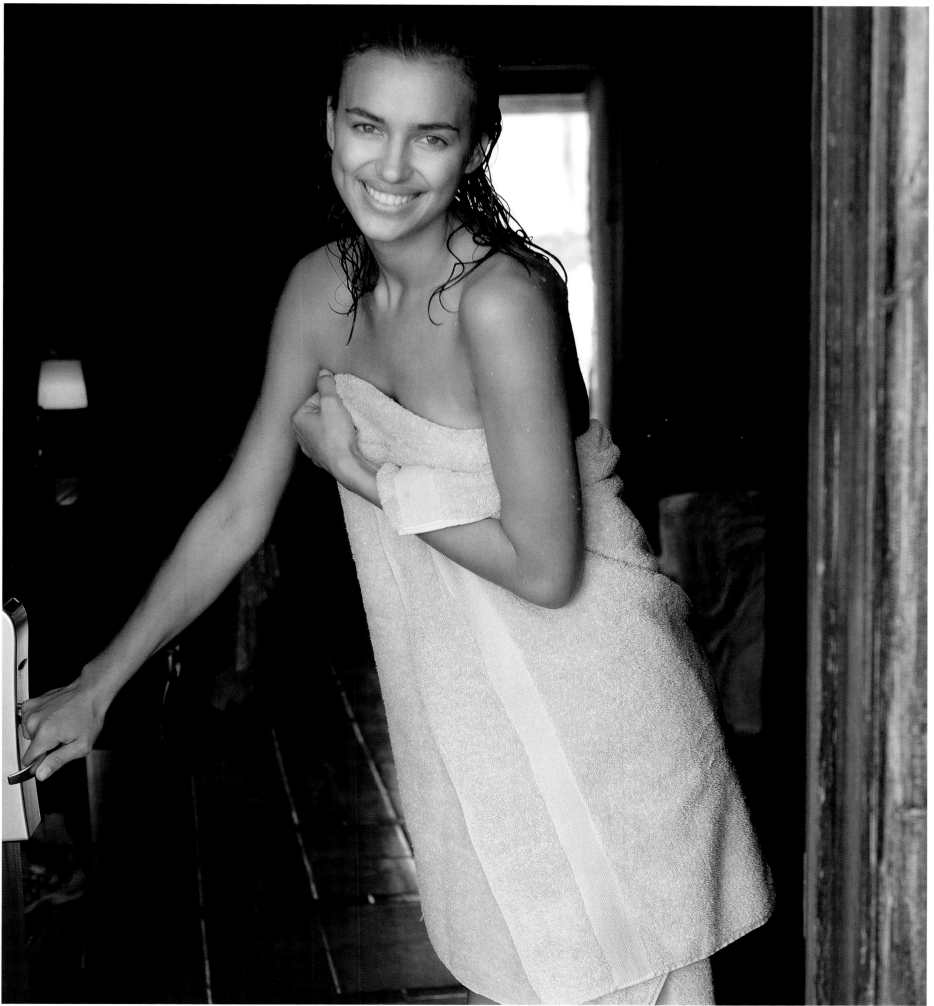

PORTFOLIO PHOTOGRAPHED ON LOCATION IN CHILE BY
RAPHAEL MAZZUCCO

*" Over the years I have worked with Irina on many jobs
and she just keeps getting better and better. When I
look at her I always notice how her skin tone contrasts with
her eyes—such a beautiful thing. You can see her
uniqueness in the way she moves her body. That's a
big part of her quality. She has those magnificent legs,
and when she is moving them they always look aesthetically
perfect. She also has a great inner self. She's very spontaneous,
naturally funny. She doesn't take herself too seriously. She just
goes with the flow and really lives in the moment.
That's the best way to describe Irina. She's just very alive
and I loved being around her in Chile. "*

—RAPHAEL MAZZUCCO

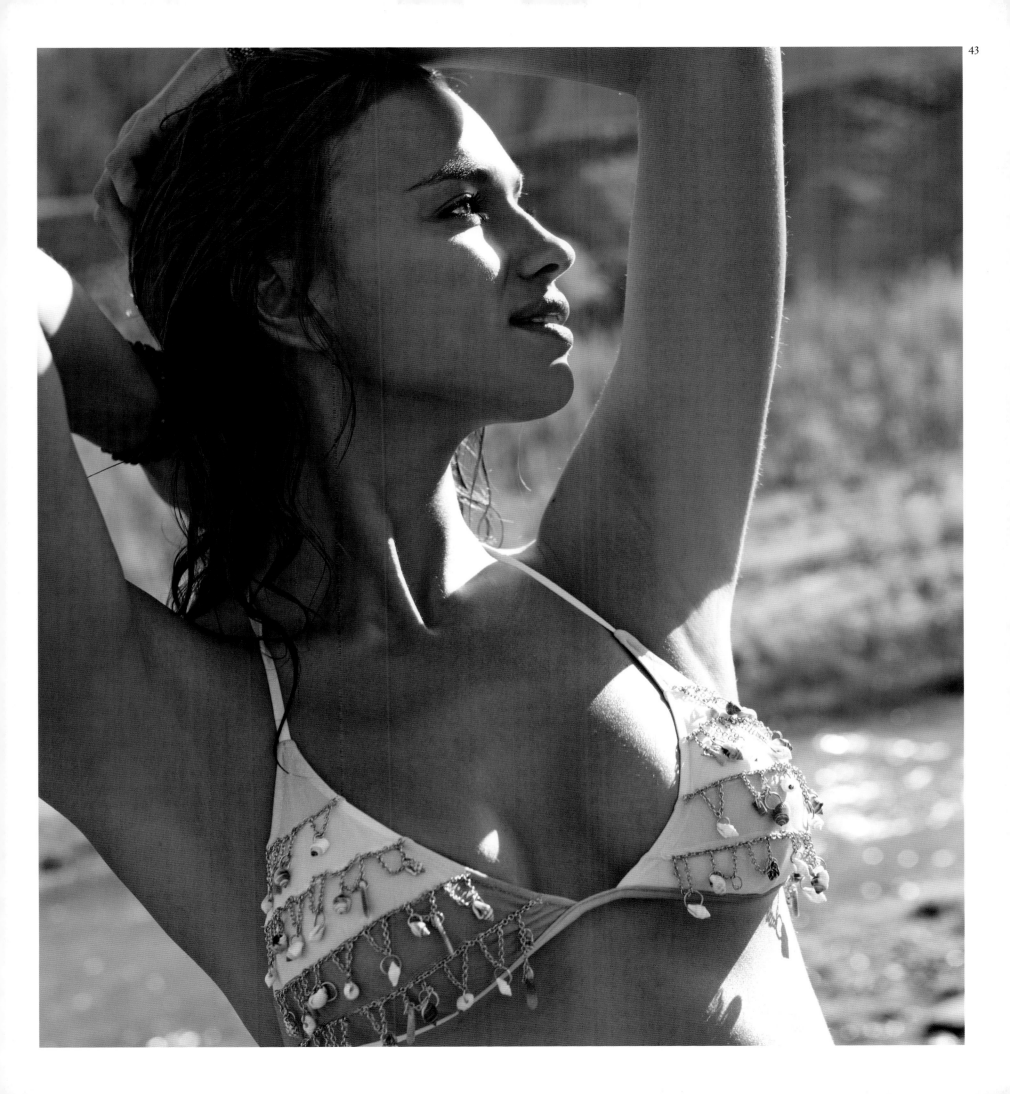

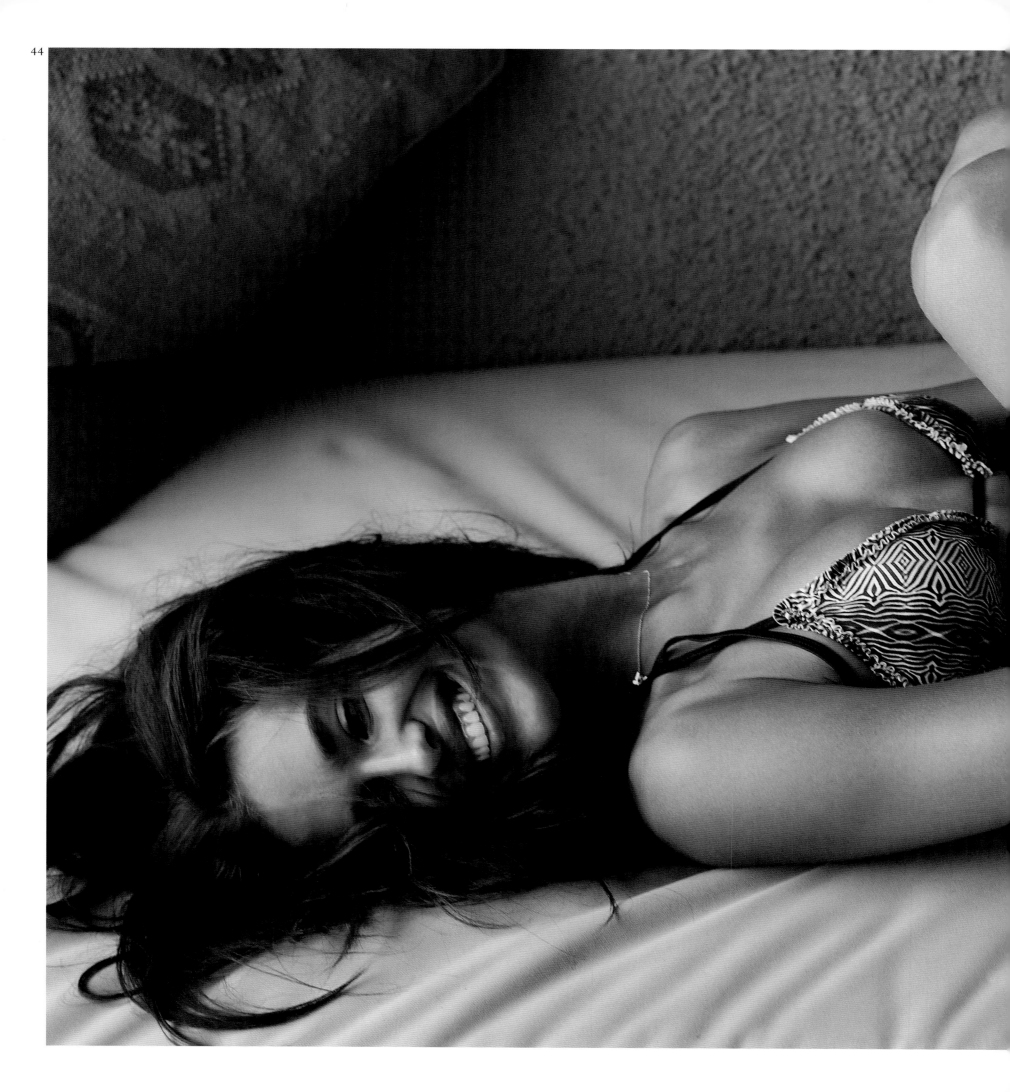

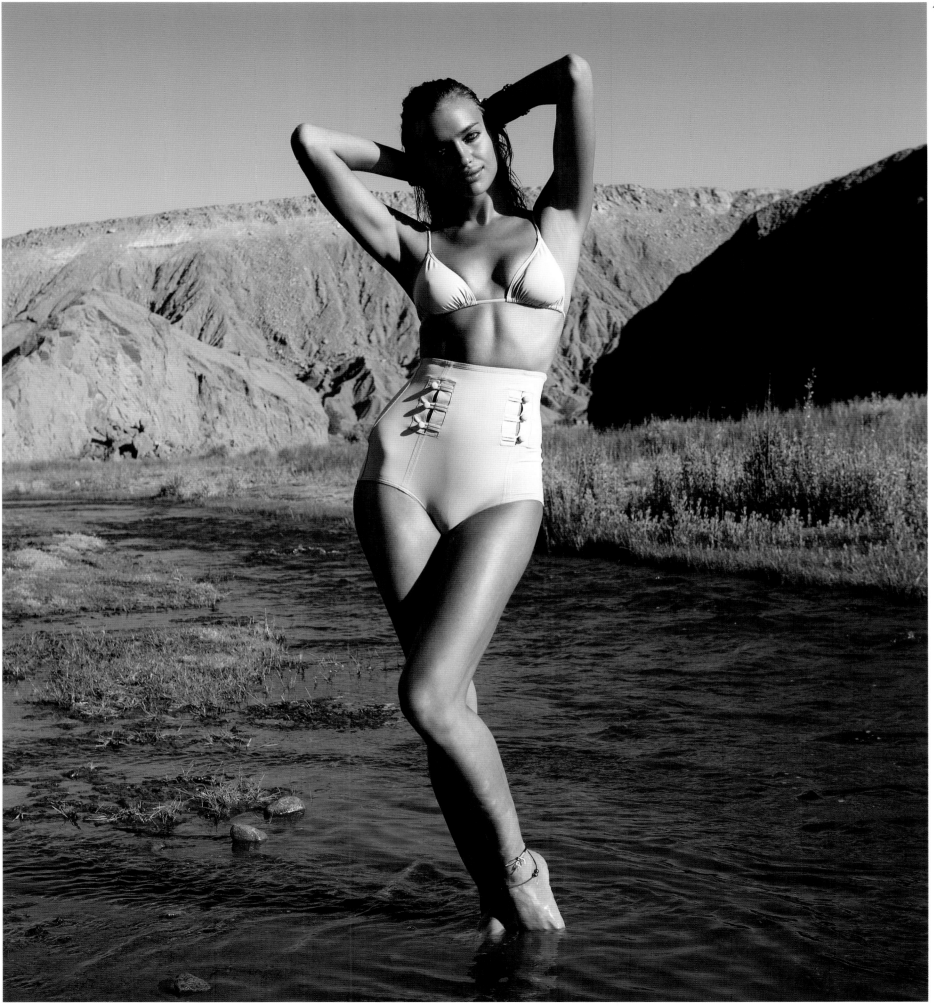

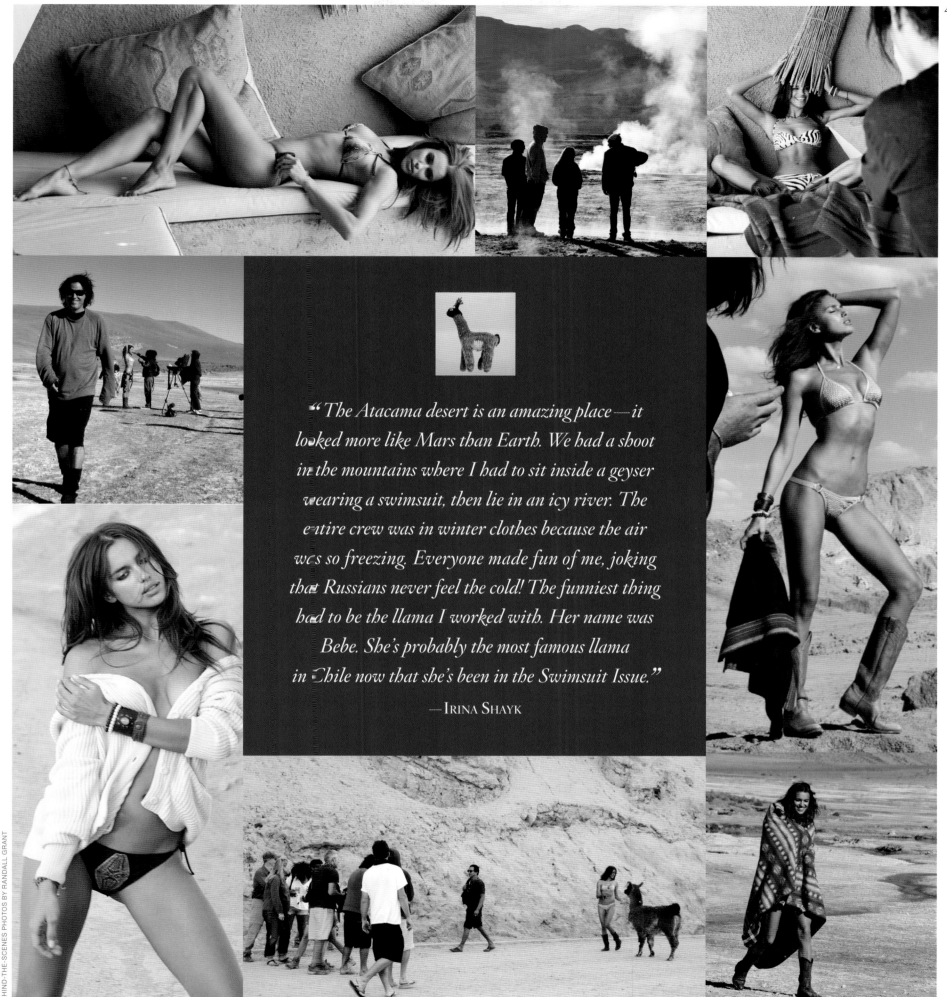

49

"*The Atacama desert is an amazing place—it looked more like Mars than Earth. We had a shoot in the mountains where I had to sit inside a geyser wearing a swimsuit, then lie in an icy river. The entire crew was in winter clothes because the air was so freezing. Everyone made fun of me, joking that Russians never feel the cold! The funniest thing had to be the llama I worked with. Her name was Bebe. She's probably the most famous llama in Chile now that she's been in the Swimsuit Issue.*"

—IRINA SHAYK

BEHIND-THE-SCENES PHOTOS BY RANDALL GRANT

JESSICA WHITE | LISBON, PORTUGAL

JESSICA

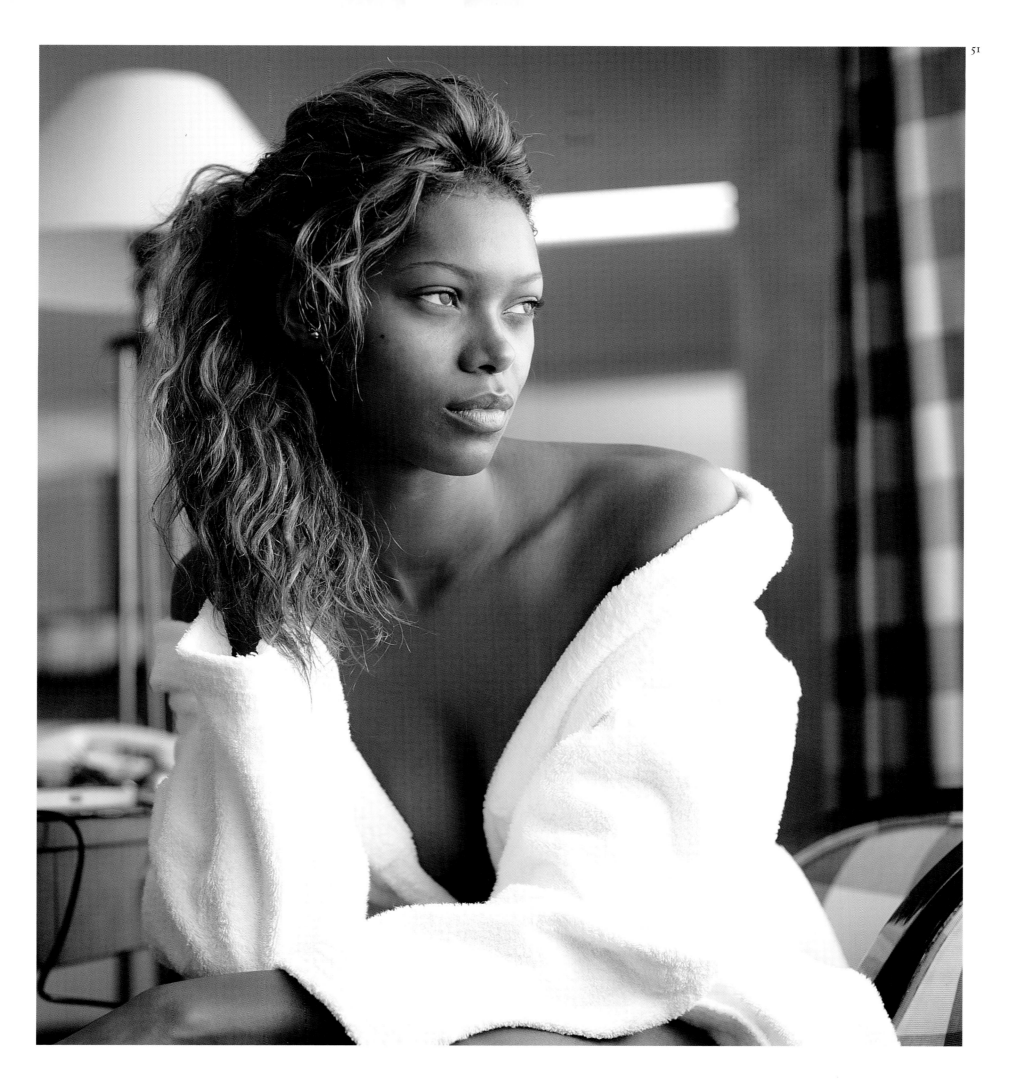

PORTFOLIO PHOTOGRAPHED ON LOCATION IN PORTUGAL BY

STEWART SHINING

" Jessica has this kind of outrageous side to her. She is not shy. She is full-throttle and will give you a run for your money. You cannot tease her without getting teased back. She is always all there and all in with this crazy sense of humor. When you look at her through the lens, there is something about the quality and color of her skin. She also has a long, lean elegance. She reminds me of Iman. She has that exotic thing and that kind of build. When I stand next to her, her legs go to the middle of my chest. Jessica is like a giraffe, long and lean forever. When you see her in real life, you think, 'Wow, what a pretty girl.' But the minute she stands in front of that camera, it's like 'Game on.' "

—STEWART SHINING

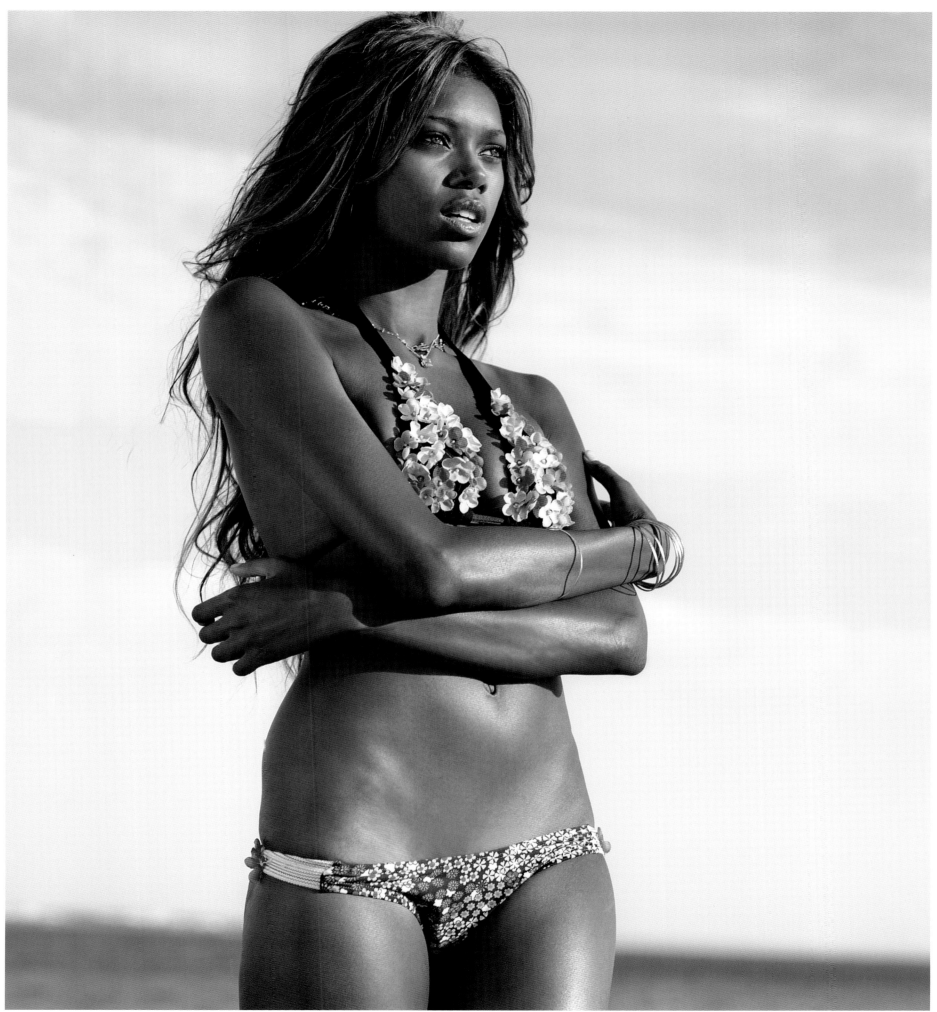

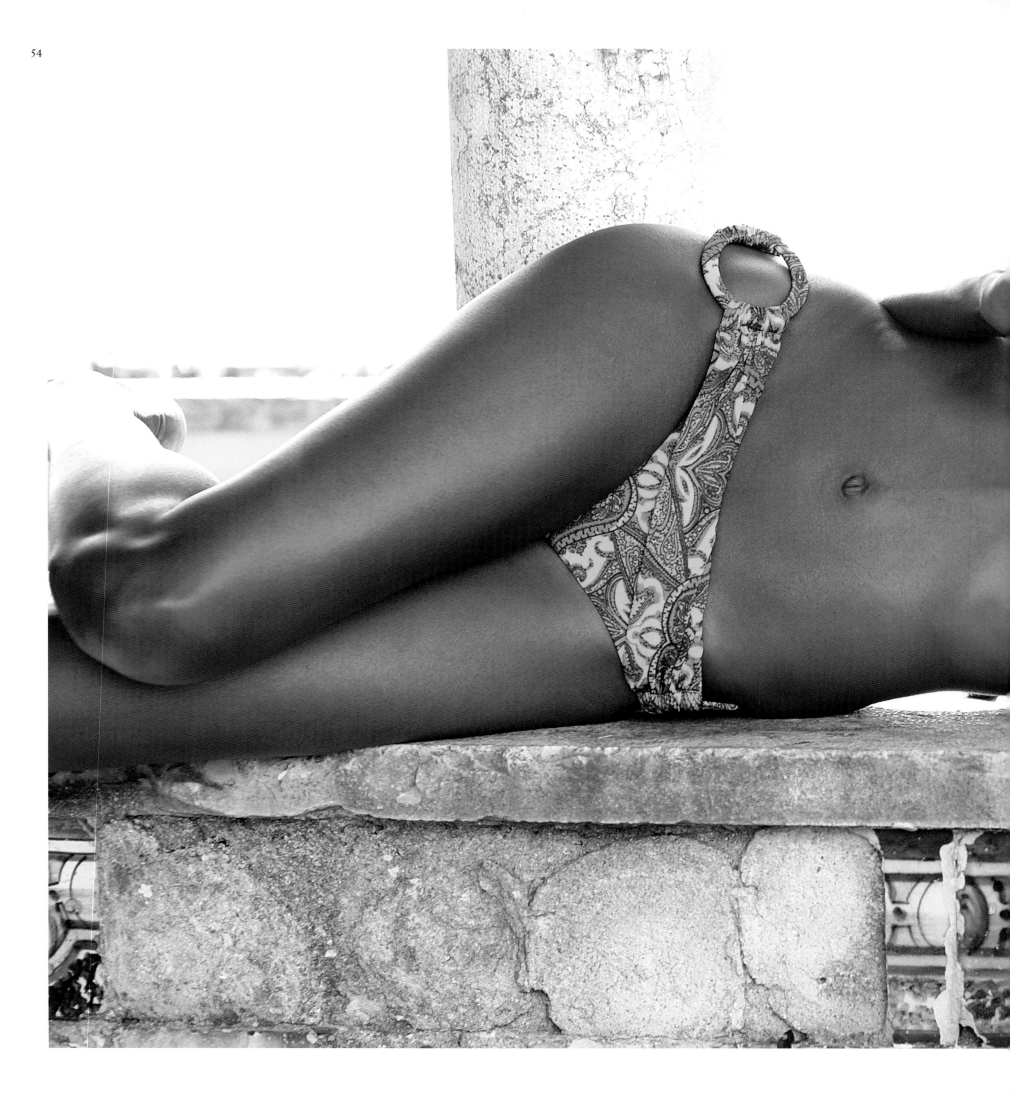

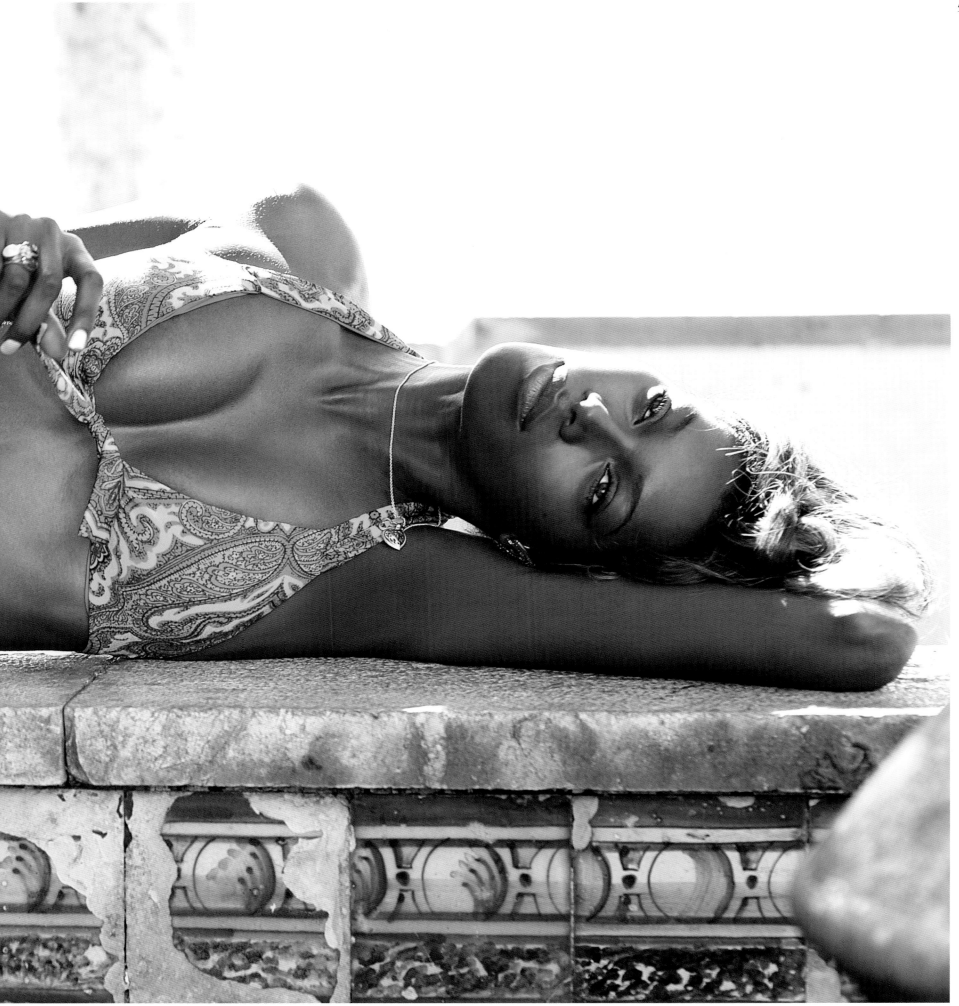

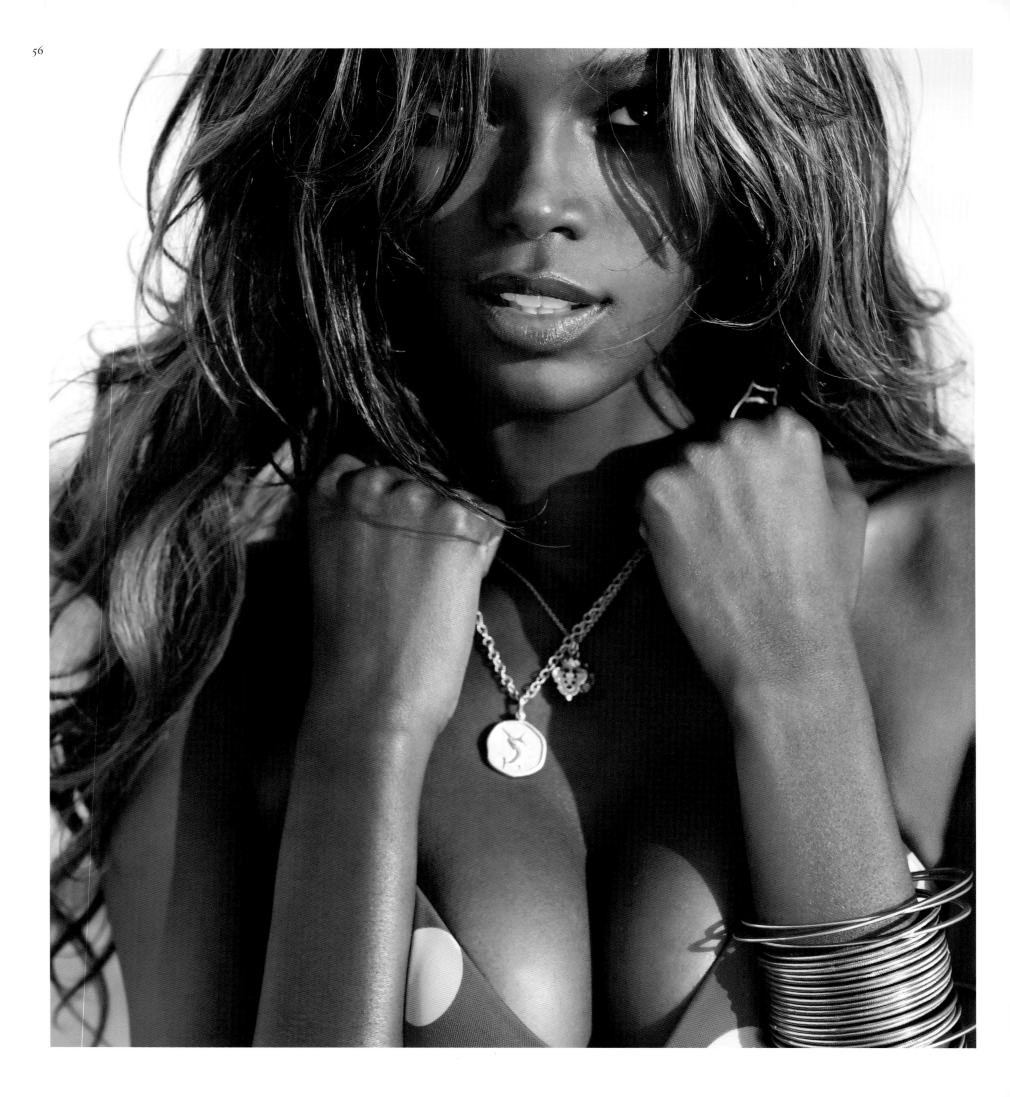

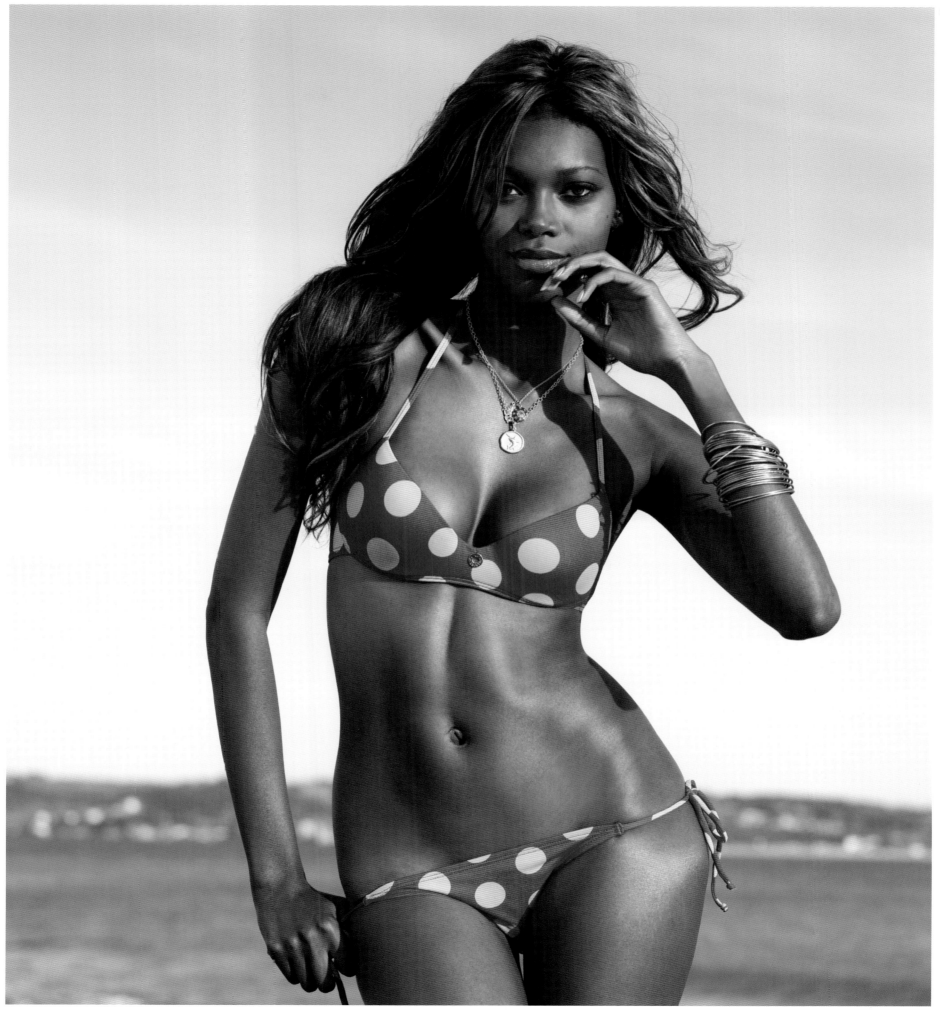

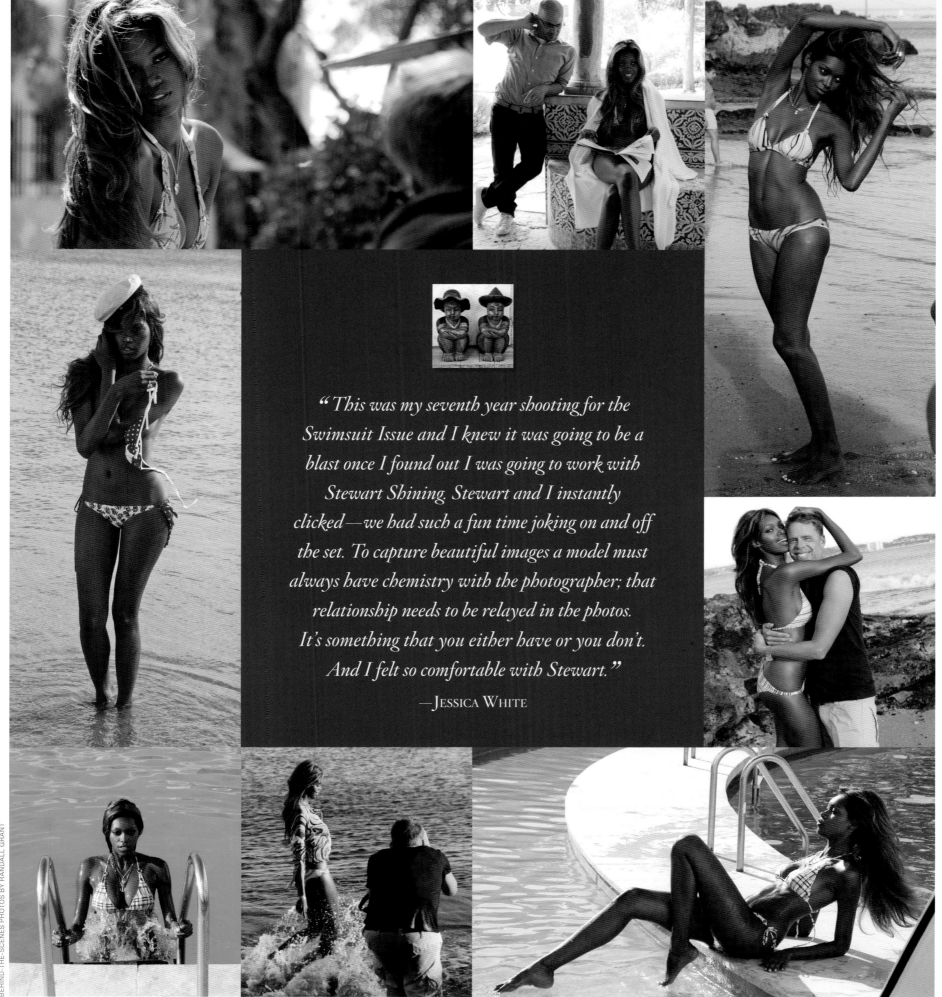

"*This was my seventh year shooting for the Swimsuit Issue and I knew it was going to be a blast once I found out I was going to work with Stewart Shining. Stewart and I instantly clicked—we had such a fun time joking on and off the set. To capture beautiful images a model must always have chemistry with the photographer; that relationship needs to be relayed in the photos. It's something that you either have or you don't. And I felt so comfortable with Stewart.*"

—JESSICA WHITE

BEHIND-THE-SCENES PHOTOS BY RANDALL GRANT

BAR REFAELI | SOUTH MALÉ ATOLL, MALDIVES

BAR

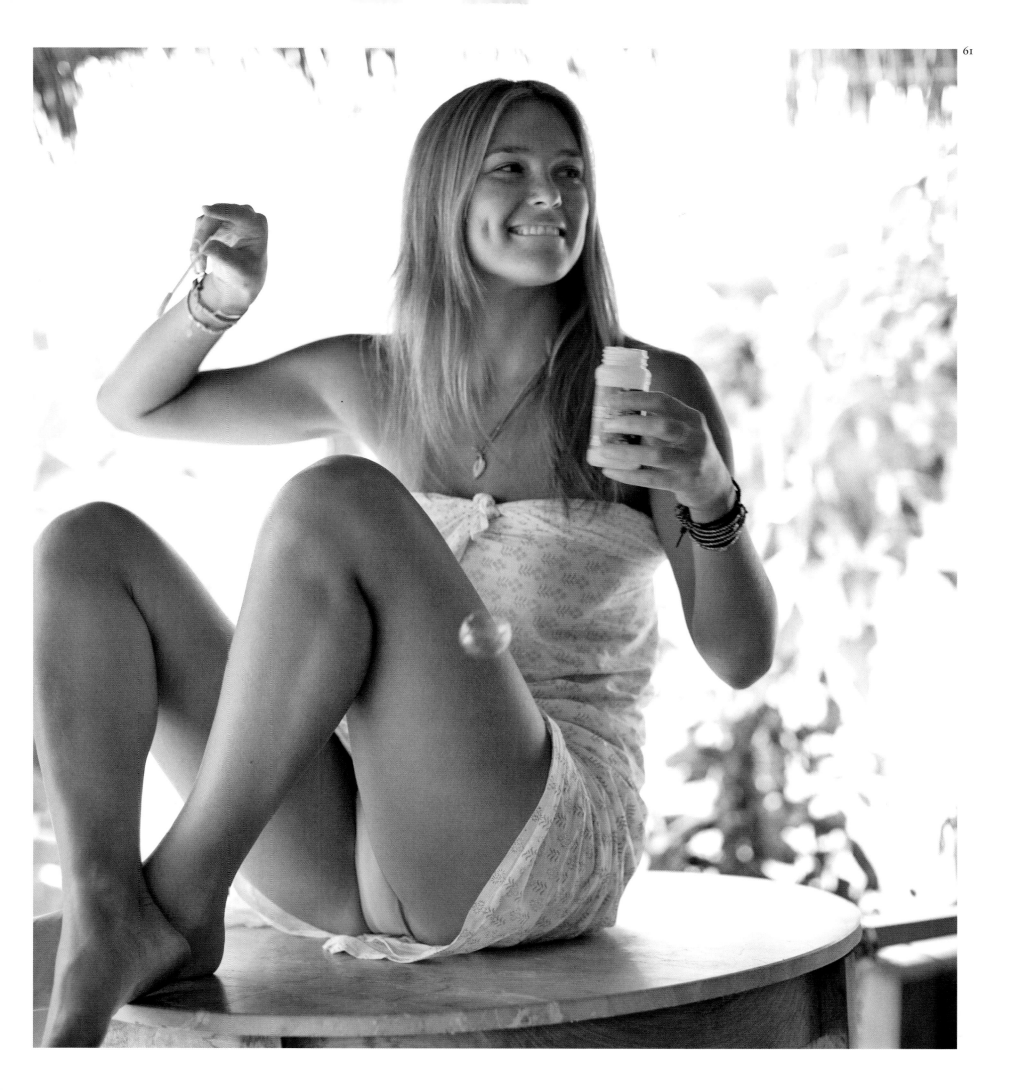

PORTFOLIO PHOTOGRAPHED ON LOCATION IN THE MALDIVES BY

WALTER IOOSS JR.

" I tell you, that Bar is good. She can really pose. She was
even better than I thought she'd be. I looked at all
the pictures I took of her and there wasn't a bad frame.
When she smiles, she is radiant. She has a world-class
body, great hair and the most beautiful eyes. She might
not be the most effervescent girl; she's quiet. But once
the trust came, she looked good in everything we did. That's
why she's Bar. You don't get to her level accidentally. She
has the body and she knows how to project with her
eyes. But she works too. I love the names in her family.
Her brother's name is Dor and her father's name is Rafael
Refaeli. Talk about Hollywood—that's a good name."

—WALTER IOOSS JR.

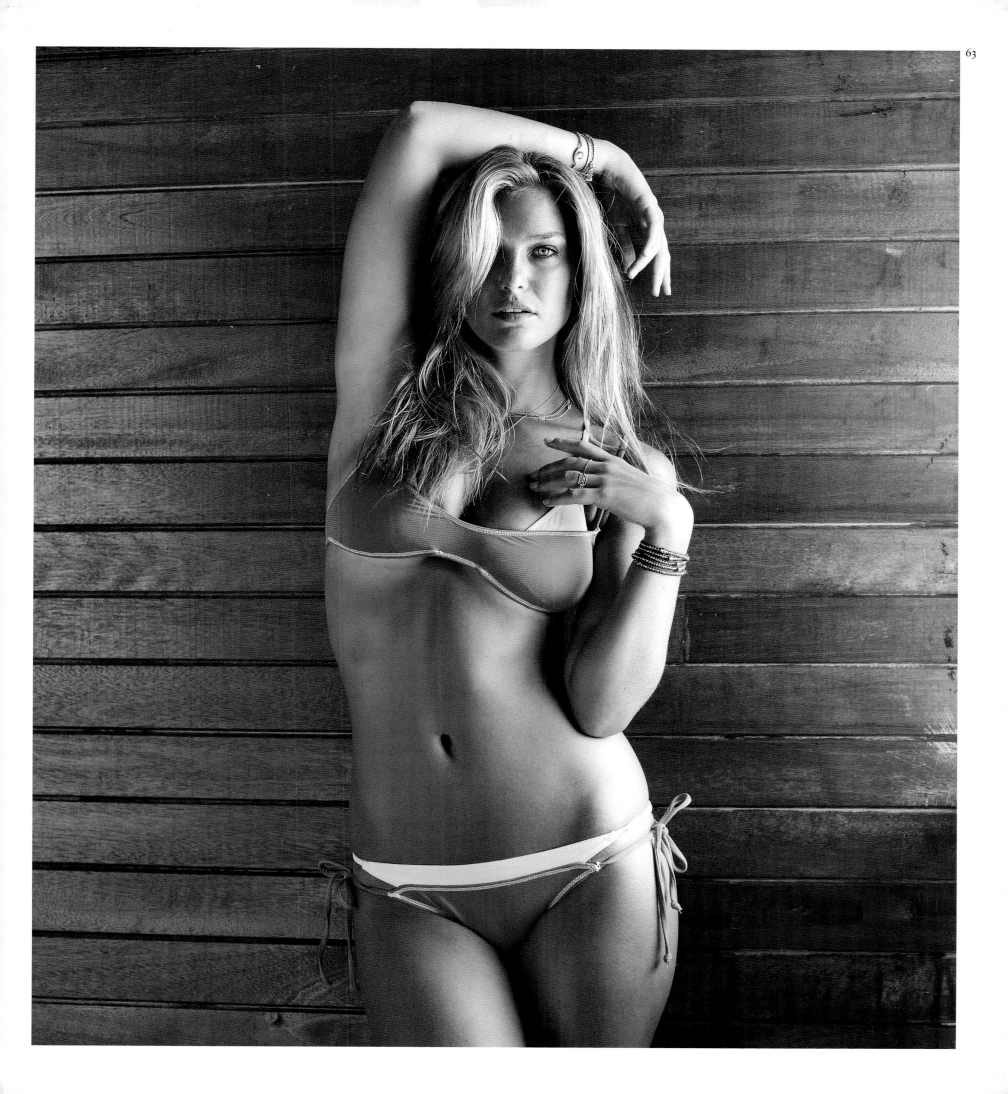

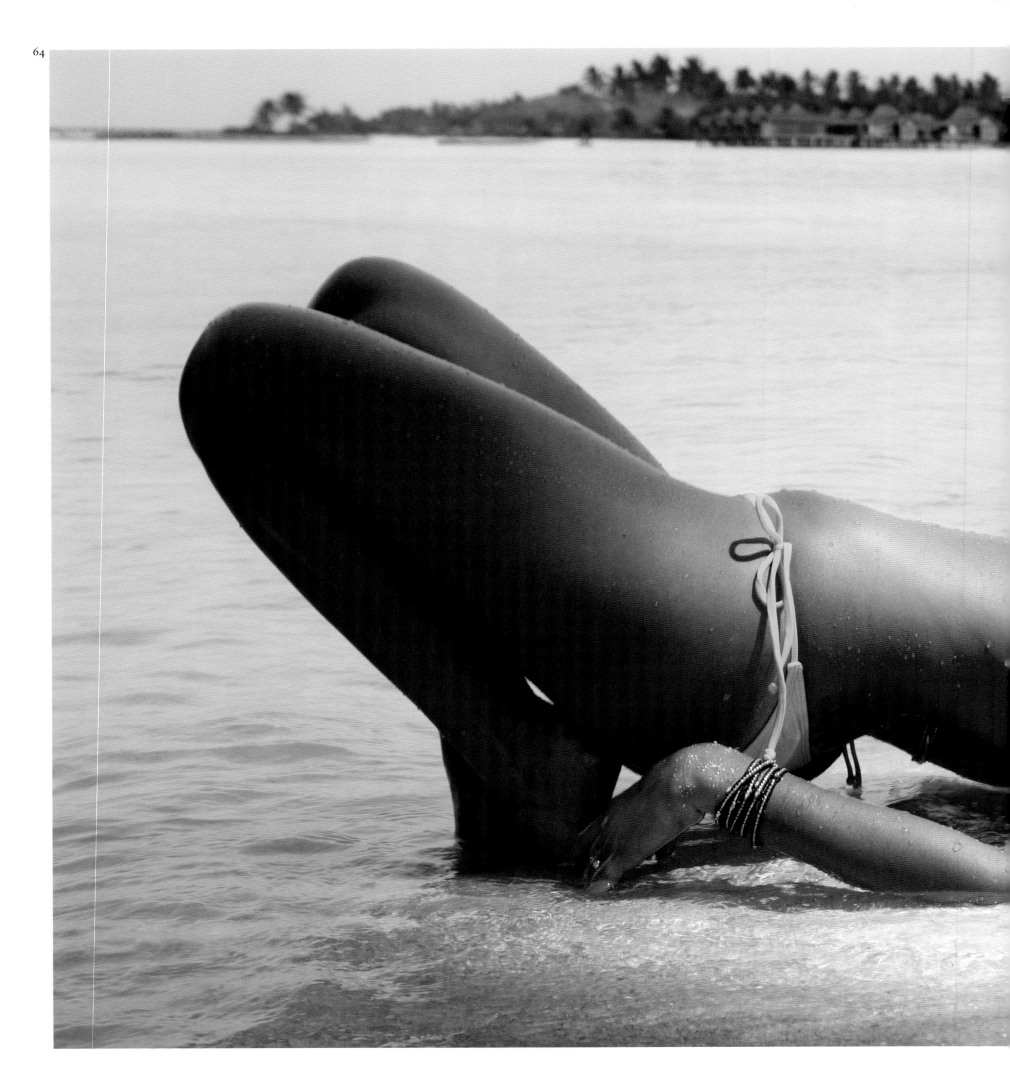

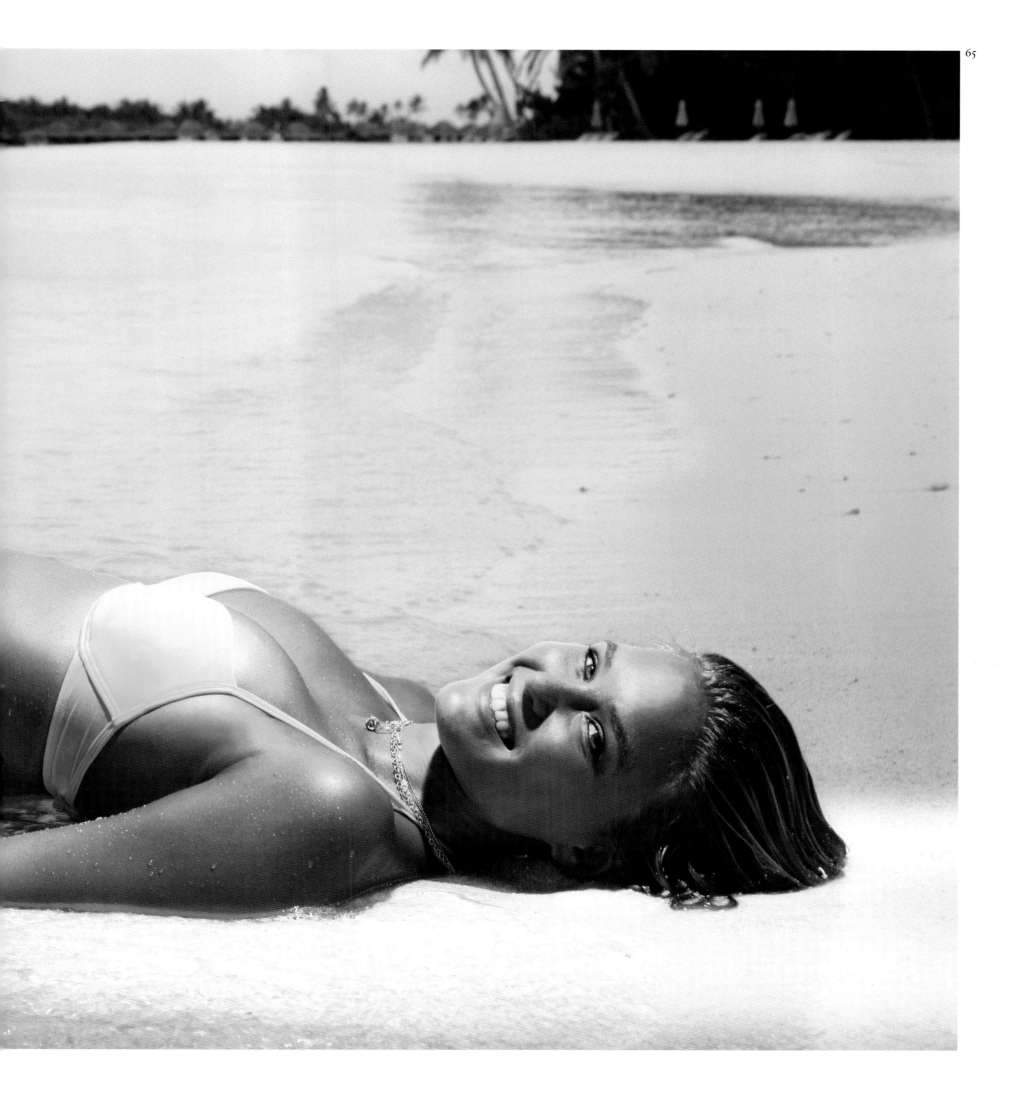

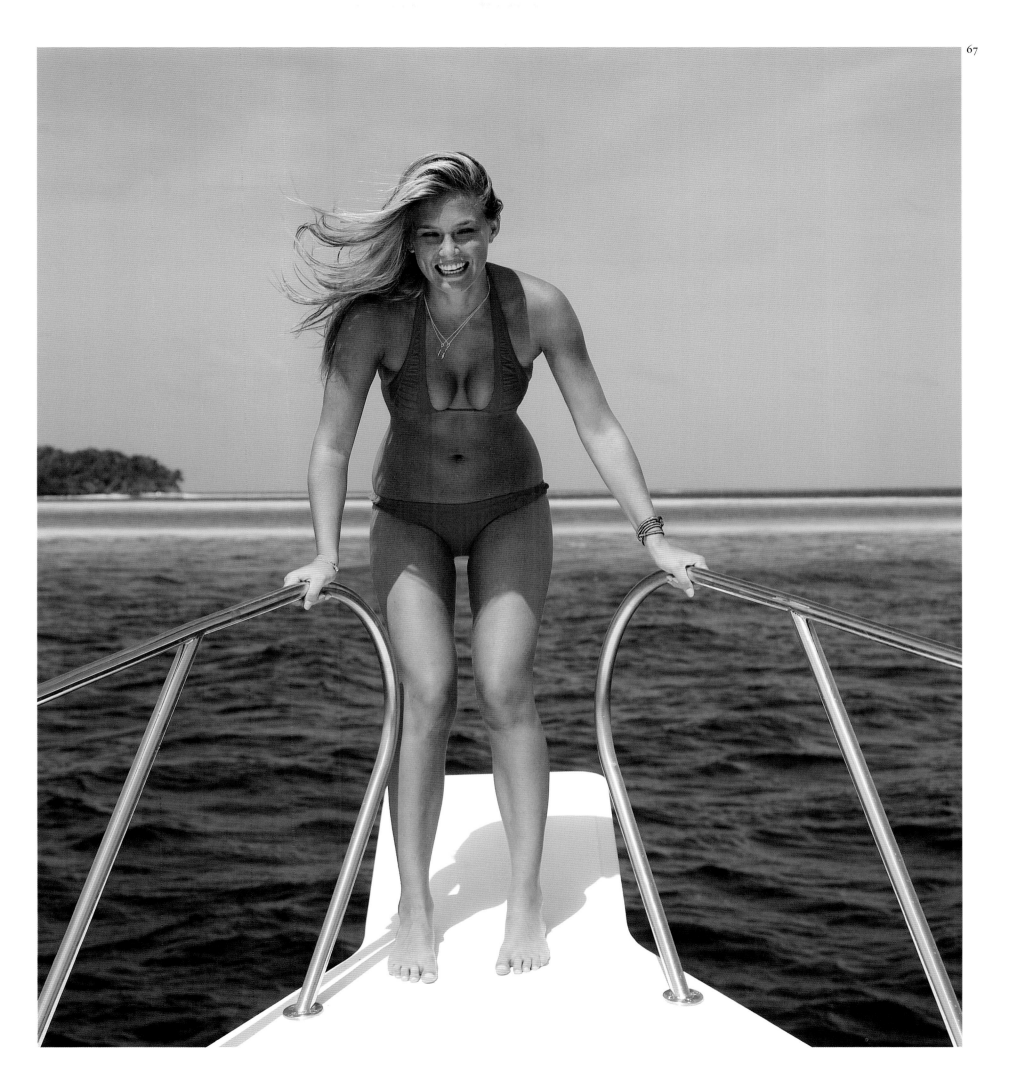

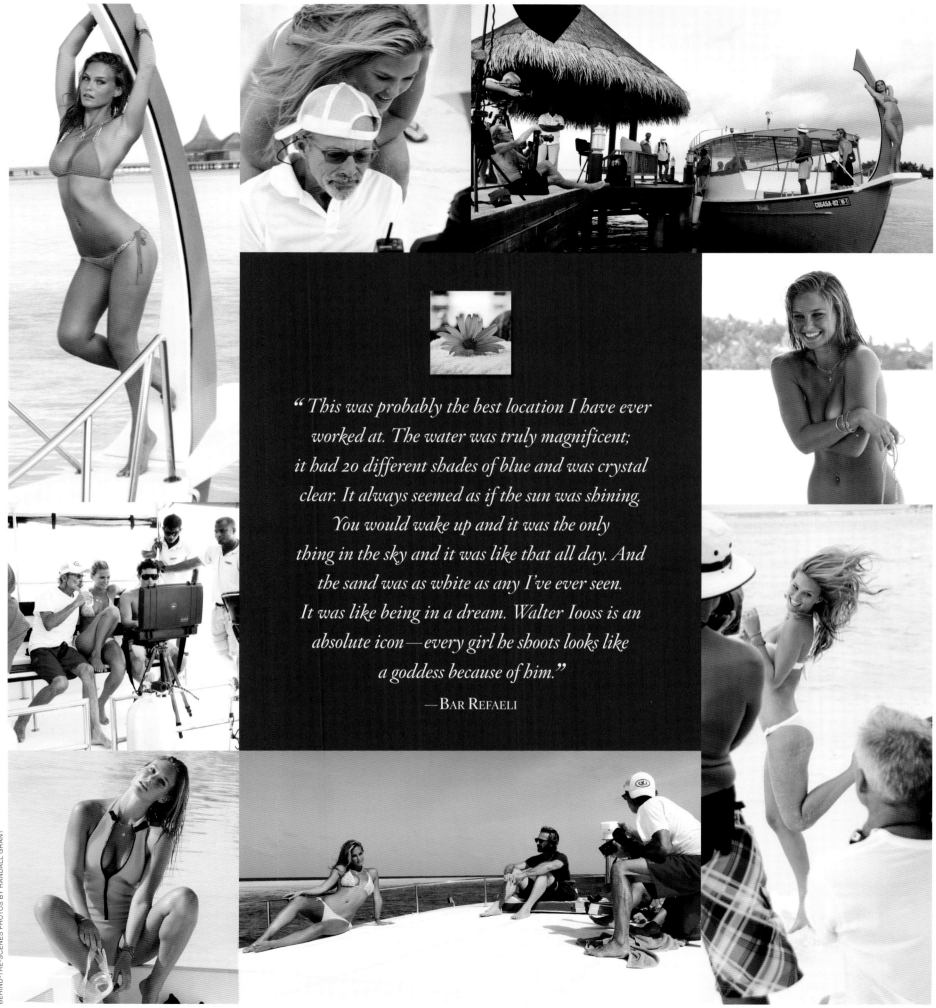

" *This was probably the best location I have ever worked at. The water was truly magnificent; it had 20 different shades of blue and was crystal clear. It always seemed as if the sun was shining. You would wake up and it was the only thing in the sky and it was like that all day. And the sand was as white as any I've ever seen. It was like being in a dream. Walter Iooss is an absolute icon—every girl he shoots looks like a goddess because of him.*"

—Bar Refaeli

BEHIND-THE-SCENES PHOTOS BY RANDALL GRANT

GENEVIEVE MORTON | PALM SPRINGS, CALIFORNIA

GENEVIEVE

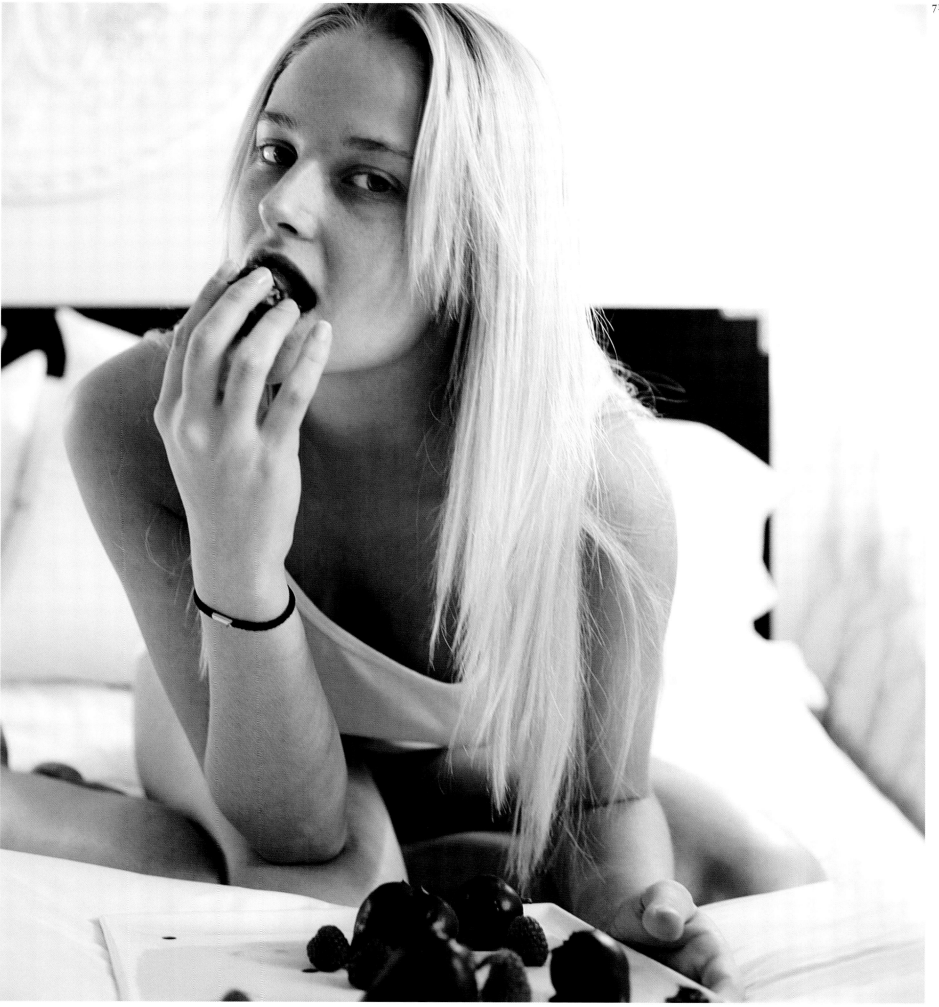

PORTFOLIO PHOTOGRAPHED ON LOCATION IN CALIFORNIA BY

WALTER CHIN

"Somehow, maybe by chance, Genevieve fit perfectly for this shoot. Look at her. She looks very 1940s. I was lucky she had the perfect body type and attitude for that period. If we had put a skinny girl on these planes, it just wouldn't have worked. The people at the Palm Springs Air Museum showed me some fighter planes and I chose the ones I thought would be best for Genevieve's skin tone. I loved the Air Force symbols and the way she looked against them. I kept thinking to myself, Genevieve is the girl the airmen wanted to see. That's who they wanted to see painted all over the plane. Those legs of hers are like wings. I mean, she was perfect for this, the perfect pinup girl. She just really illustrated the form we needed."

—Walter Chin

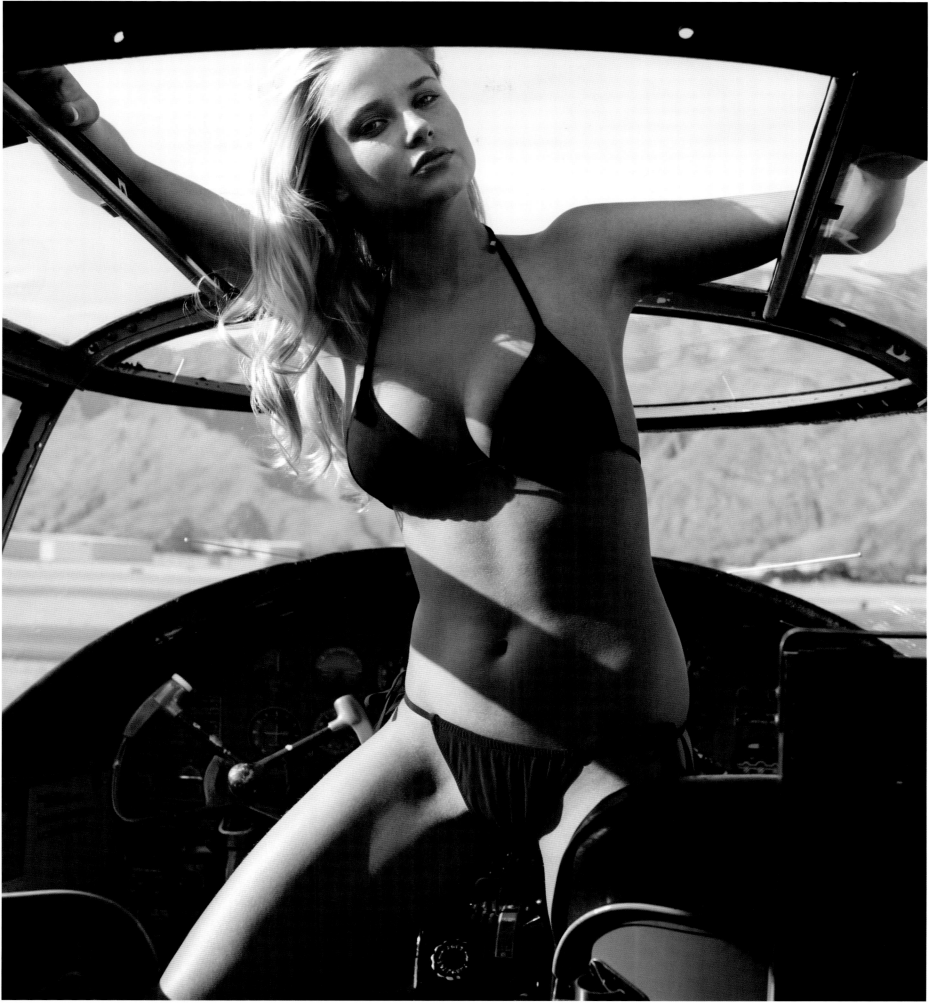

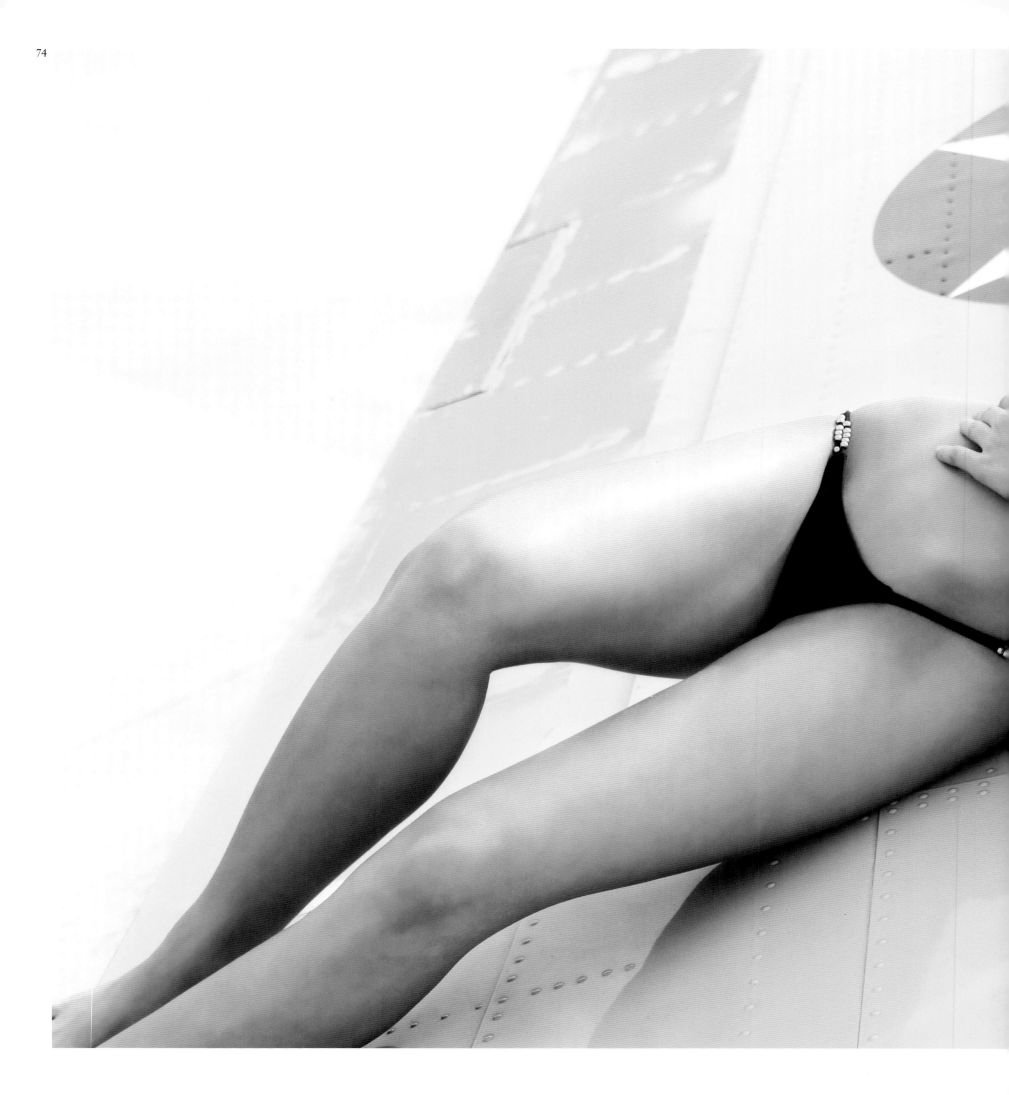

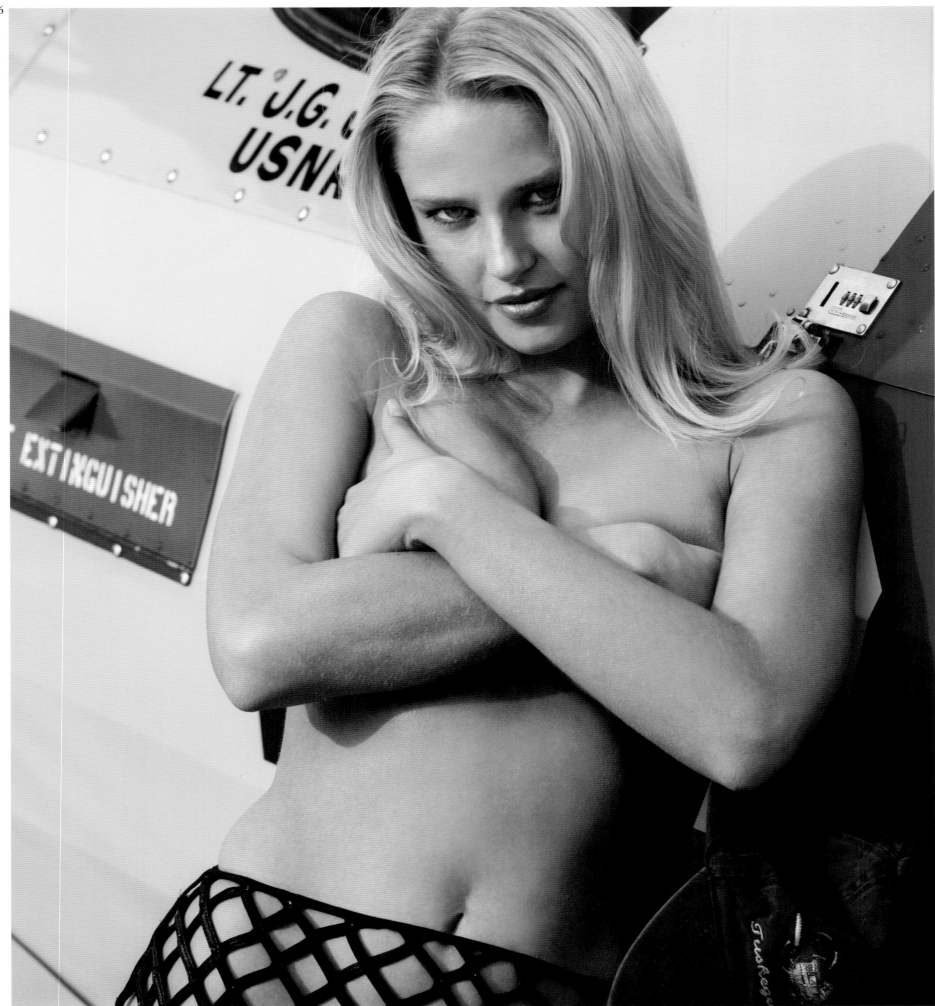

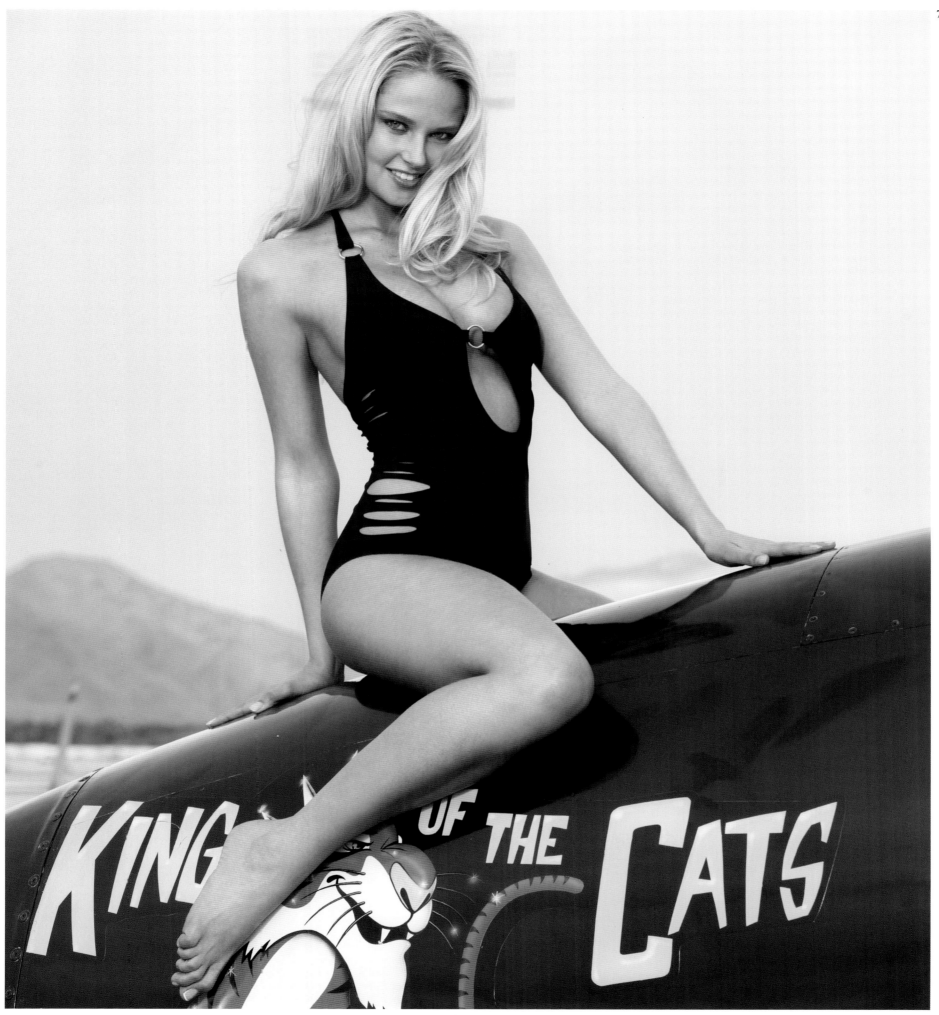

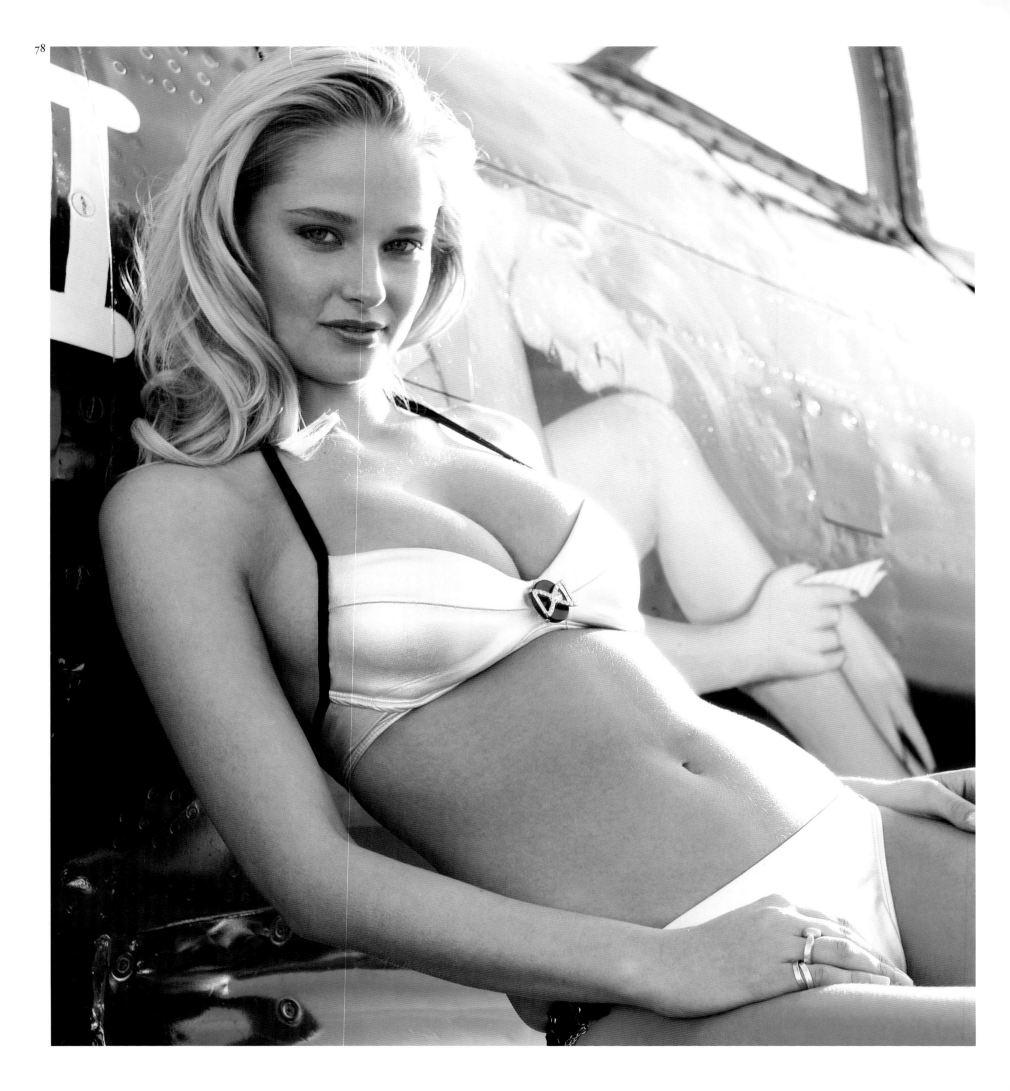

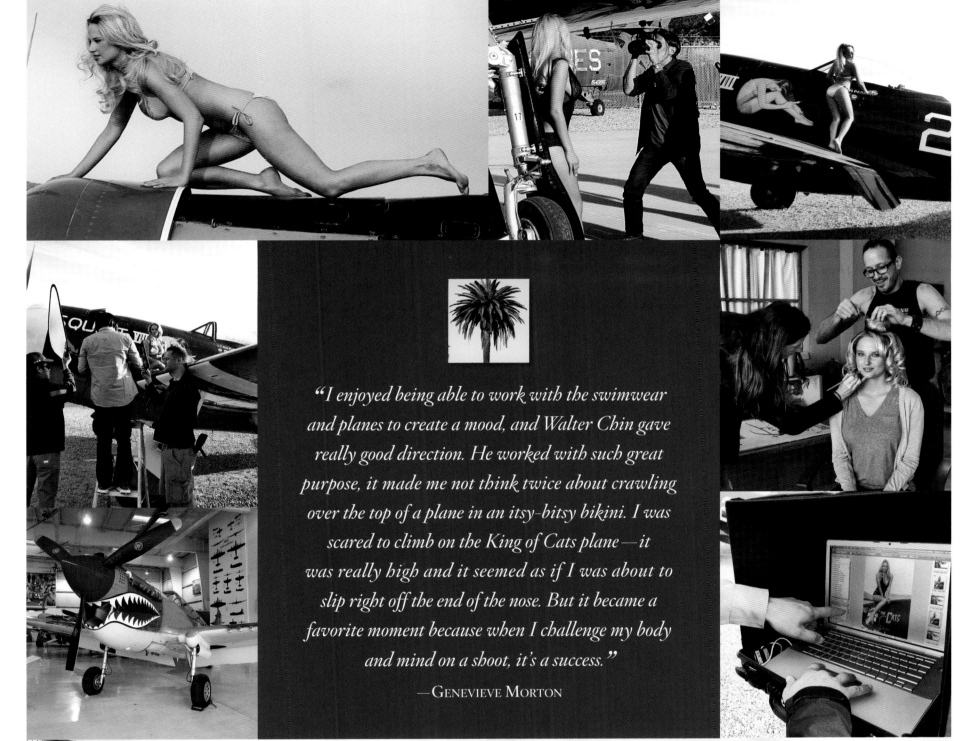

"*I enjoyed being able to work with the swimwear and planes to create a mood, and Walter Chin gave really good direction. He worked with such great purpose, it made me not think twice about crawling over the top of a plane in an itsy-bitsy bikini. I was scared to climb on the King of Cats plane—it was really high and it seemed as if I was about to slip right off the end of the nose. But it became a favorite moment because when I challenge my body and mind on a shoot, it's a success.*"

—GENEVIEVE MORTON

BEHIND-THE-SCENES PHOTOS BY DARCIE BAUM

HILARY RHODA | RAJASTHAN, INDIA

HILARY

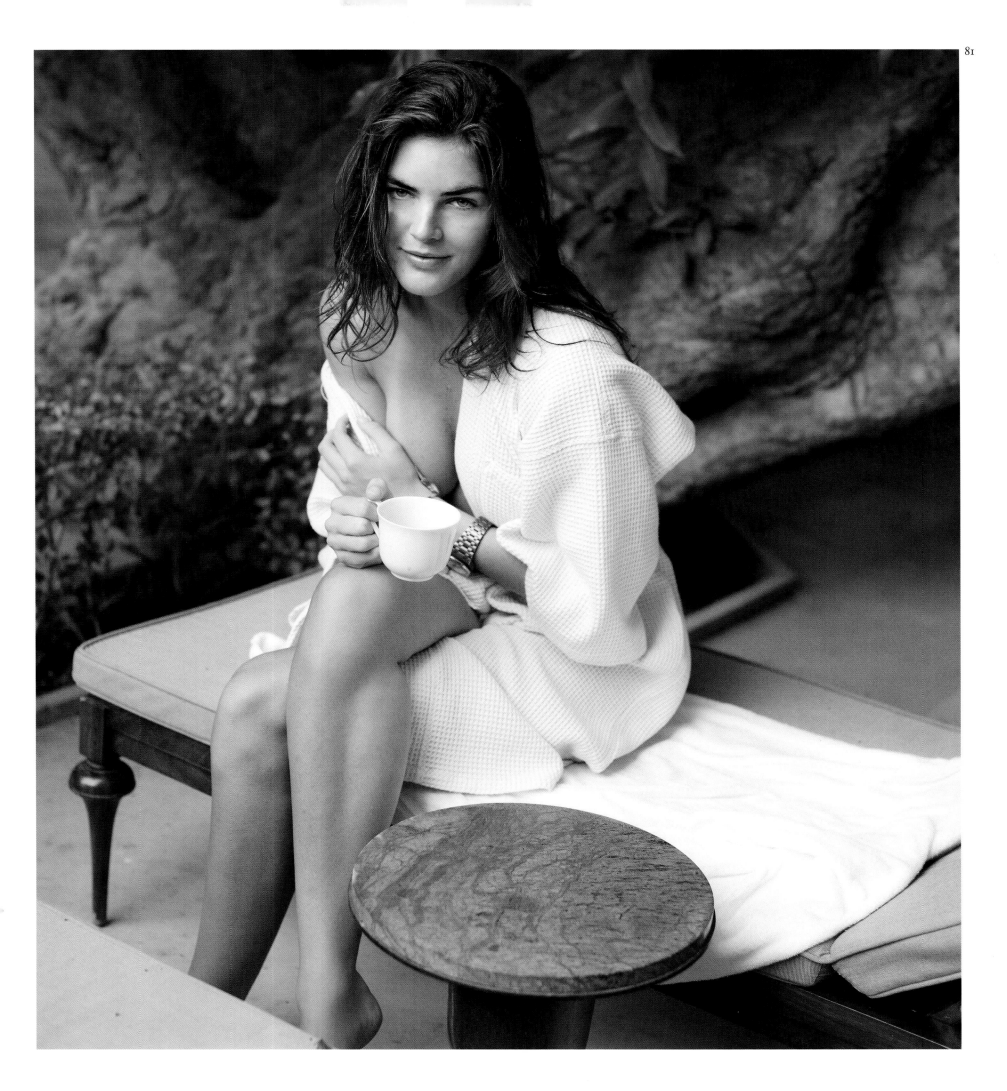

PORTFOLIO PHOTOGRAPHED ON LOCATION IN INDIA BY
RICCARDO TINELLI

*" The power that Hilary has in her photos with that body,
you just have to say, 'Wow.' She is so strong and
powerful. Her body is stunning. With Hilary, every time
I saw her in the camera, I was surprised at how photogenic
she was. It was crazy. Look at that shot of her on
the elephant. If you've ever seen an elephant in real life,
these are very huge things; they're like big trucks. But
look at Hilary and see how she puts her hands on the elephant
and leans into it—this is an amazing thing. That's what
I'm talking about with her power. It looks like the
elephant is stopped by her. She was completely confident
with this beast. How did she do that?"*

—RICCARDO TINELLI

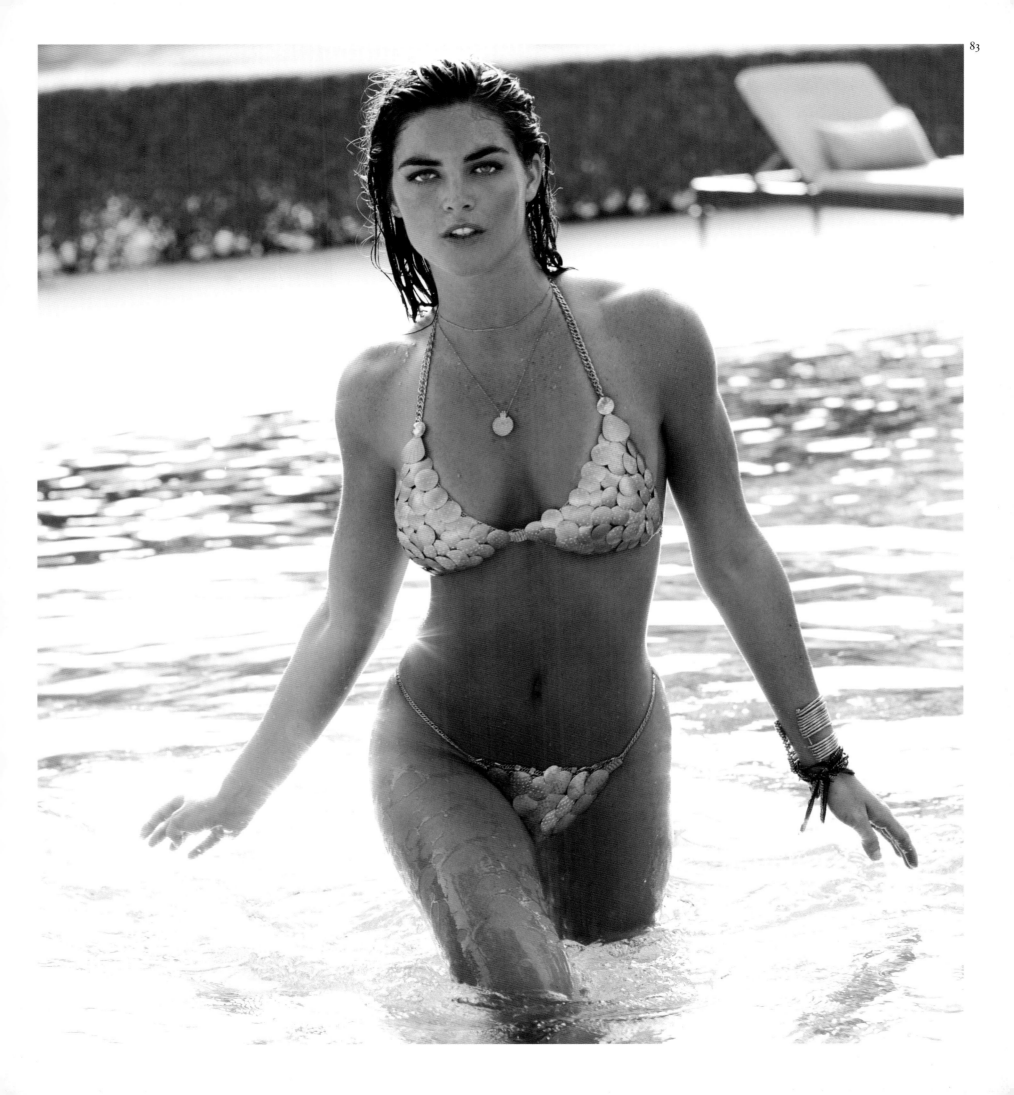

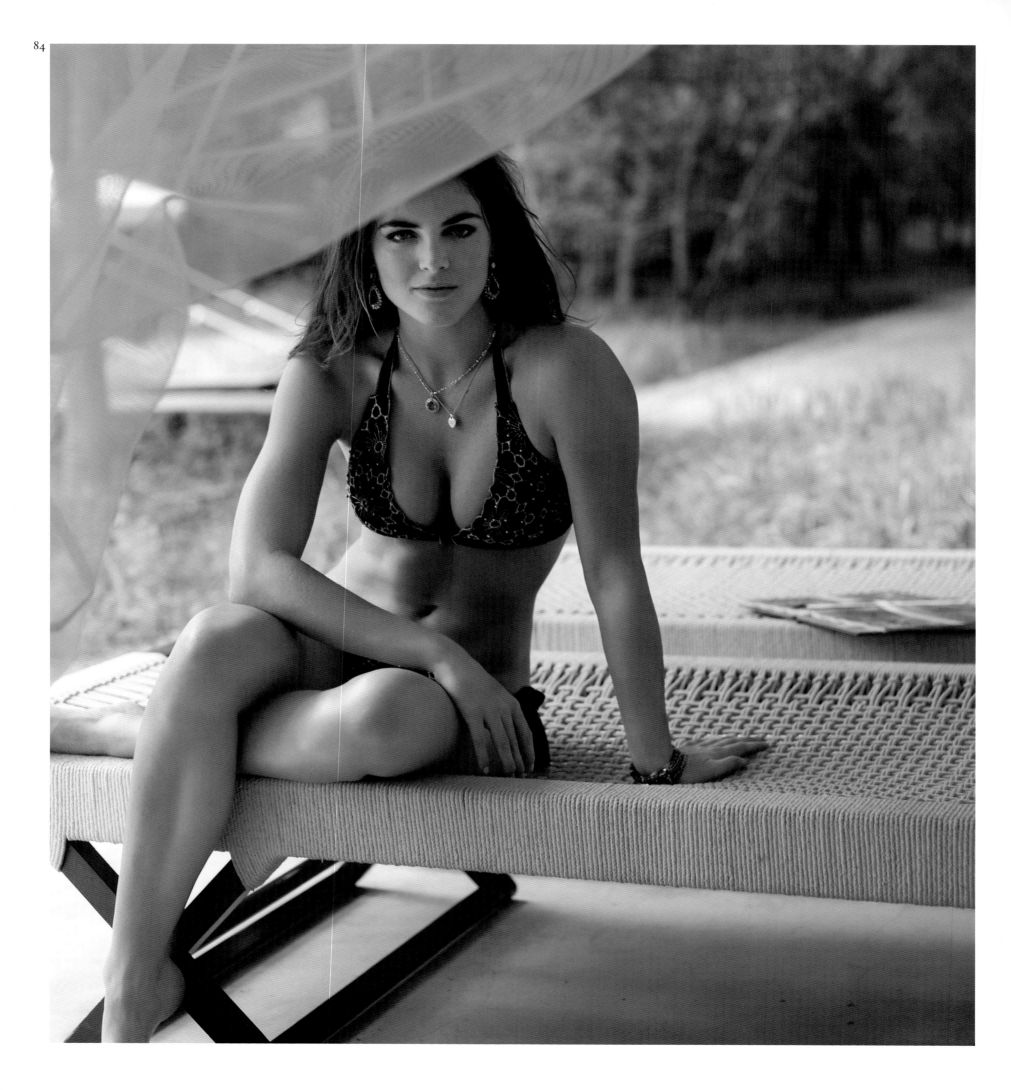

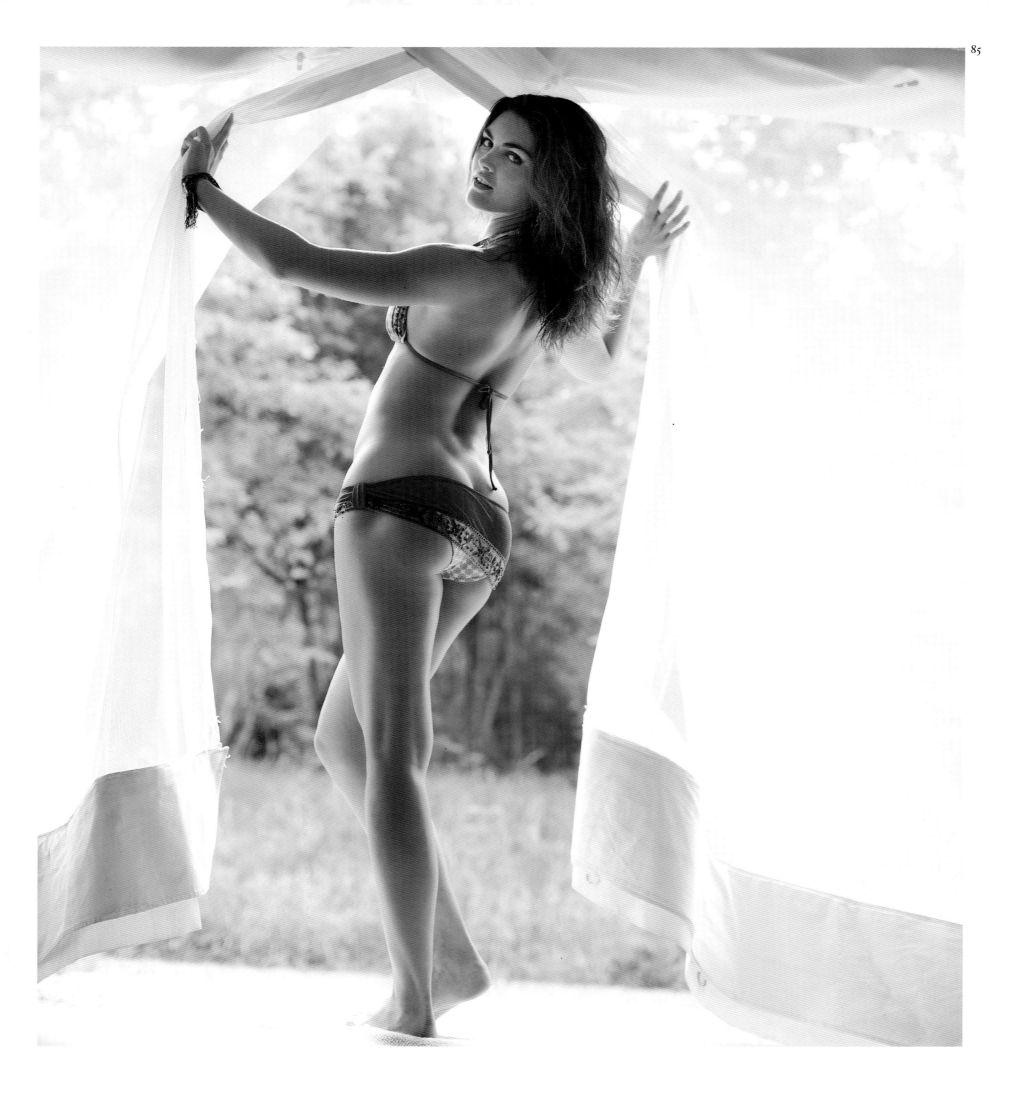

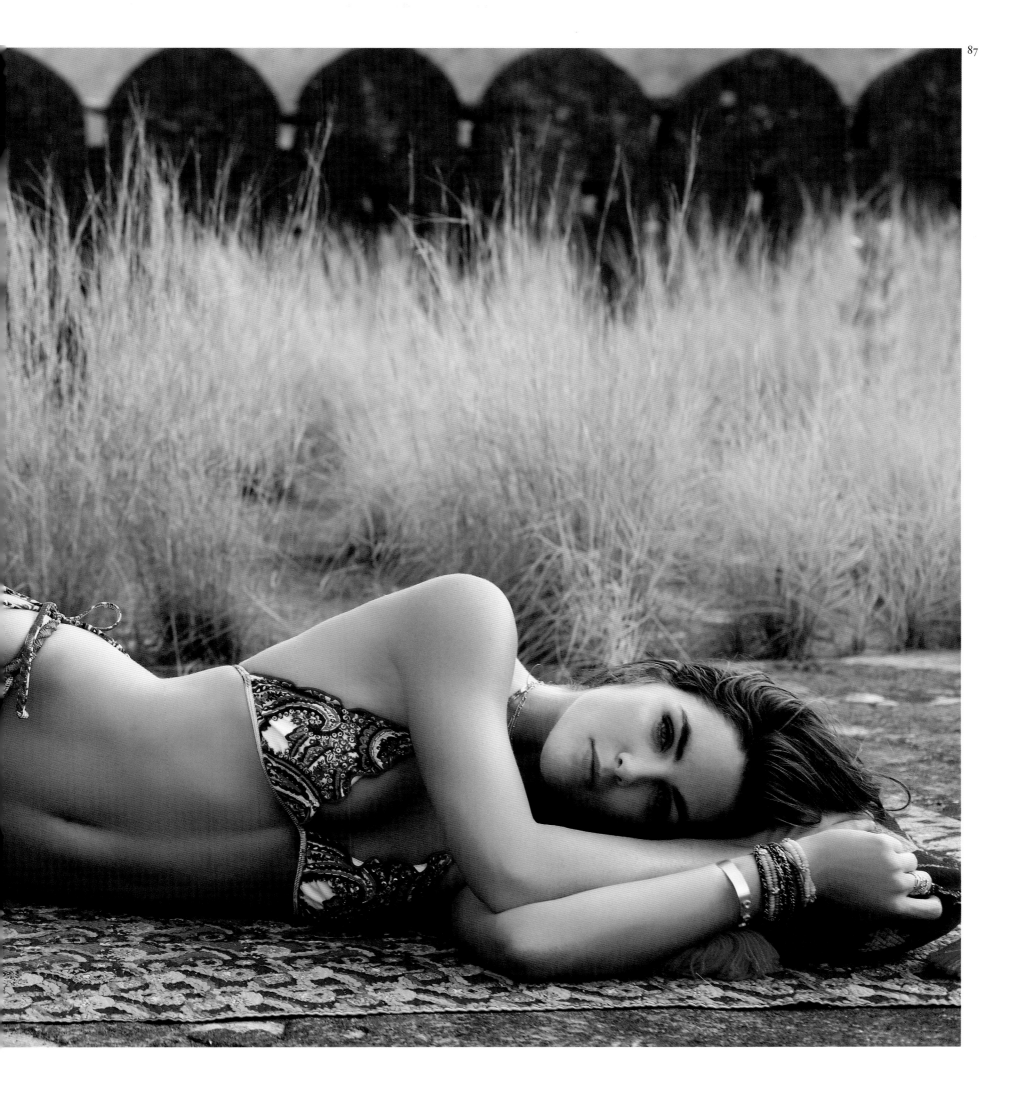

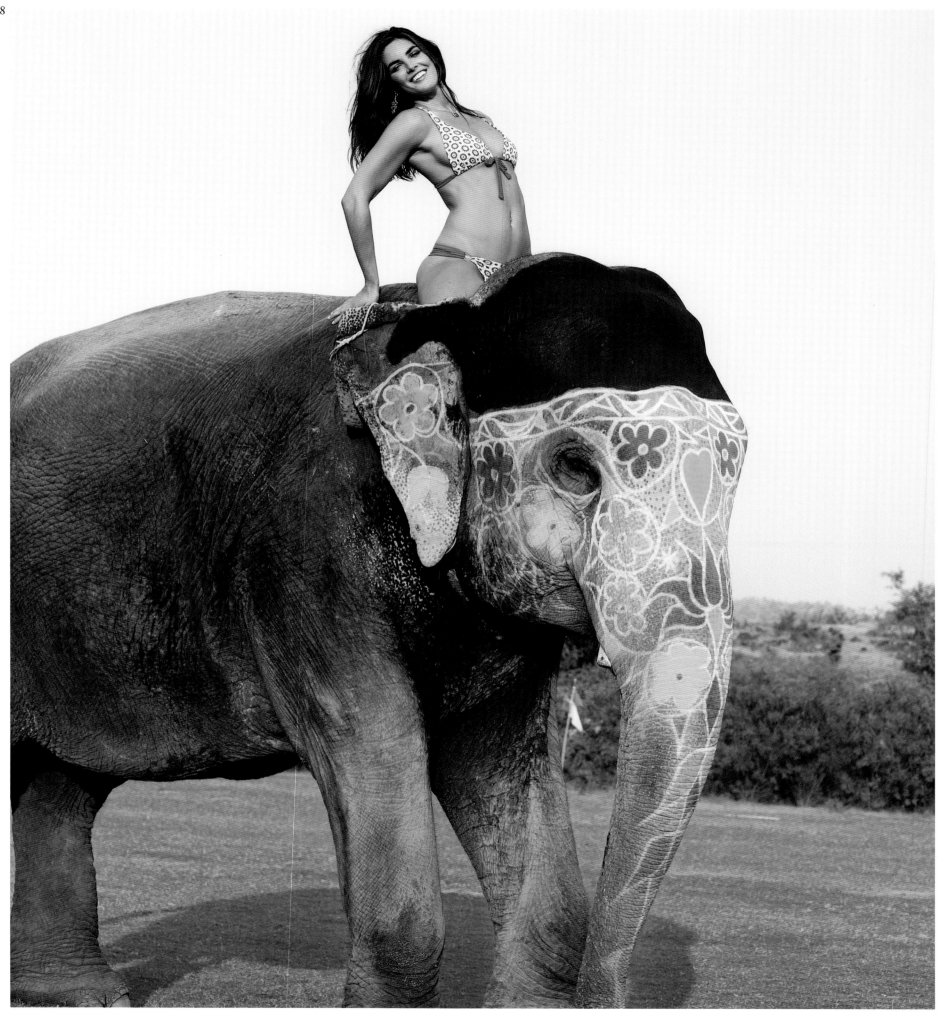

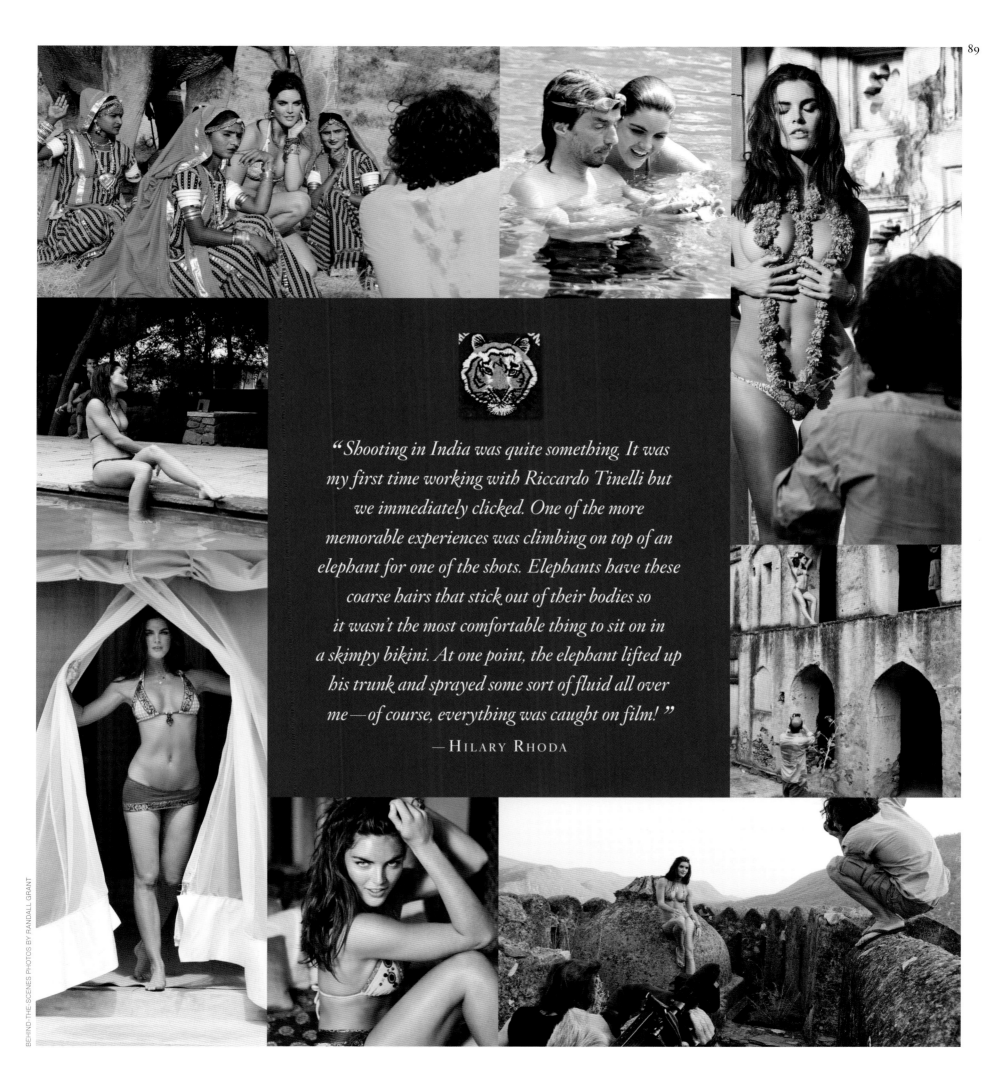

"Shooting in India was quite something. It was my first time working with Riccardo Tinelli but we immediately clicked. One of the more memorable experiences was climbing on top of an elephant for one of the shots. Elephants have these coarse hairs that stick out of their bodies so it wasn't the most comfortable thing to sit on in a skimpy bikini. At one point, the elephant lifted up his trunk and sprayed some sort of fluid all over me—of course, everything was caught on film!"

—HILARY RHODA

BEHIND-THE-SCENES PHOTOS BY RANDALL GRANT

JULIE HENDERSON | SAN PEDRO DE ATACAMA, CHILE

JULIE

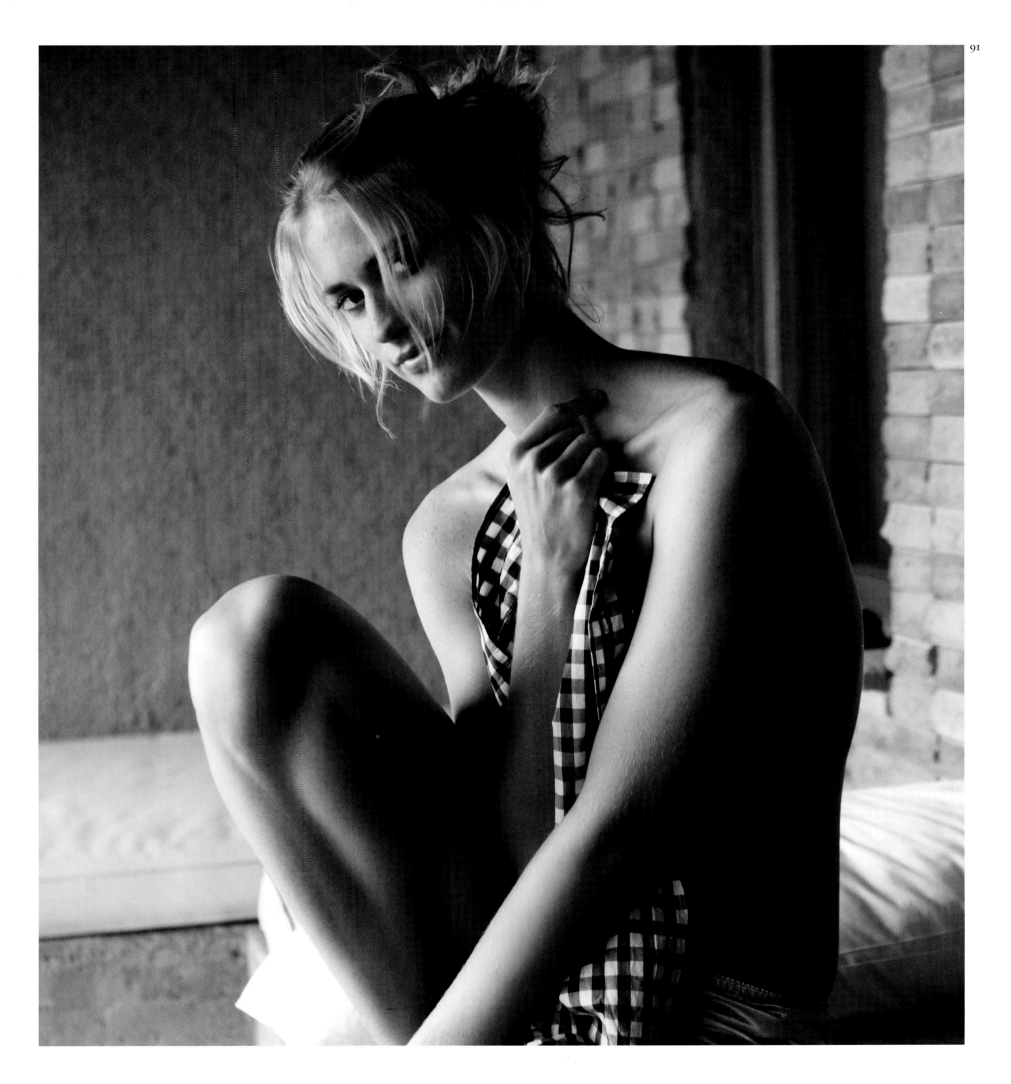

PORTFOLIO PHOTOGRAPHED ON LOCATION IN CHILE BY

RAPHAEL MAZZUCCO

" Julie had the most difficult task of all the girls in
Chile in that we had her in a lot of different landscapes,
working very early in the morning. She never complained;
she always remained calm and was able to improvise
in the setting. There was one day when it was about 4 a.m.
and we had her lying on her back on a horse, just below
this big cliff. When you shoot Julie, she gives you the sense
that she is really tall. She has perfect body proportions
and an ability to move so easily and elegantly. She is unique
in that's she has the all-American look, but she also
has an intensity about her that is timeless and belongs
to no single place. I love Julie. "

—RAPHAEL MAZZUCCO

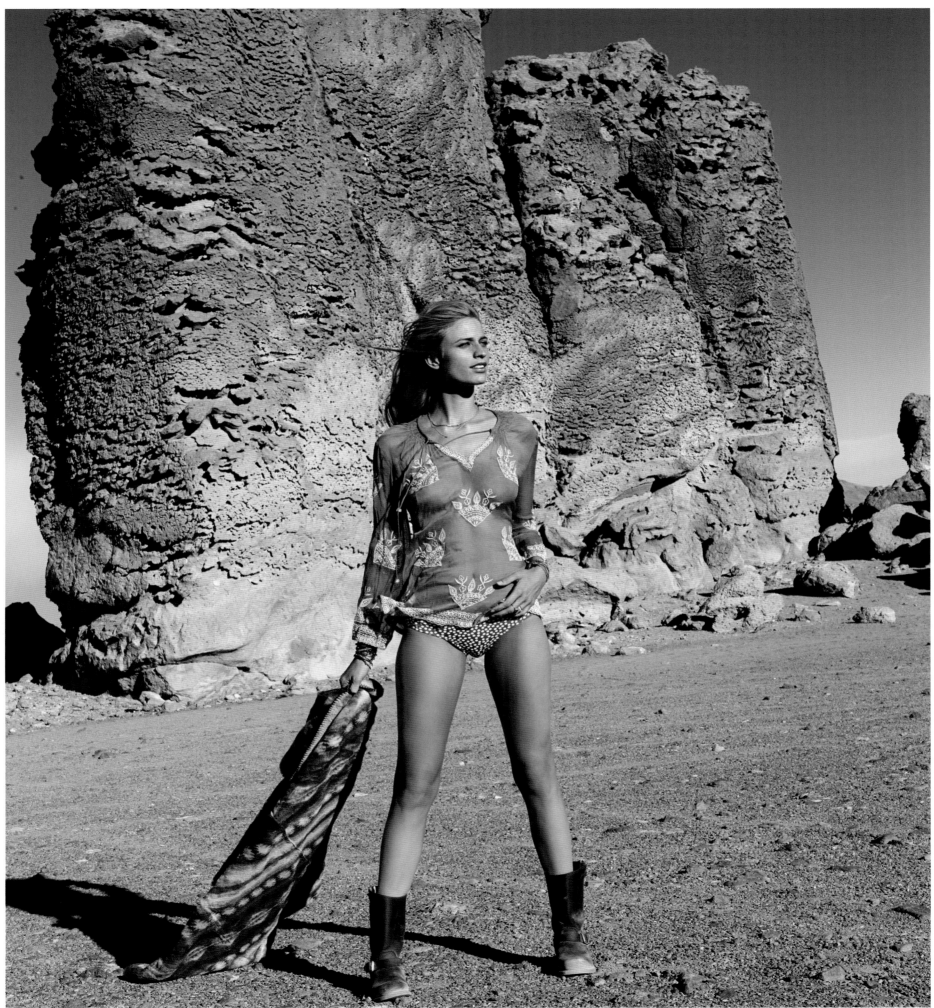

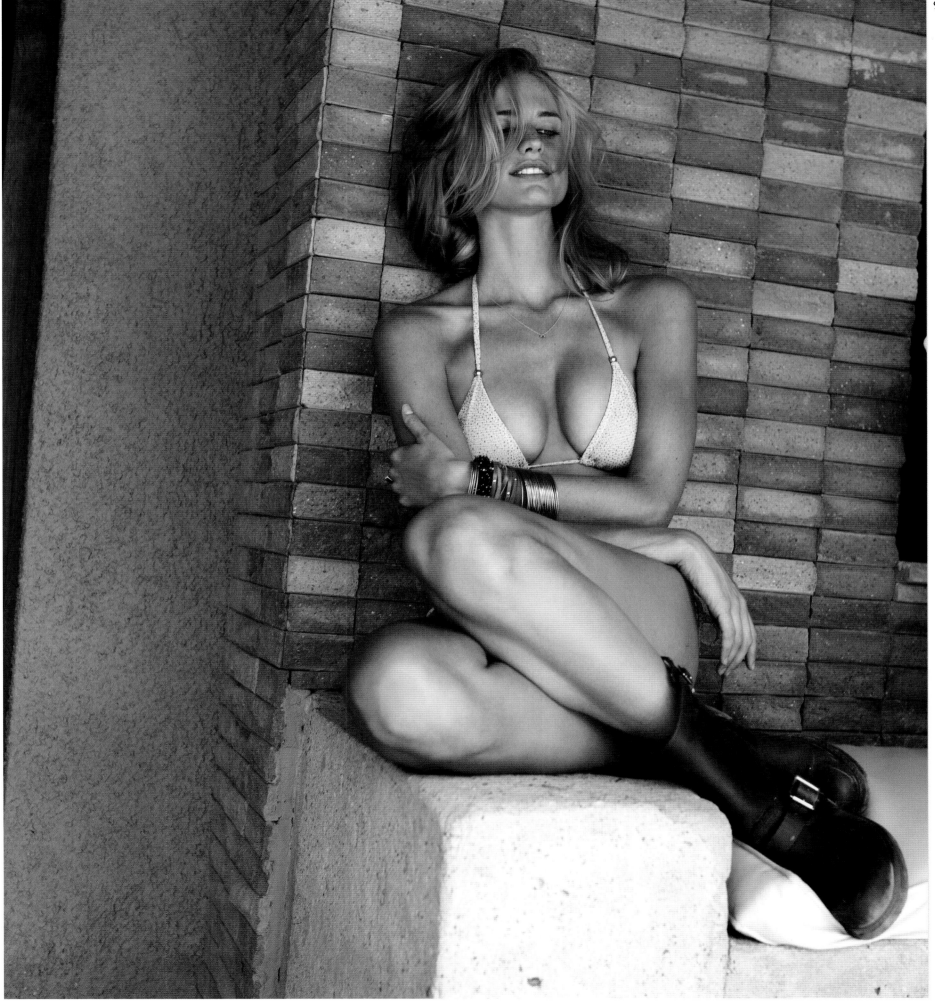

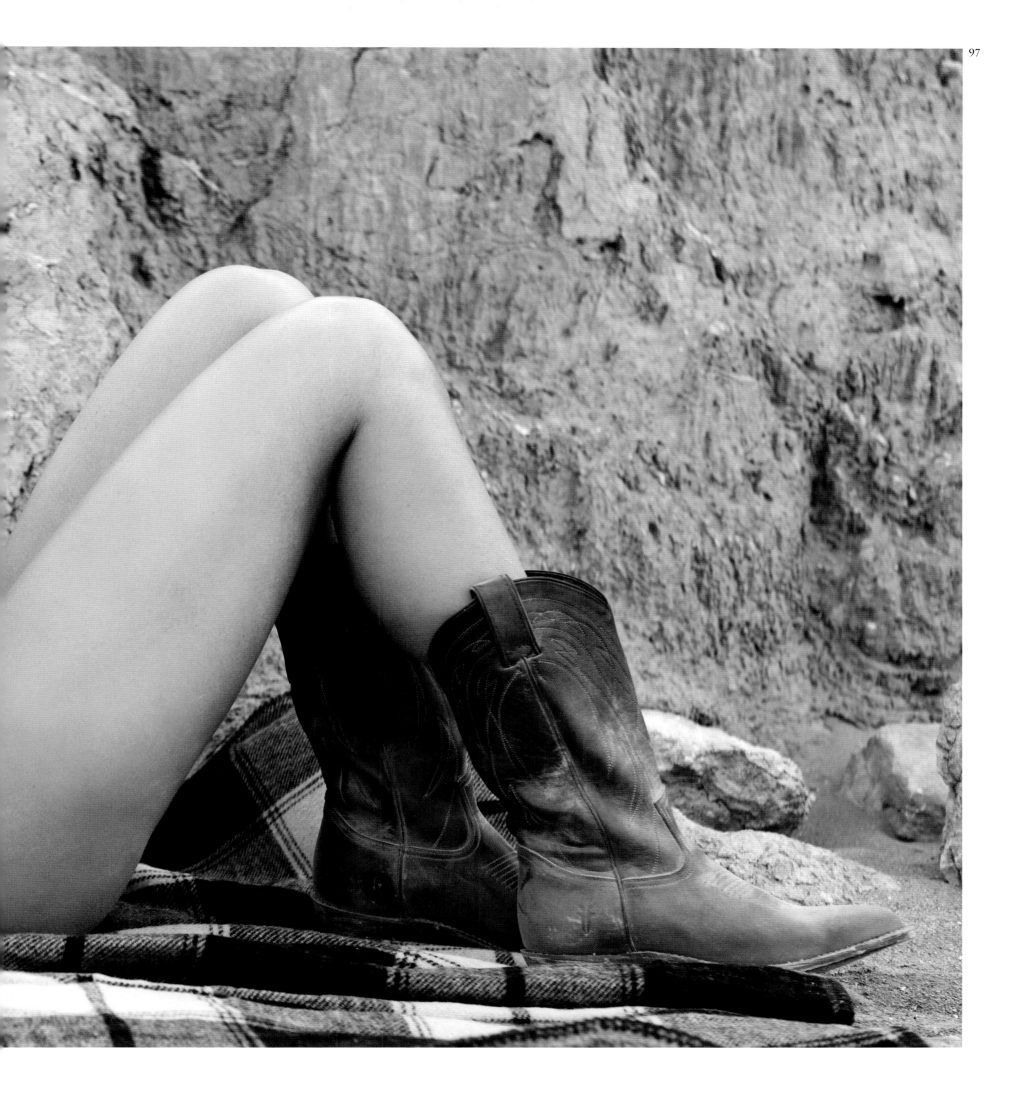

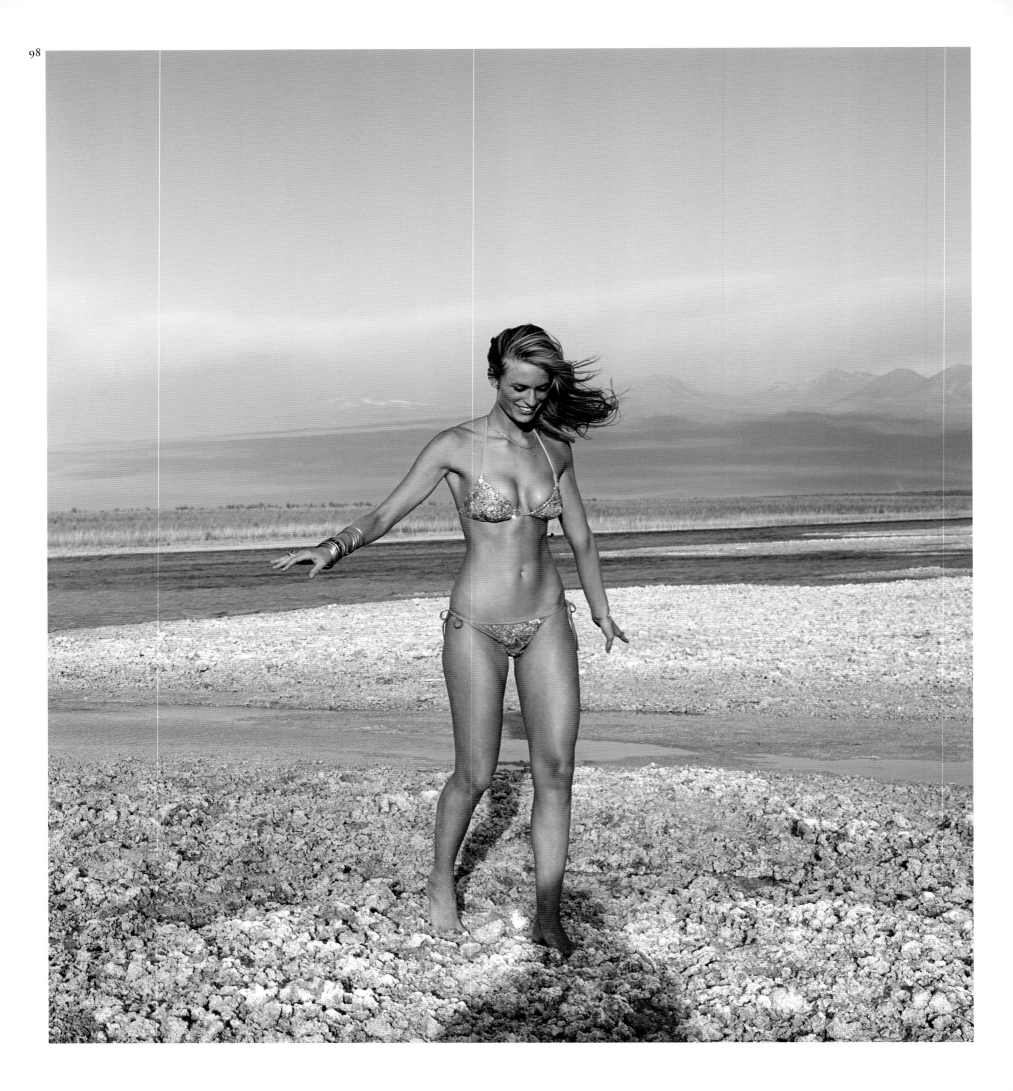

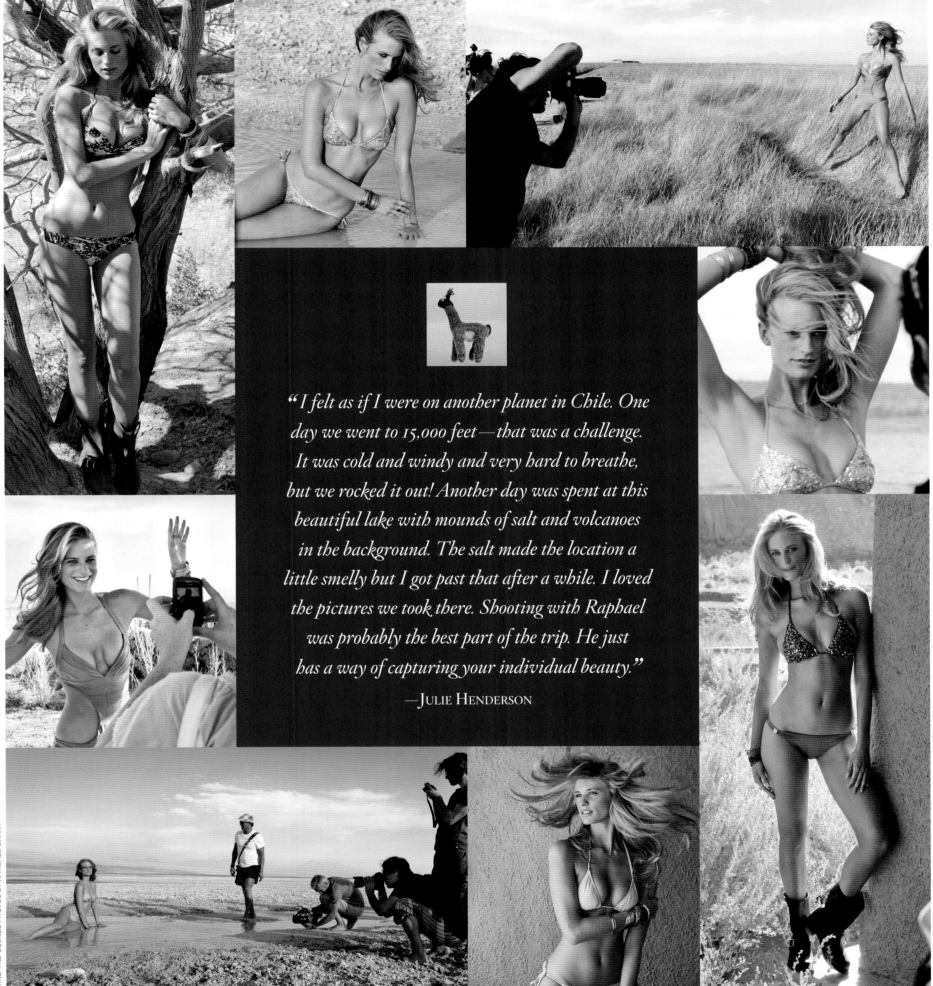

"I felt as if I were on another planet in Chile. One day we went to 15,000 feet—that was a challenge. It was cold and windy and very hard to breathe, but we rocked it out! Another day was spent at this beautiful lake with mounds of salt and volcanoes in the background. The salt made the location a little smelly but I got past that after a while. I loved the pictures we took there. Shooting with Raphael was probably the best part of the trip. He just has a way of capturing your individual beauty."

—JULIE HENDERSON

BEHIND-THE-SCENES PHOTOS BY RANDALL GRANT

JESSICA GOMES | LISBON, PORTUGAL

JESSICA

PORTFOLIO PHOTOGRAPHED ON LOCATION IN PORTUGAL BY

STEWART SHINING

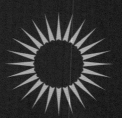

*" Jessica has a wonderful softness to her and very sexy eyes.
She has this exotic look but she's Australian. You kind
of think a different voice will come out of her and then you
get a 'G'day, mate!' It's pretty funny. She isn't as tall as some
of the other girls but that can really work with Swimsuit.
With the tall girls, there is a lot of arm and leg to fit into a
picture. With Jessica, because she is more compact,
everything just falls into place really easily. It doesn't take
much work. Jessica is fun, flirty and playful on set; she has
a certain little girl quality. I remember doing one picture
of her in a yellow bikini; it reminded me of the Coppertone
girl from the old ads. She is just a really sweet girl. "*

— STEWART SHINING

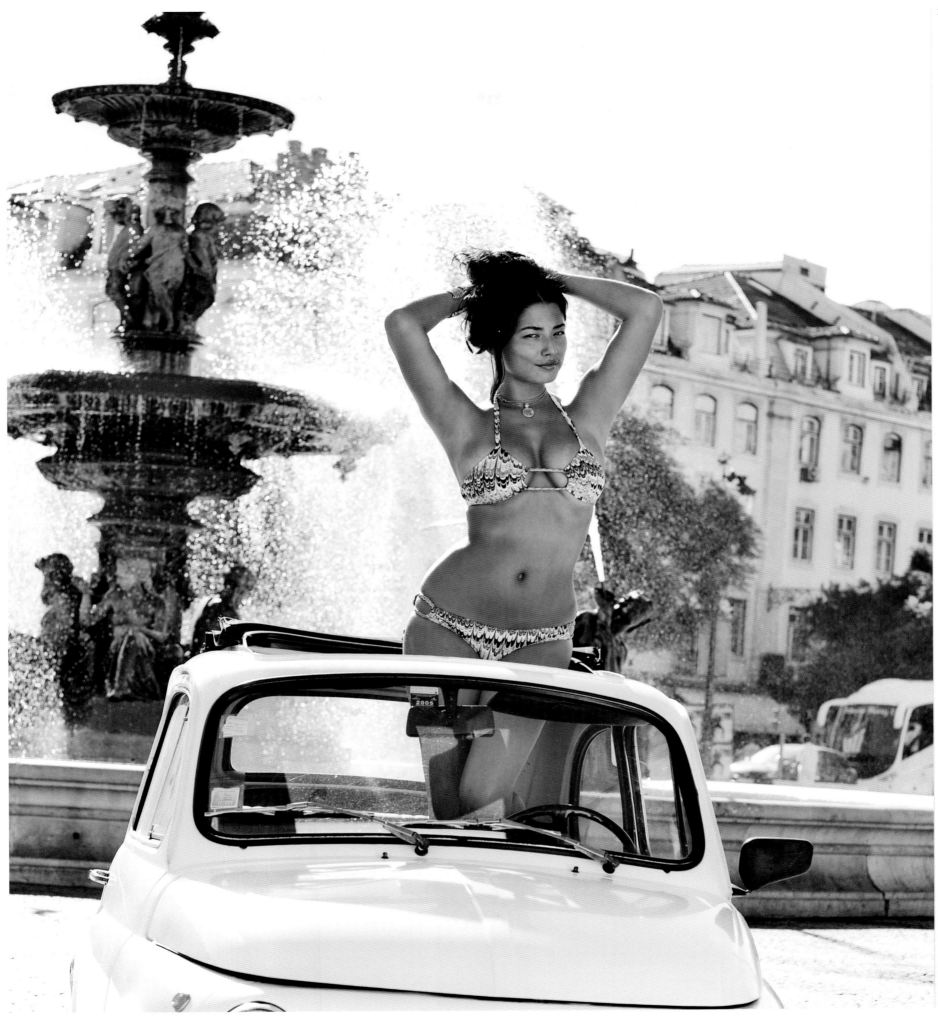

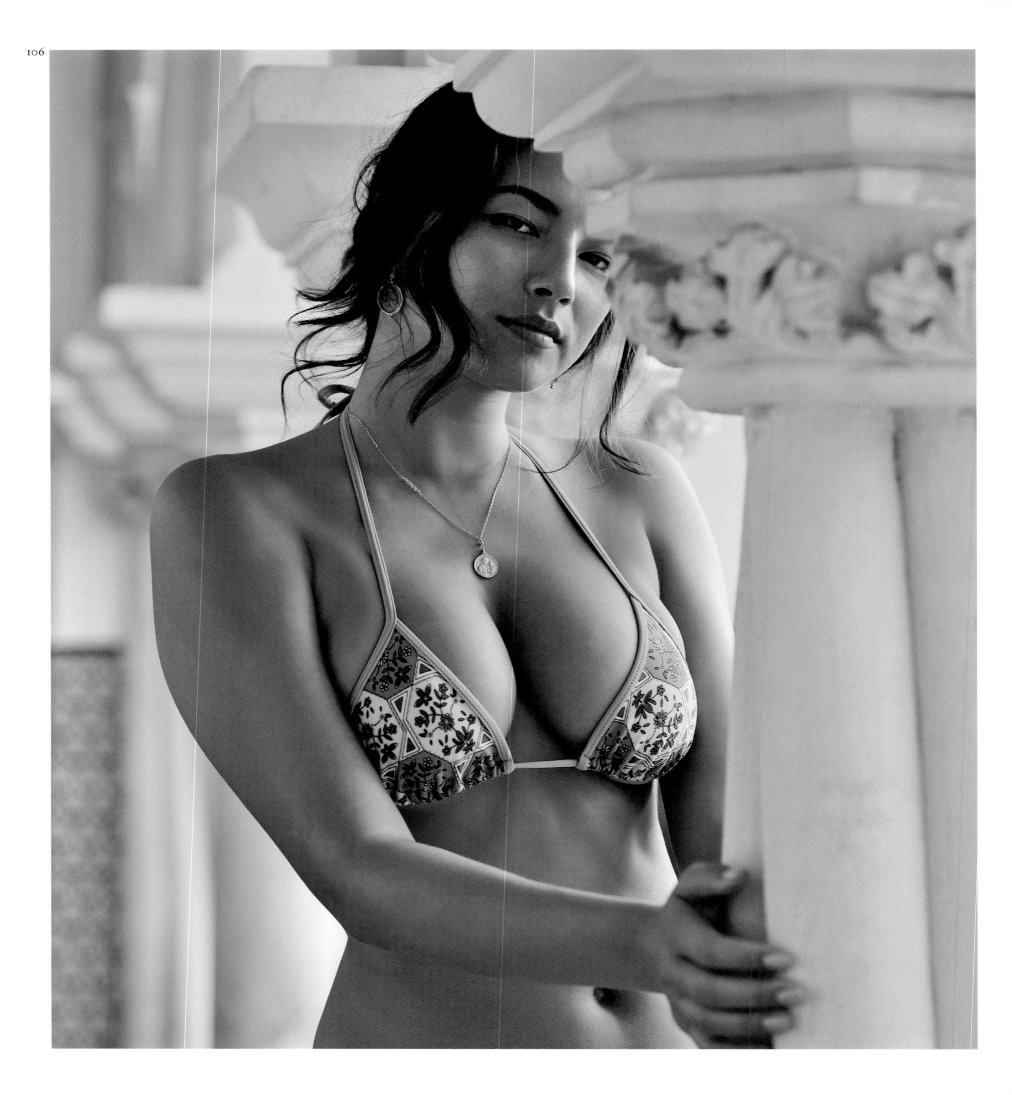

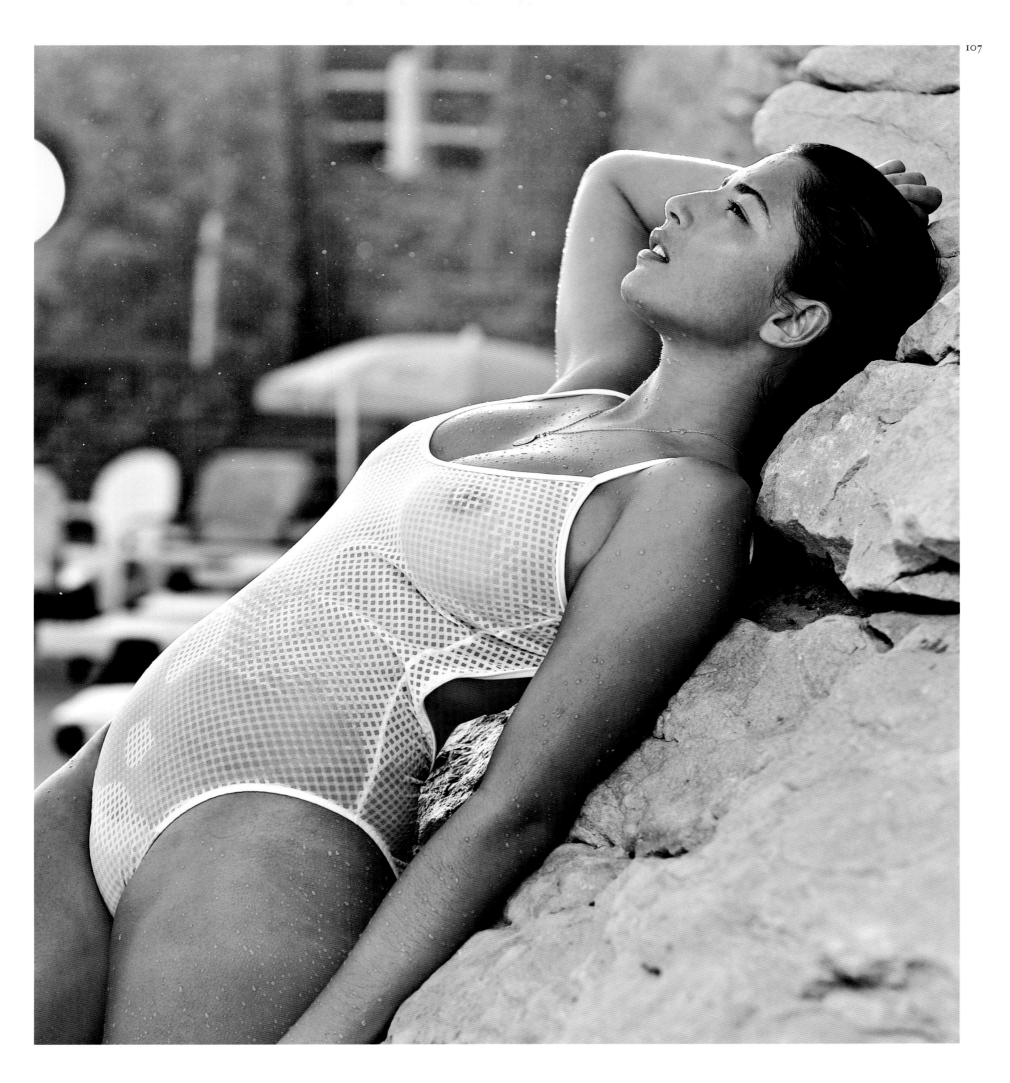

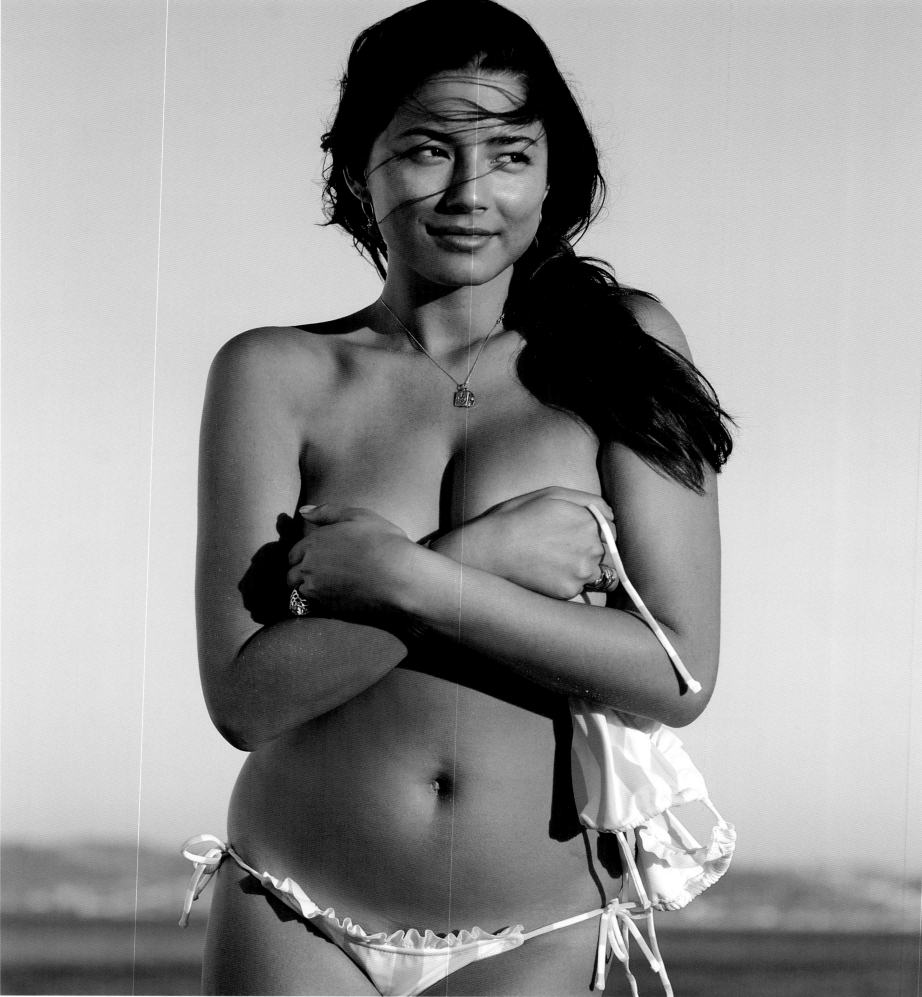

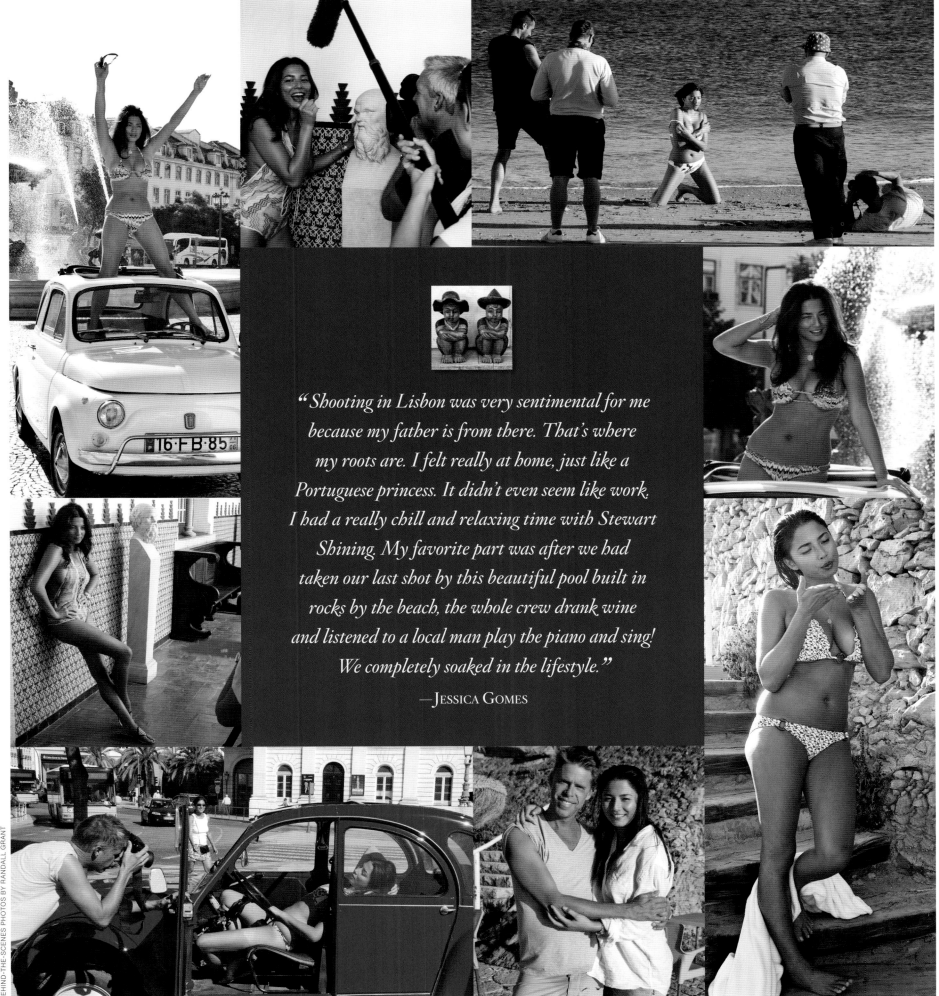

"*Shooting in Lisbon was very sentimental for me because my father is from there. That's where my roots are. I felt really at home, just like a Portuguese princess. It didn't even seem like work. I had a really chill and relaxing time with Stewart Shining. My favorite part was after we had taken our last shot by this beautiful pool built in rocks by the beach, the whole crew drank wine and listened to a local man play the piano and sing! We completely soaked in the lifestyle.*"

—JESSICA GOMES

BEHIND-THE-SCENES PHOTOS BY RANDALL GRANT

DOMINIQUE PIEK | SOUTH MALÉ ATOLL, MALDIVES

DOMINIQUE

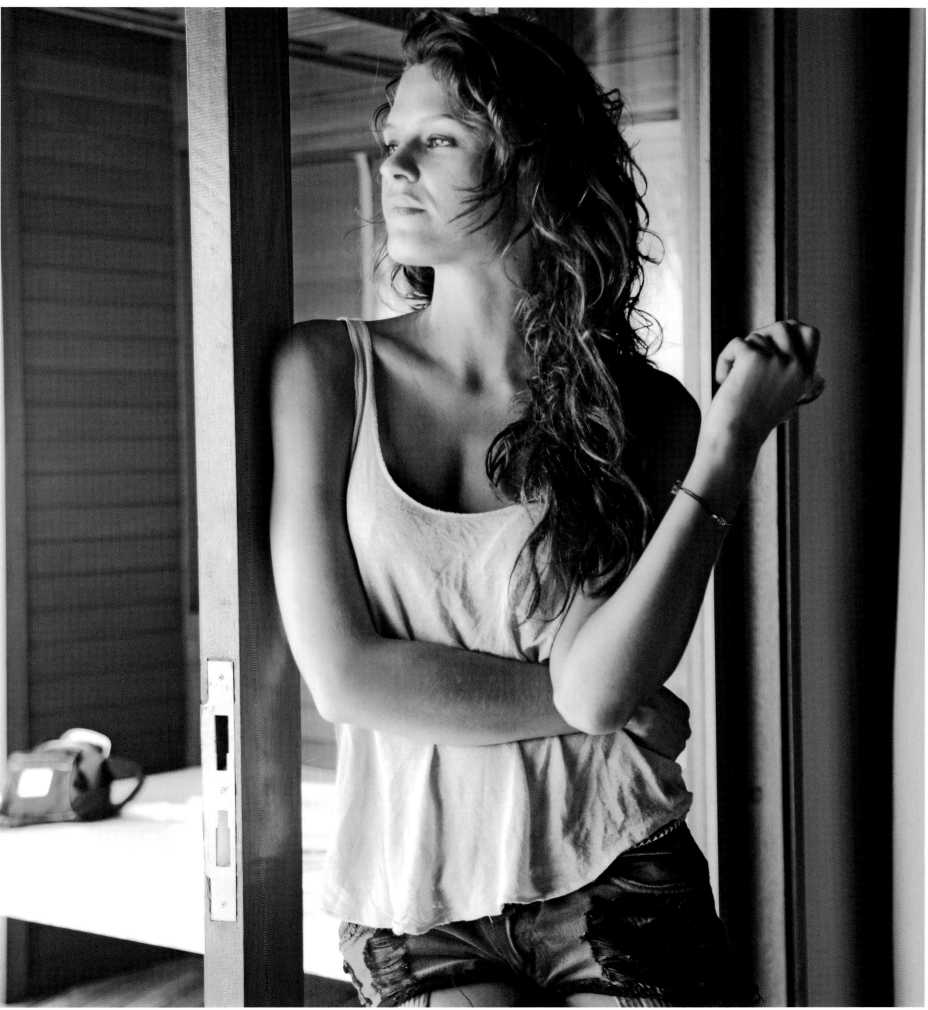

PORTFOLIO PHOTOGRAPHED ON LOCATION IN THE MALDIVES BY

WALTER IOOSS JR.

*"The Maldives is truly the number 1 location I've been to in
the last 30 years. Everyone felt it was a seminal trip.
I want to do the entire thing again with the entire crew.
Dominique was so happy to be on the shoot. This was
the crème de la crème for her. I found her to be very calm and
low-key. She's just a sweet person, gentle. She's a really pretty
girl—well-proportioned with long legs and long arms.
Her torso is the perfect length. She's from South Africa and
goes out with some badass rugby player. I liked her. She was
nervous but I think everyone is nervous, especially on the
first day of a shoot. Plus, she followed Brooklyn Decker and
Bar Refaeli. Trust me, that would make anyone nervous."*

—WALTER IOOSS JR.

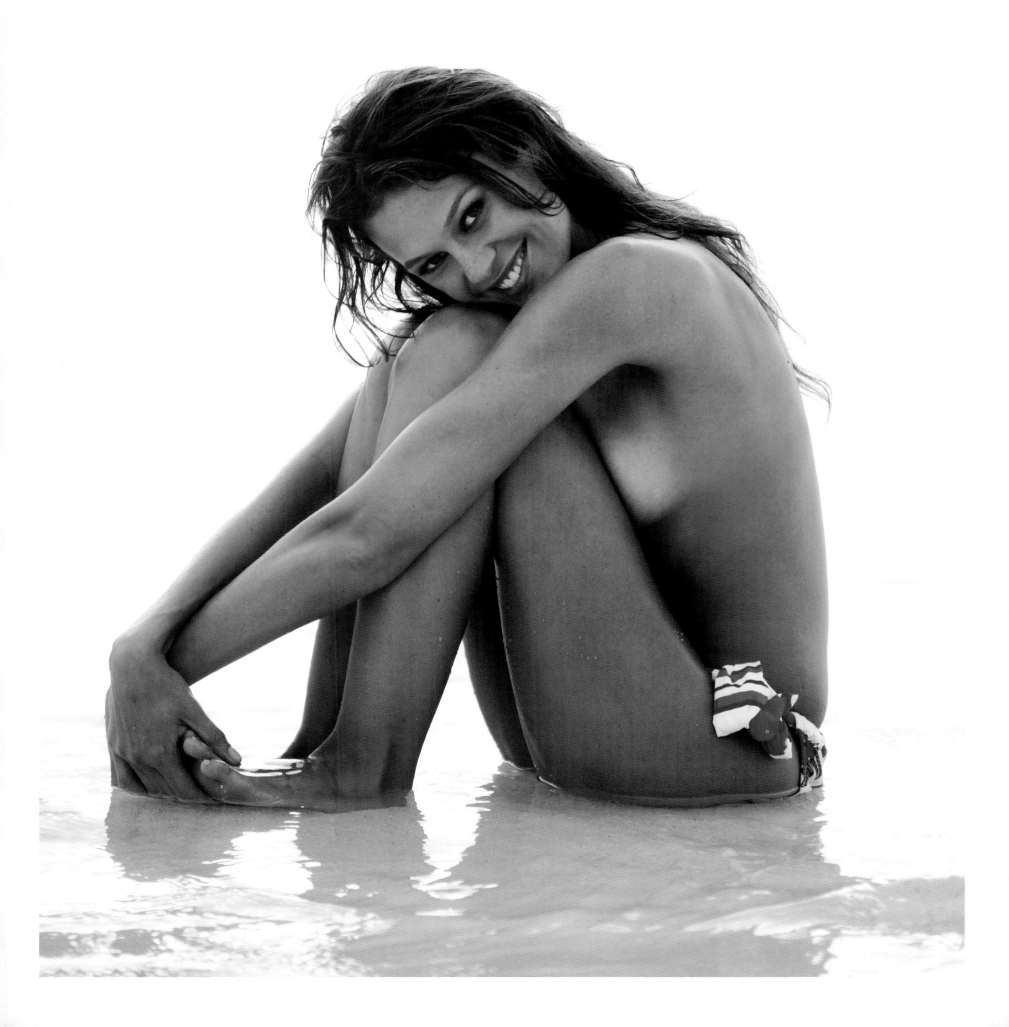

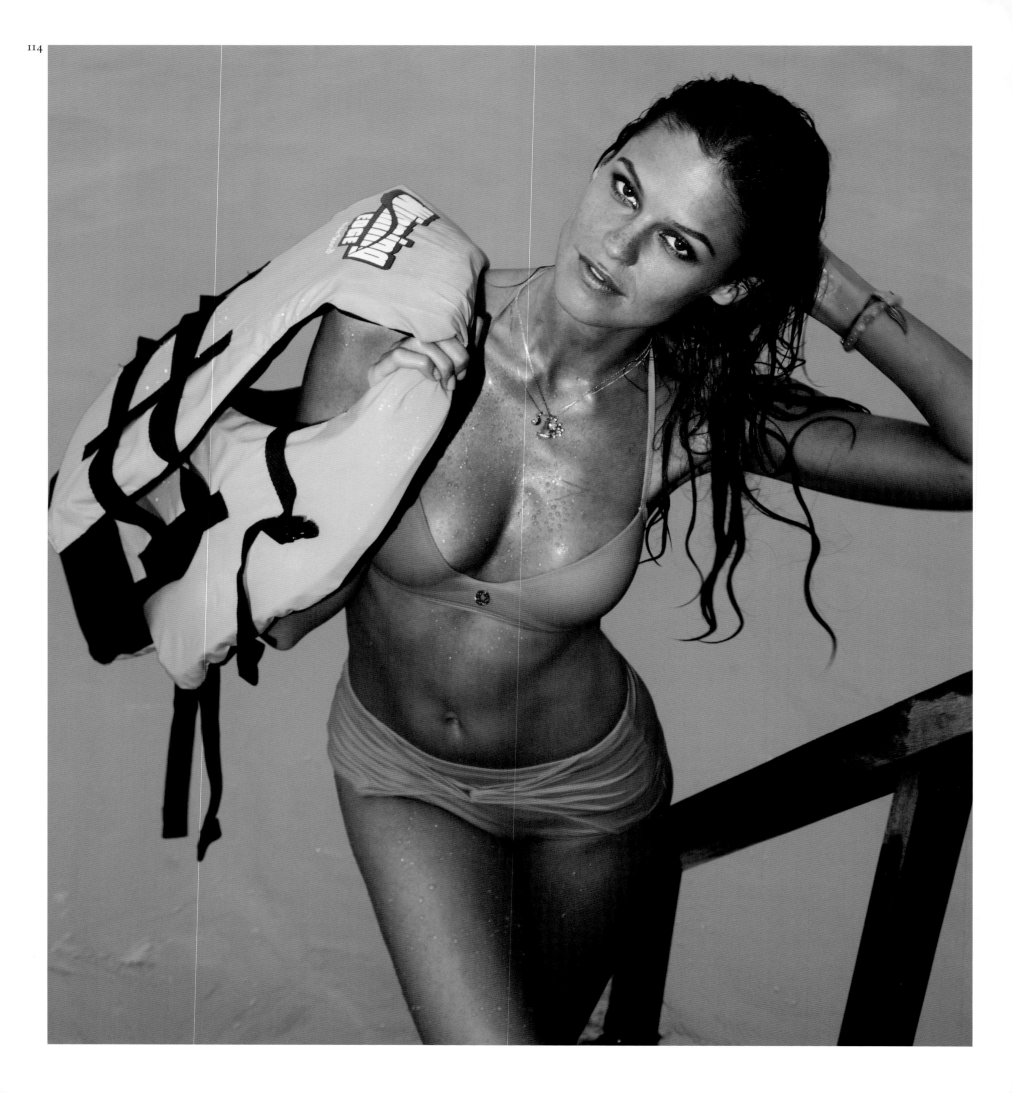

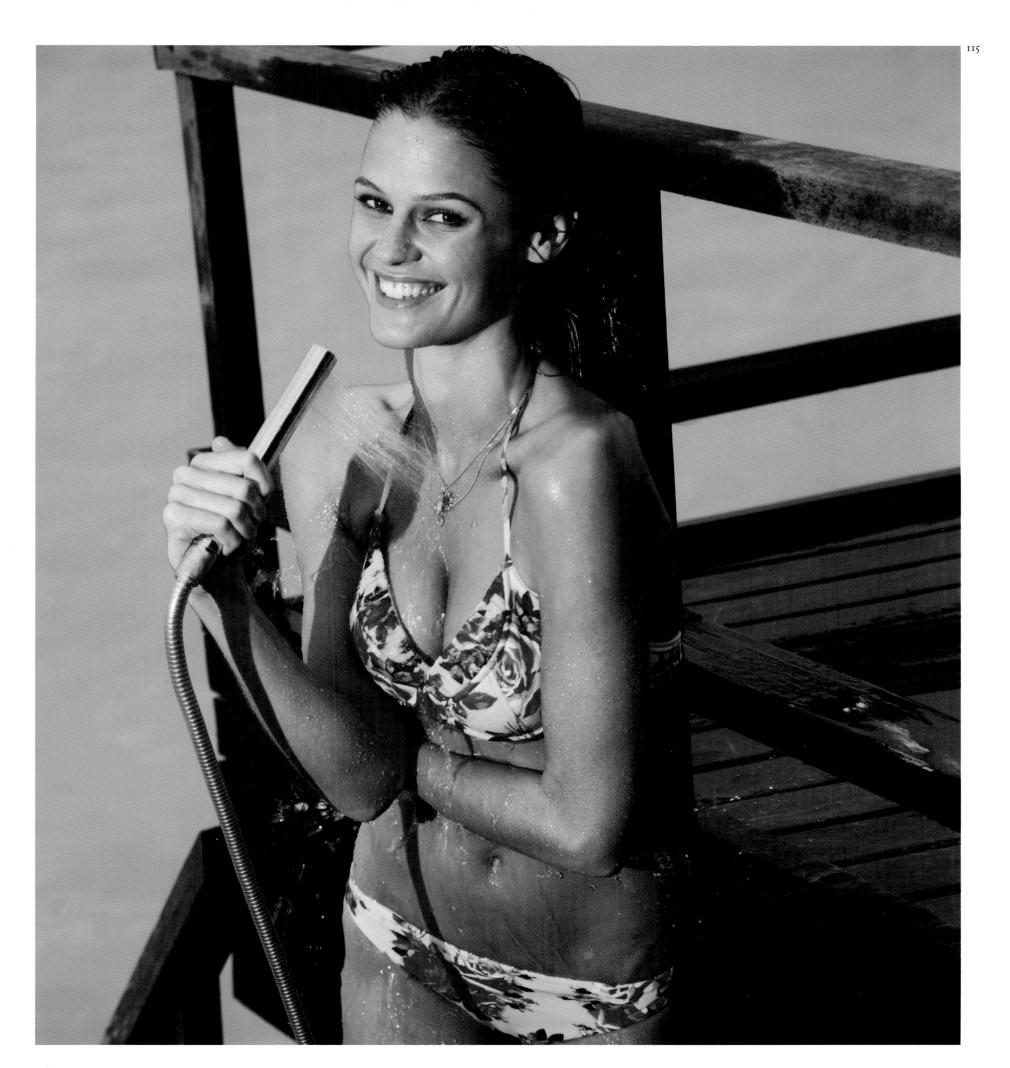

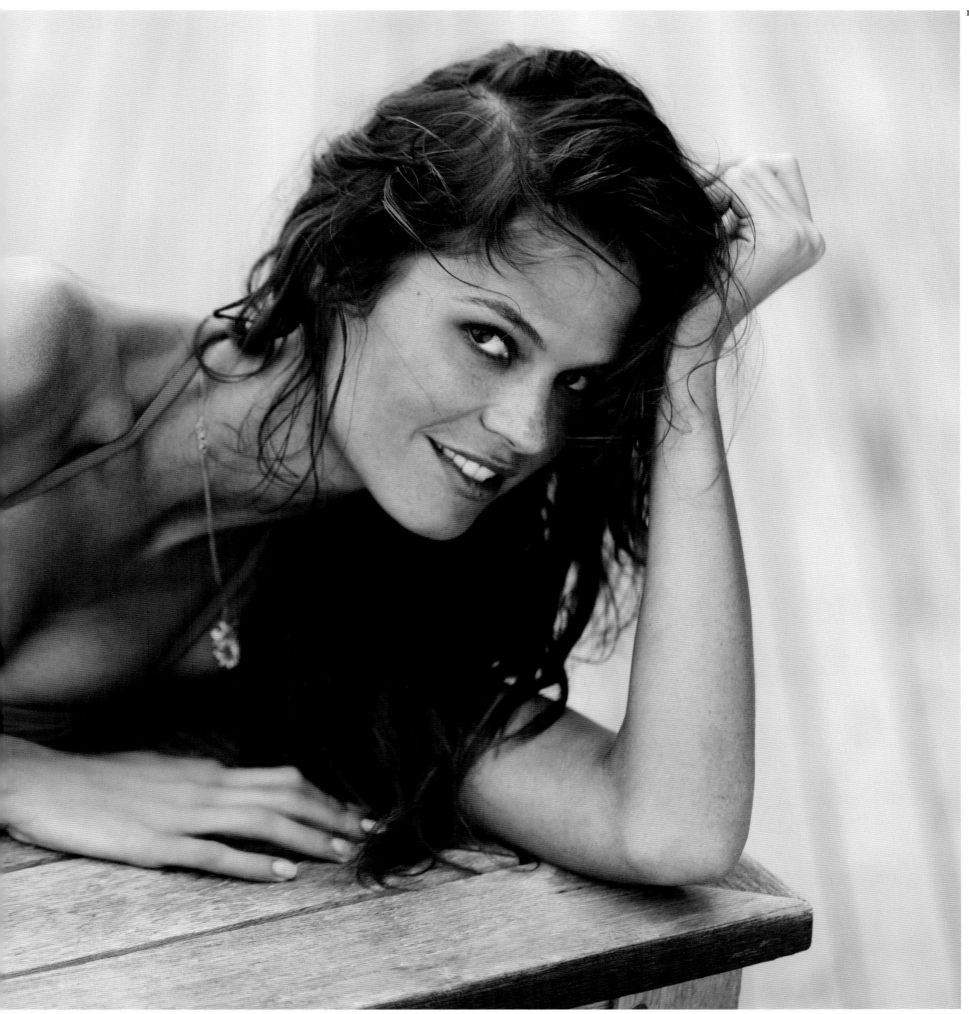

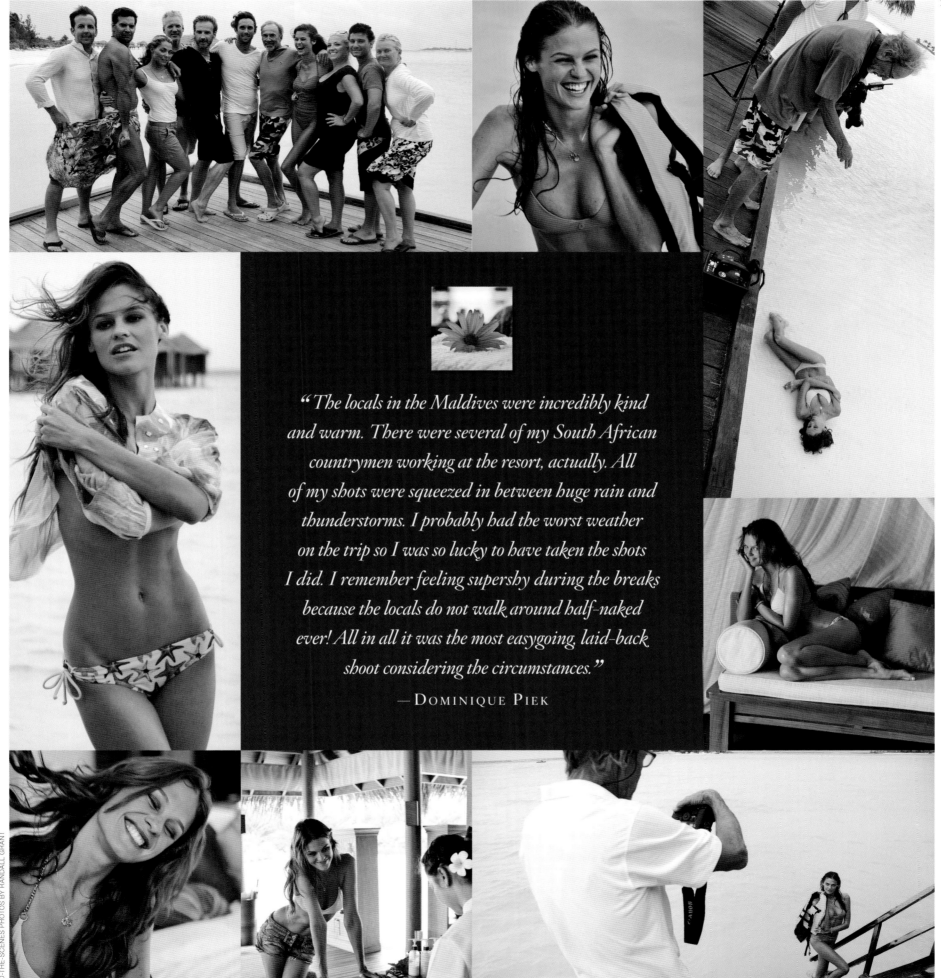

"The locals in the Maldives were incredibly kind and warm. There were several of my South African countrymen working at the resort, actually. All of my shots were squeezed in between huge rain and thunderstorms. I probably had the worst weather on the trip so I was so lucky to have taken the shots I did. I remember feeling supershy during the breaks because the locals do not walk around half-naked ever! All in all it was the most easygoing, laid-back shoot considering the circumstances."

— DOMINIQUE PIEK

BEHIND-THE-SCENES PHOTOS BY RANDALL GRANT

SONIA DARA | RAJASTHAN, INDIA

SONIA

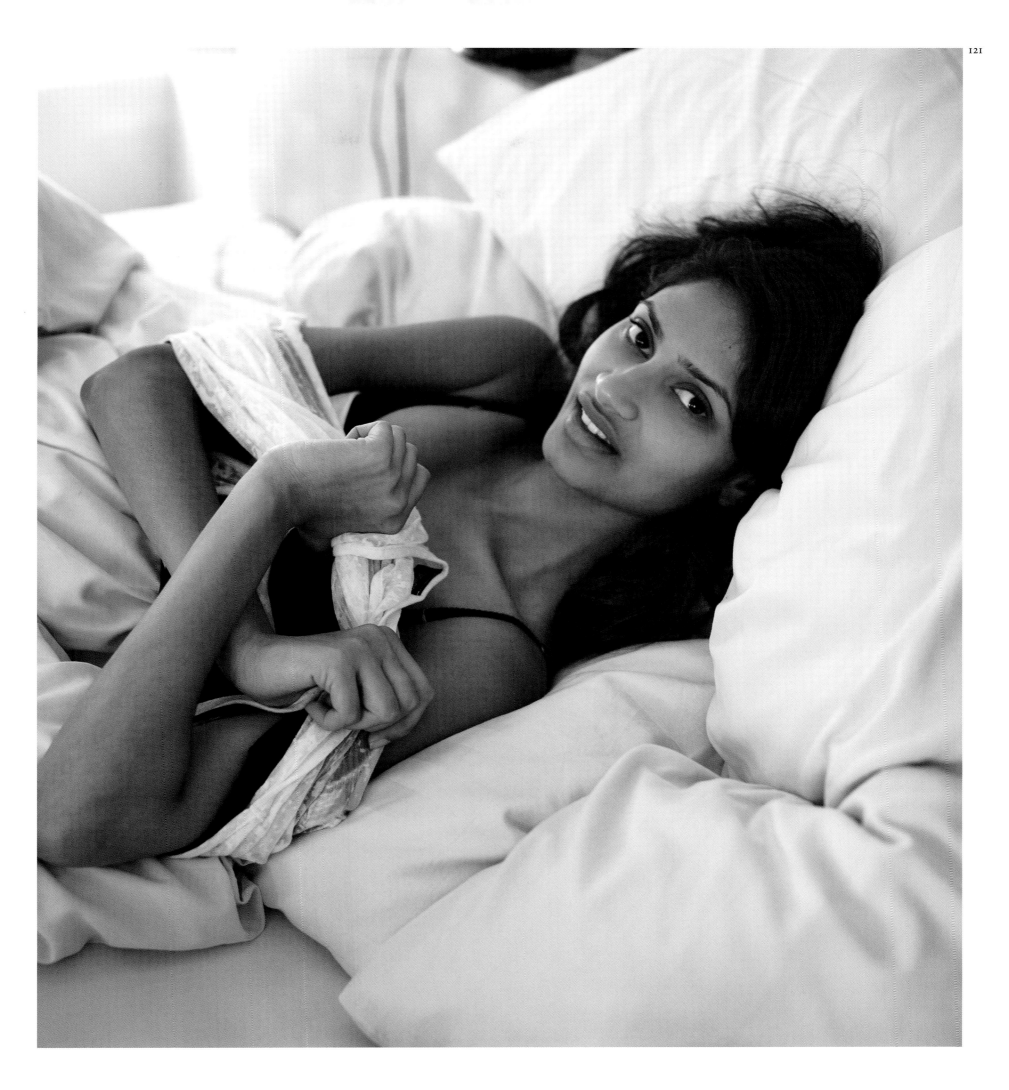

PORTFOLIO PHOTOGRAPHED ON LOCATION IN INDIA BY

RICCARDO TINELLI

*"Sonia is a really intelligent girl. After all, she goes to
Harvard. But she has two sides. There is this conservative
side, the girl that is studying all the time. Then the other side,
the glamorous one. So she is a girl in the middle of things,
going to the best school and also loving the glamour.
It was funny with Sonia: You put a girl in the SI Swimsuit
Issue, and she forgets her studies in a second. Sonia did
not have a lot of modeling experience so, at first, of course,
she was a little shy. Not in a bad way, though. We
just had to go slowly. But by the end of the shoot, she was
very comfortable and confident. I liked her very
much. She was just a great girl who will go places."*

—RICCARDO TINELLI

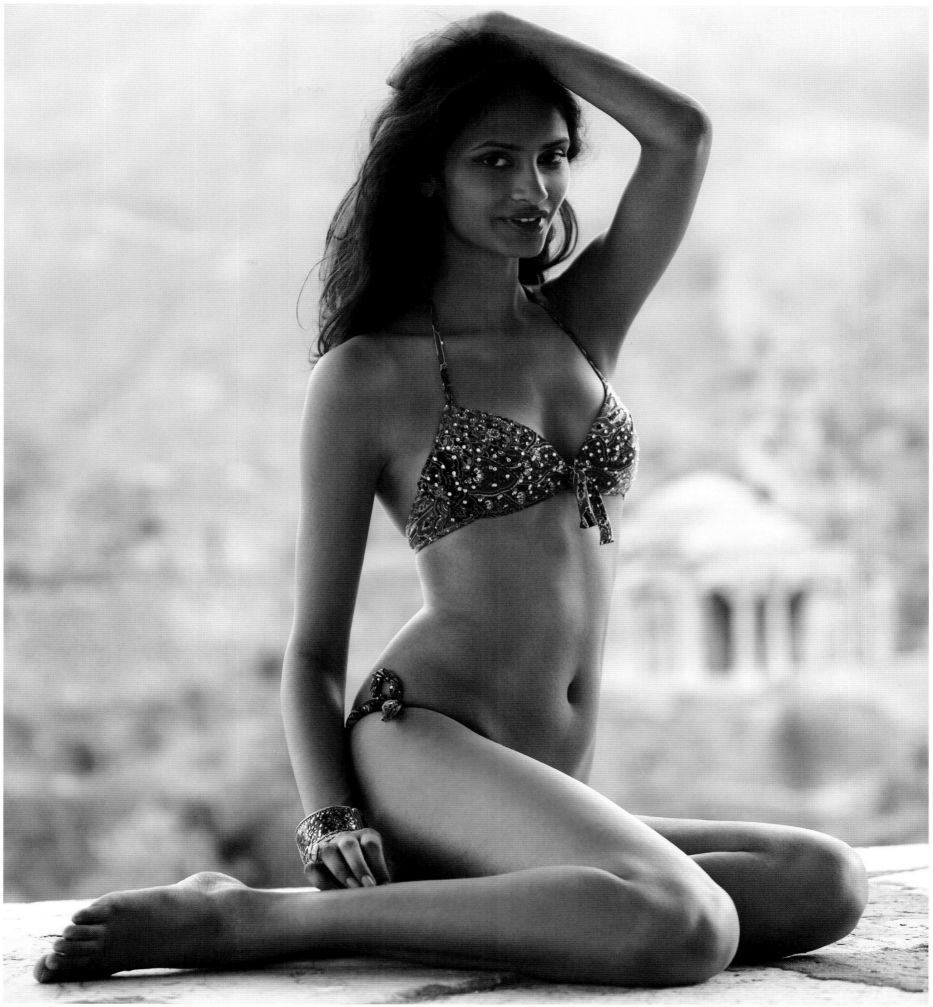

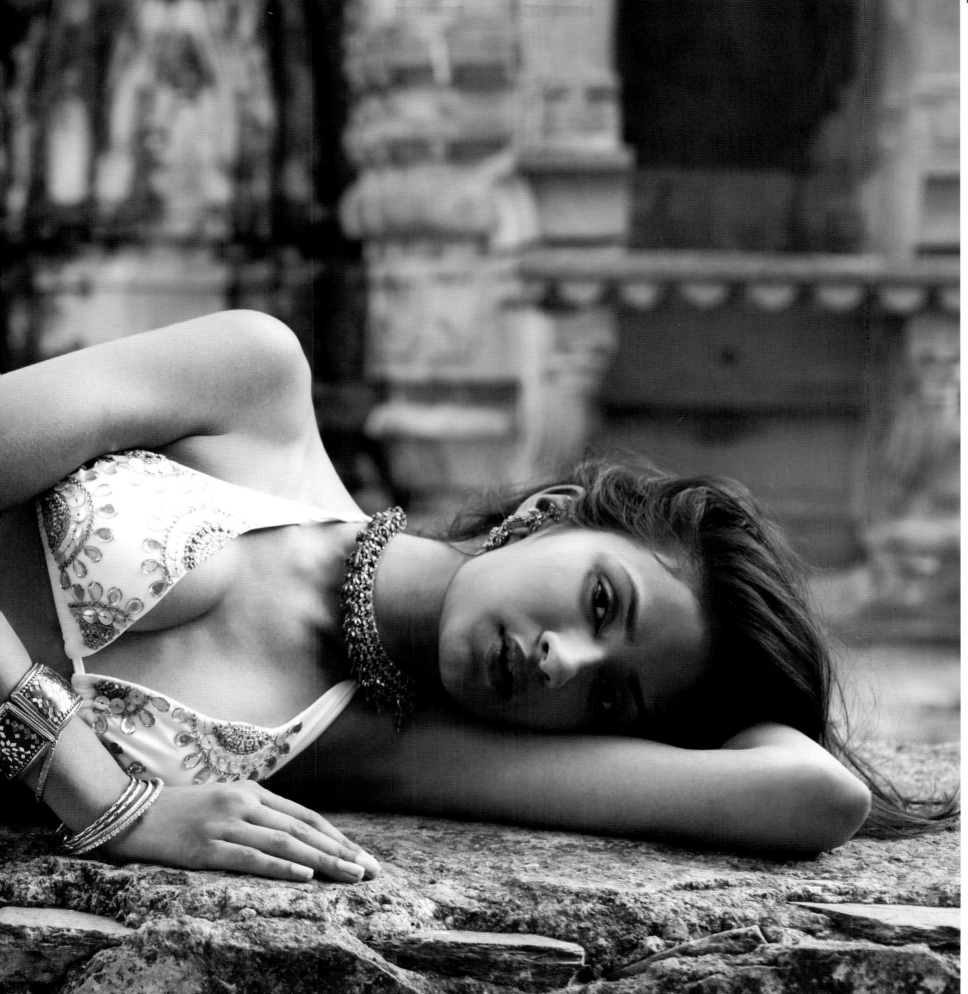

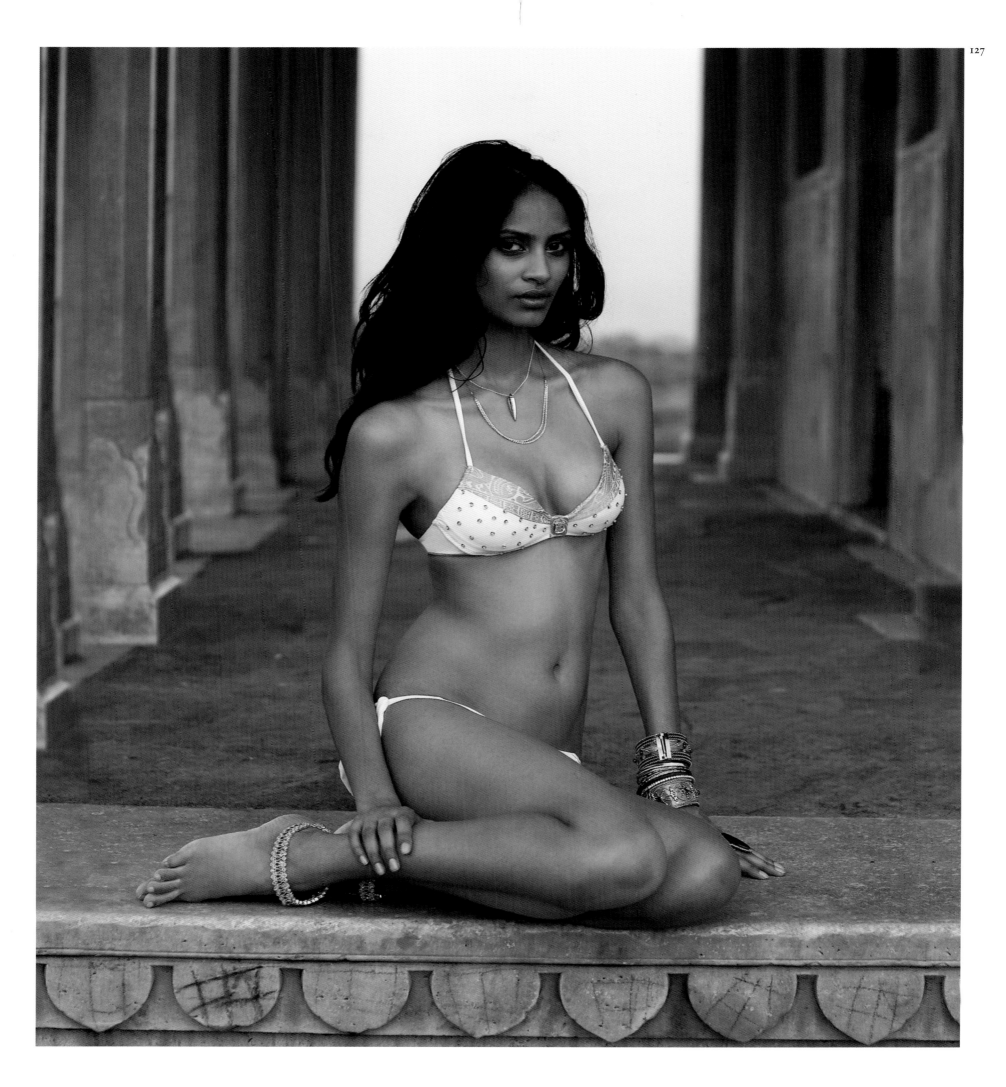

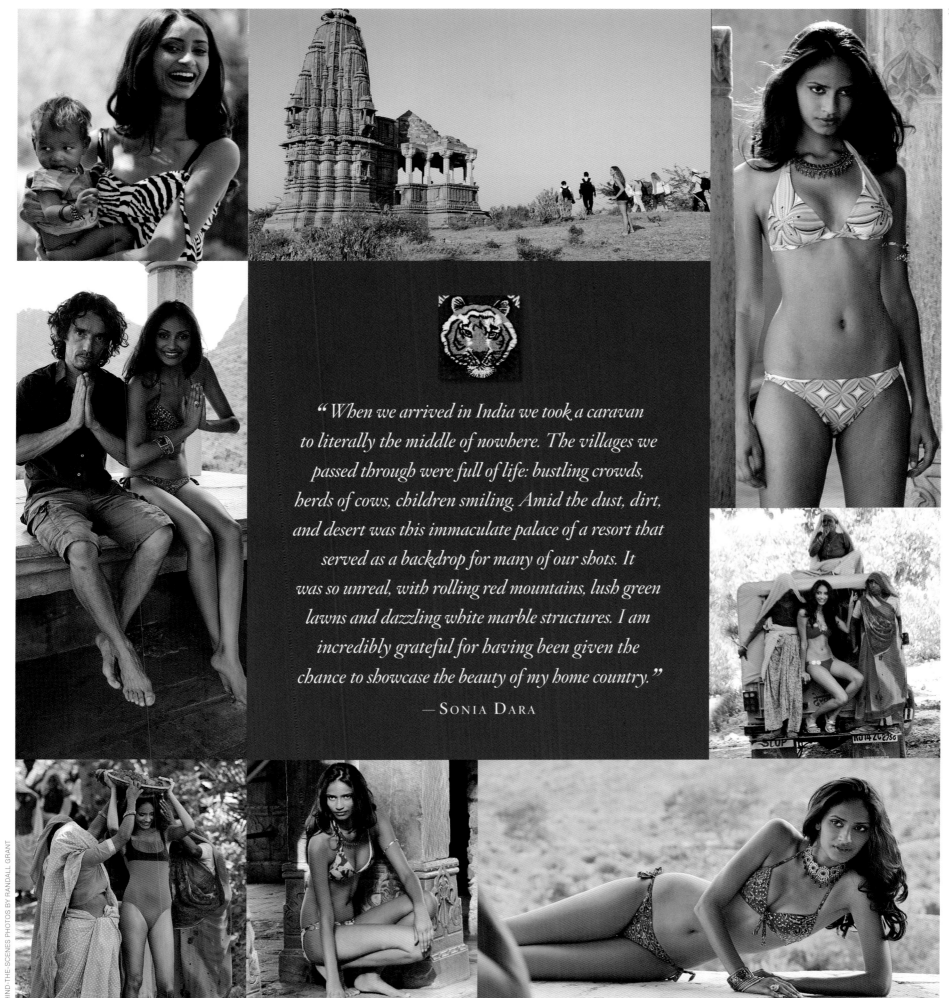

" When we arrived in India we took a caravan to literally the middle of nowhere. The villages we passed through were full of life: bustling crowds, herds of cows, children smiling. Amid the dust, dirt, and desert was this immaculate palace of a resort that served as a backdrop for many of our shots. It was so unreal, with rolling red mountains, lush green lawns and dazzling white marble structures. I am incredibly grateful for having been given the chance to showcase the beauty of my home country."

—SONIA DARA

BEHIND-THE-SCENES PHOTOS BY RANDALL GRANT

DANIELLA SARAHYBA | SAN PEDRO DE ATACAMA, CHILE

DANIELLA

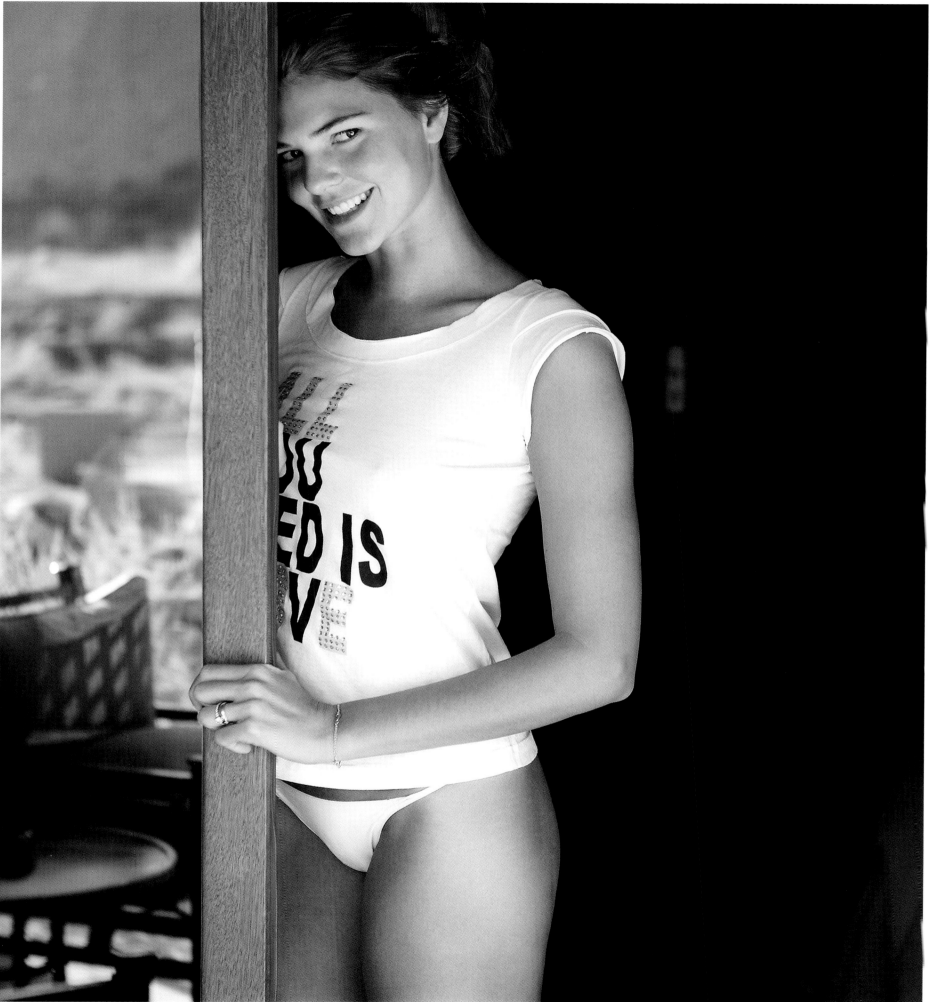

PORTFOLIO PHOTOGRAPHED ON LOCATION IN CHILE BY

RAPHAEL MAZZUCCO

" Fun, fun, fun. Daniella is just so outgoing. What a beautiful soul and spirit, and, believe me, you feel that when you are working with her. She is a very happy person and I think that comes through her life in Brazil with her family. Daniella gets inspired from different situations. She is a girl who appreciates life to its fullest and you see that in her pictures. I think she has the greatest smile ever. I am positively in love with that smile. This was the first time I'd worked with Daniella, but I'd always been a big fan of hers. For me I always thought of her as a naturally gorgeous girl. In all her photos I see someone who is a happy person, comfortable in her own skin. "

— RAPHAEL MAZZUCCO

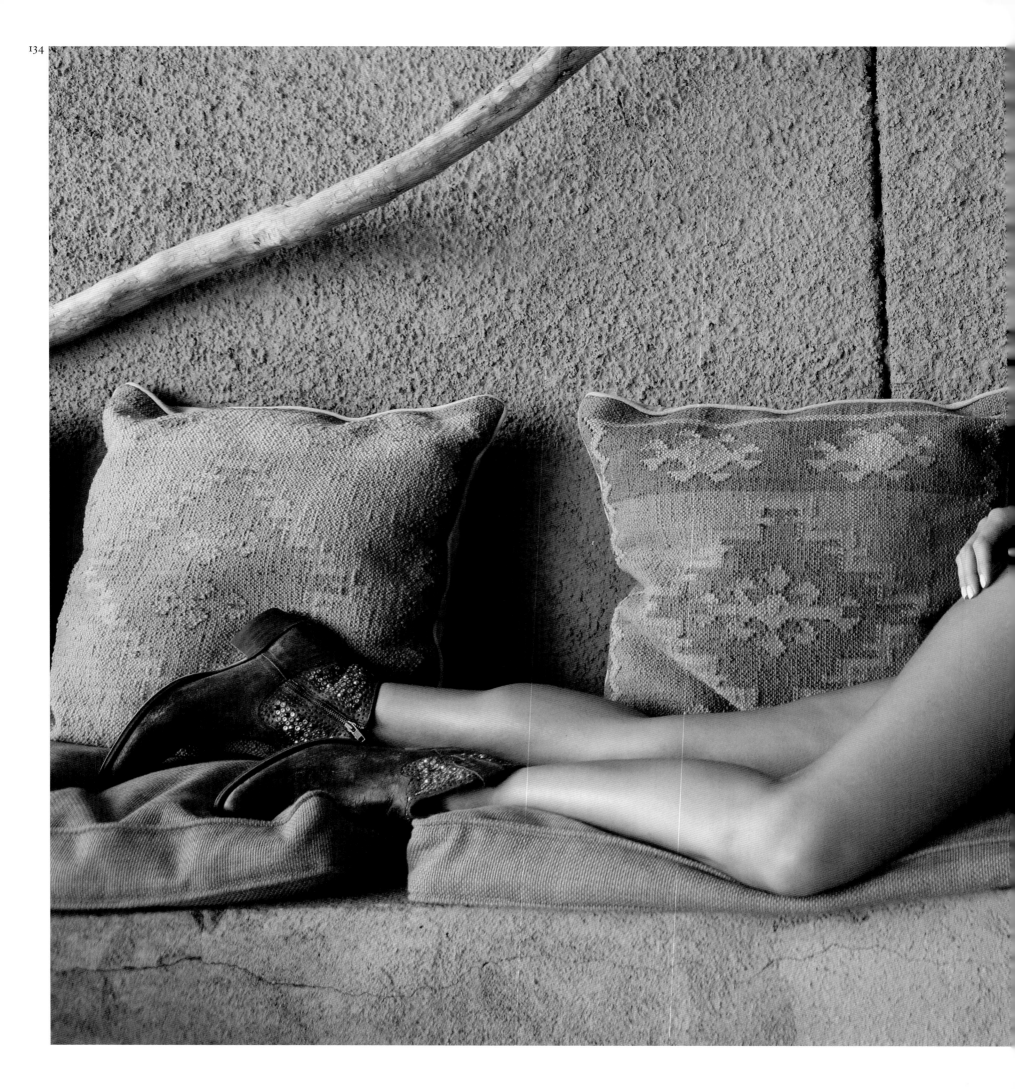

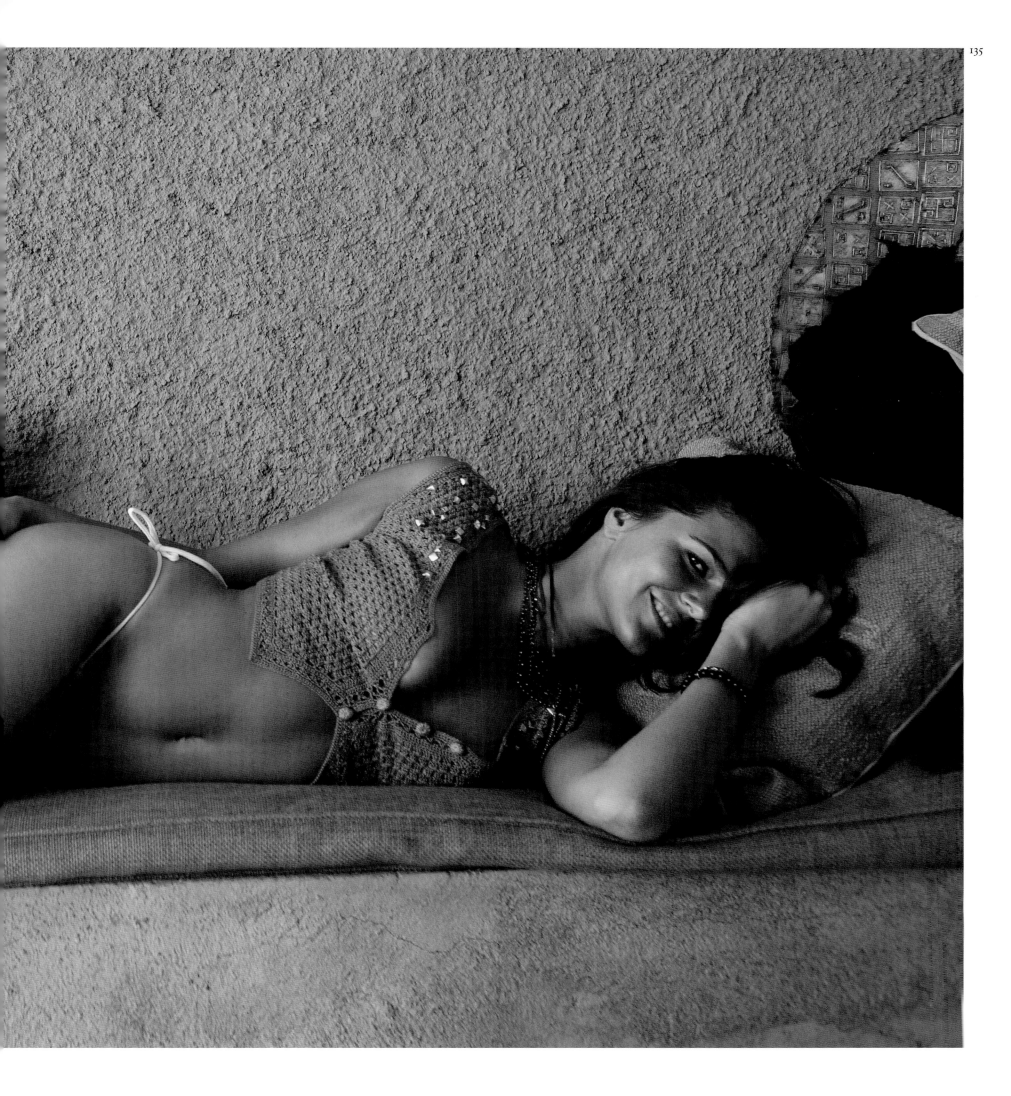

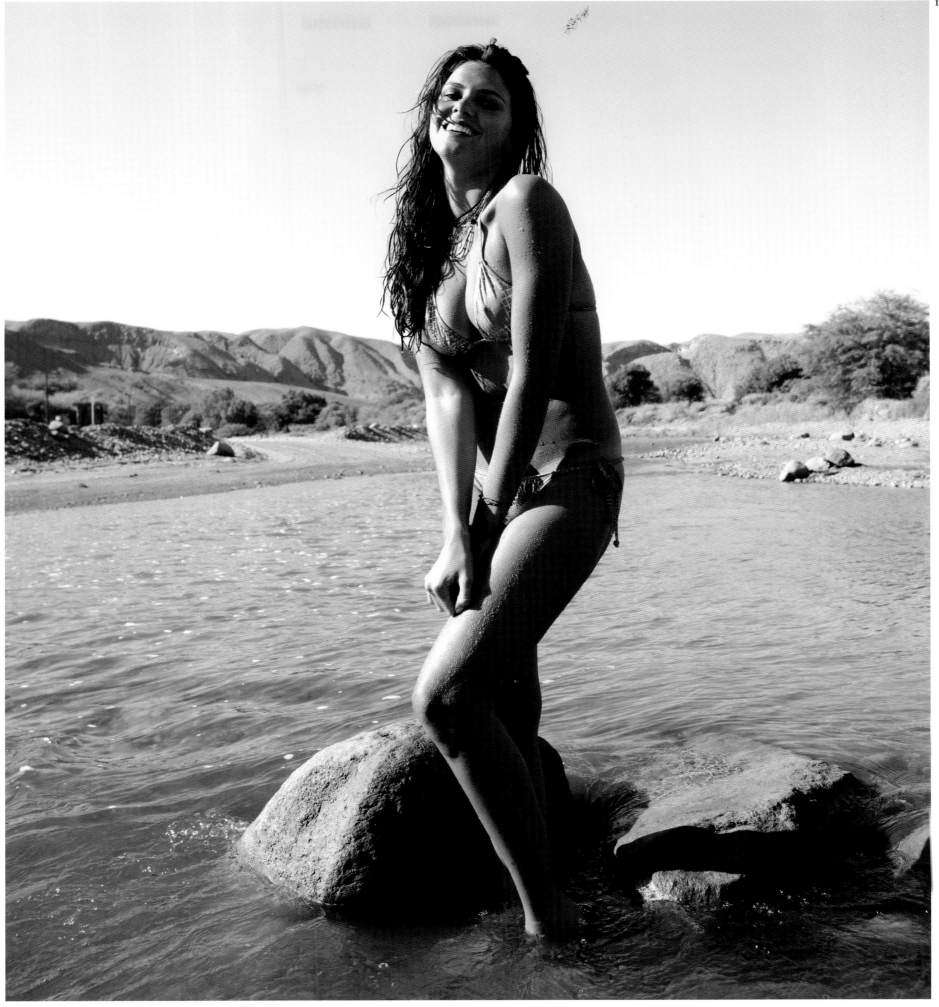

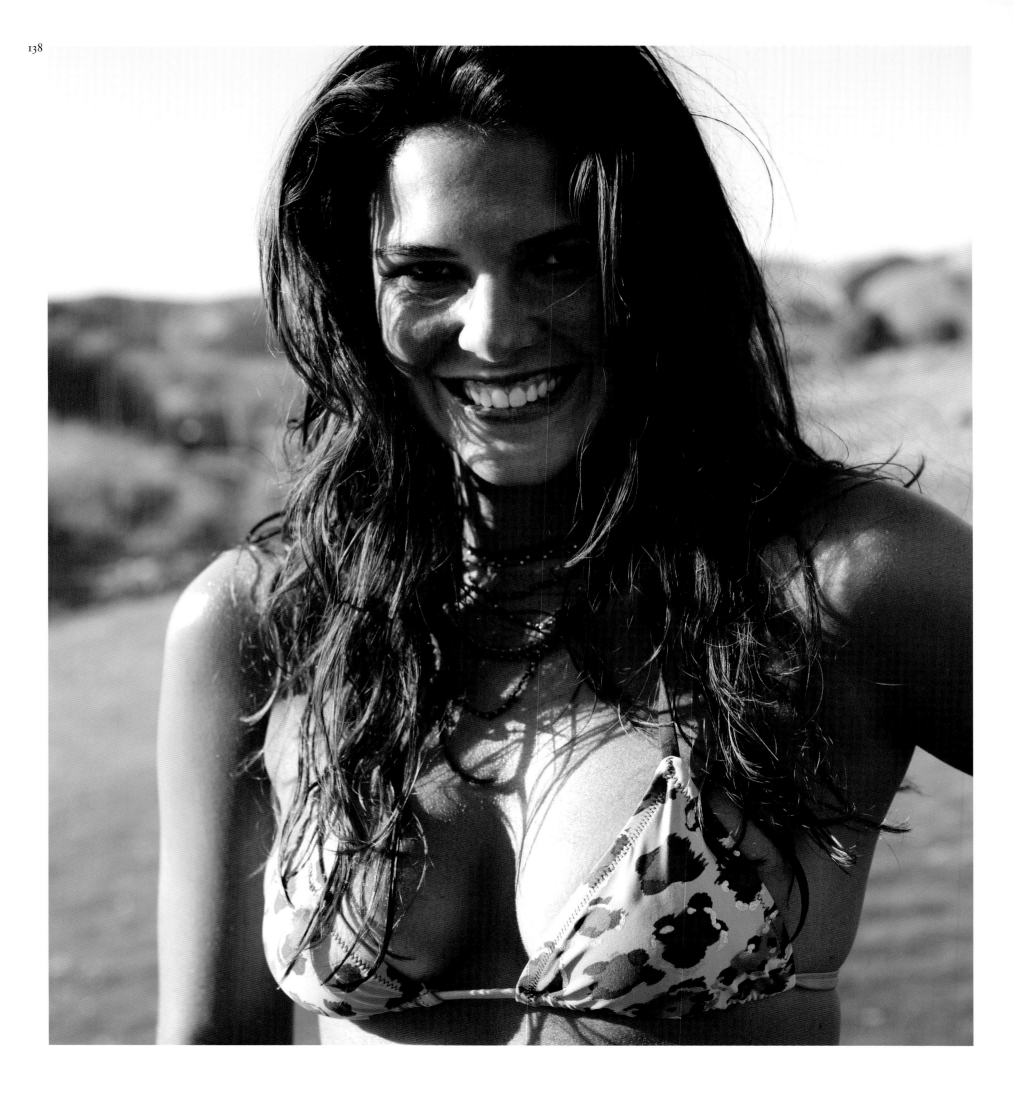

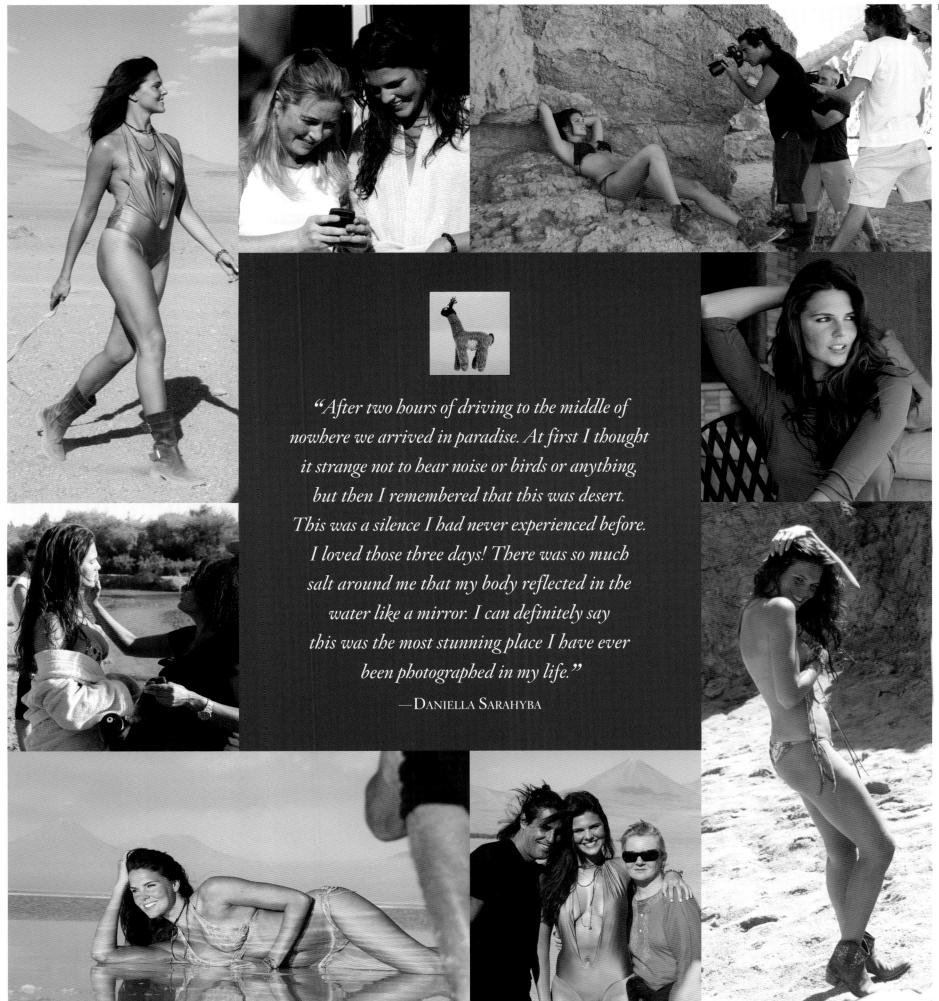

"After two hours of driving to the middle of nowhere we arrived in paradise. At first I thought it strange not to hear noise or birds or anything, but then I remembered that this was desert. This was a silence I had never experienced before. I loved those three days! There was so much salt around me that my body reflected in the water like a mirror. I can definitely say this was the most stunning place I have ever been photographed in my life."

— DANIELLA SARAHYBA

BEHIND-THE-SCENES PHOTOS BY RANDALL GRANT

DAMARIS LEWIS | PALM SPRINGS, CALIFORNIA

DAMARIS

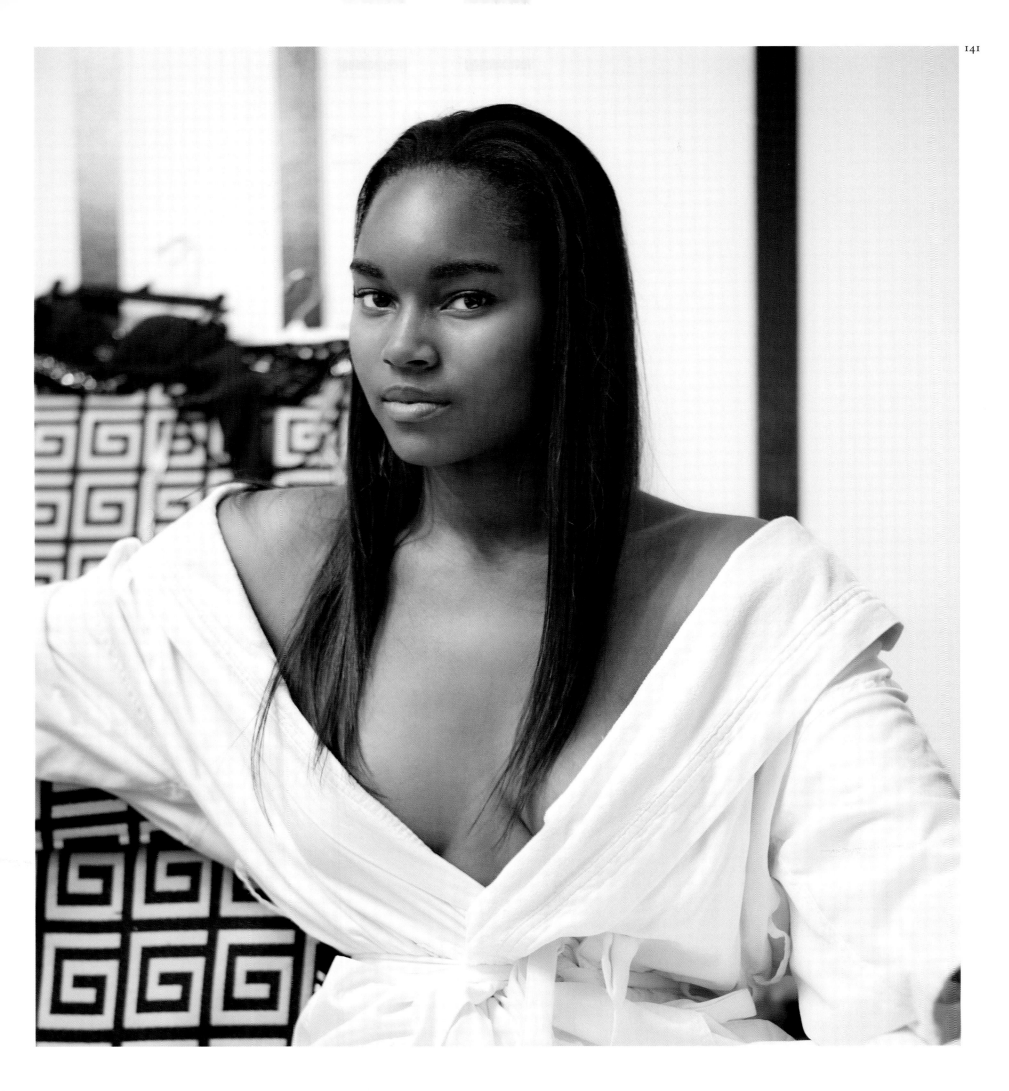

PORTFOLIO PHOTOGRAPHED ON LOCATION IN CALIFORNIA BY

WALTER CHIN

" I had never worked with Damaris before and I initially thought, 'Wow, this girl is very, very sexy.' That was good because I wanted voluptuous girls for this shoot. Working with these enormous planes and machinery in the Mojave Desert, I needed sensuous figures. There were so many angles on these planes and Damaris used her body to find the unique compositions for each of her pictures. She's going to do well in this business. People who know me and know my work know I can't shoot sticks. It makes my work harder, much harder. A lot of people get off on skinny girls, but I prefer somebody curvaceous. I want models with fullness. I looked at Damaris and right away liked what I saw."

—WALTER CHIN

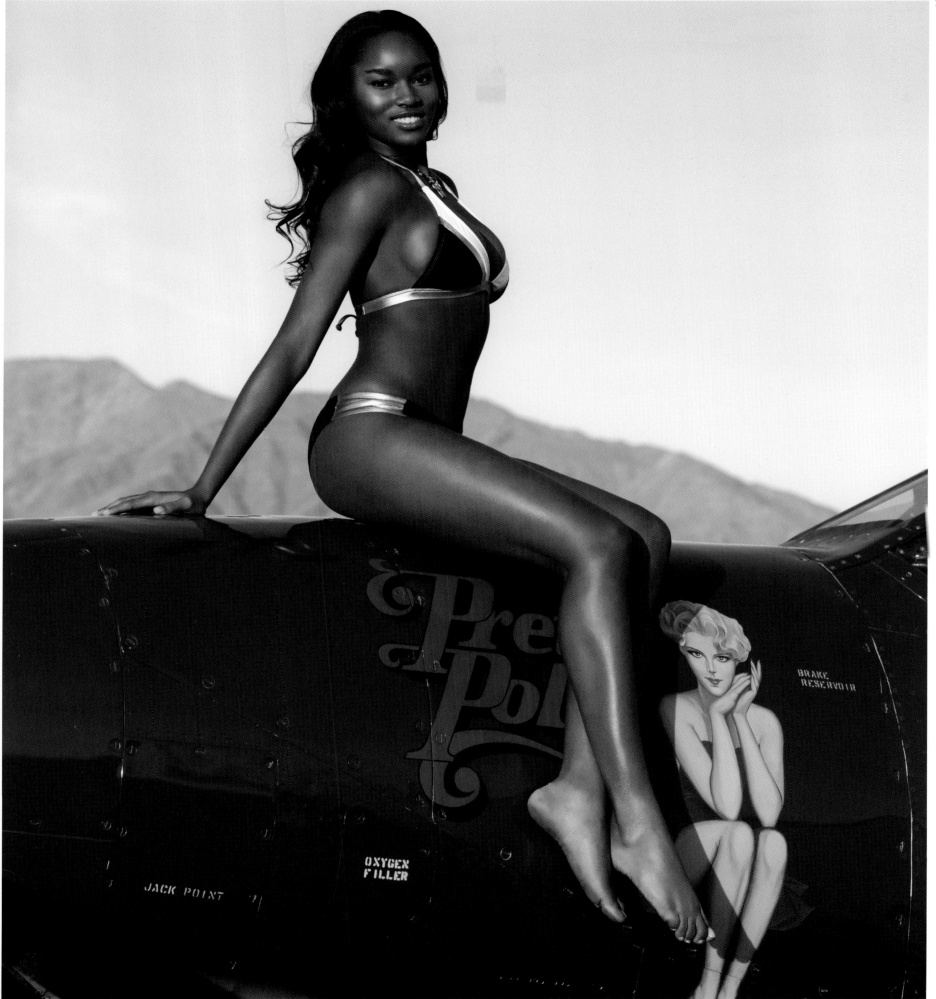

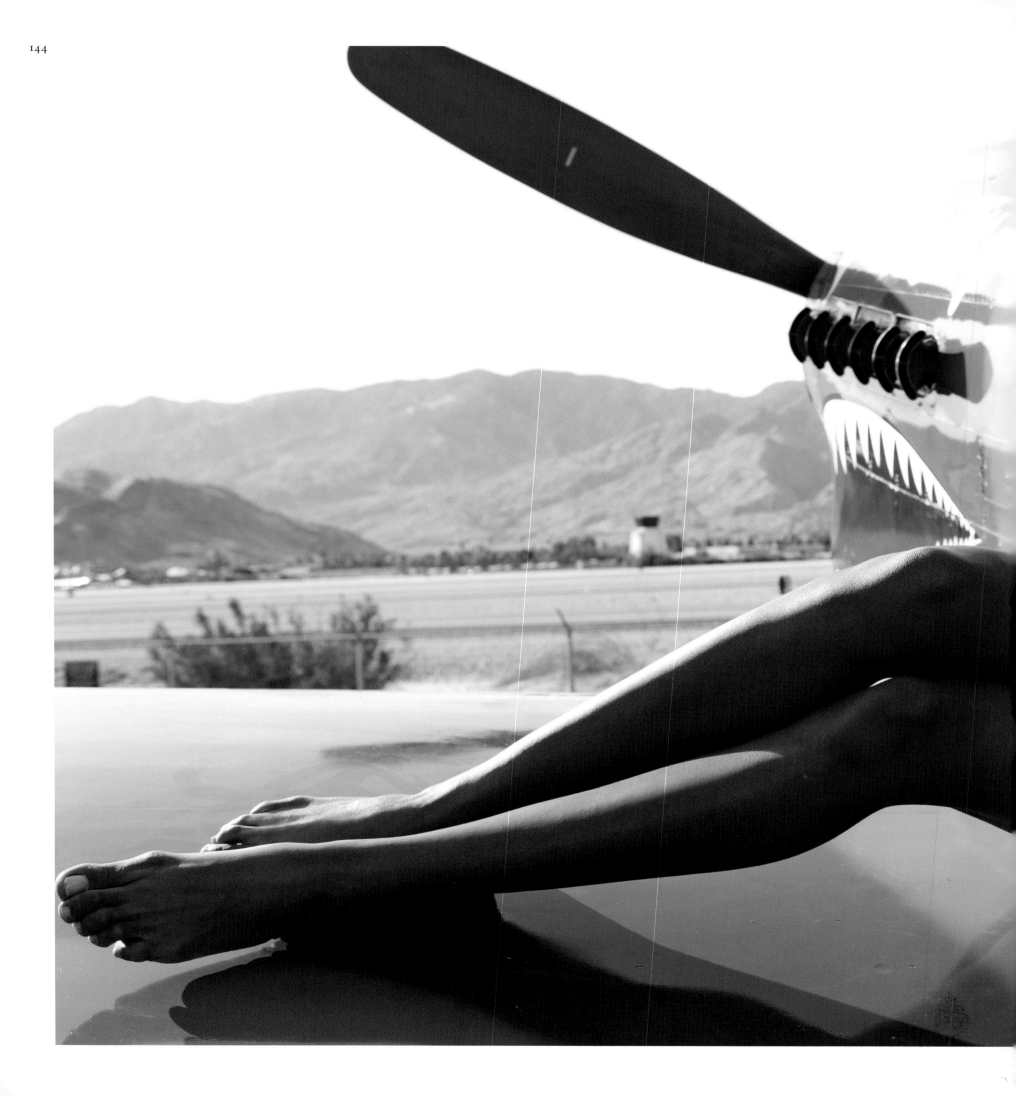

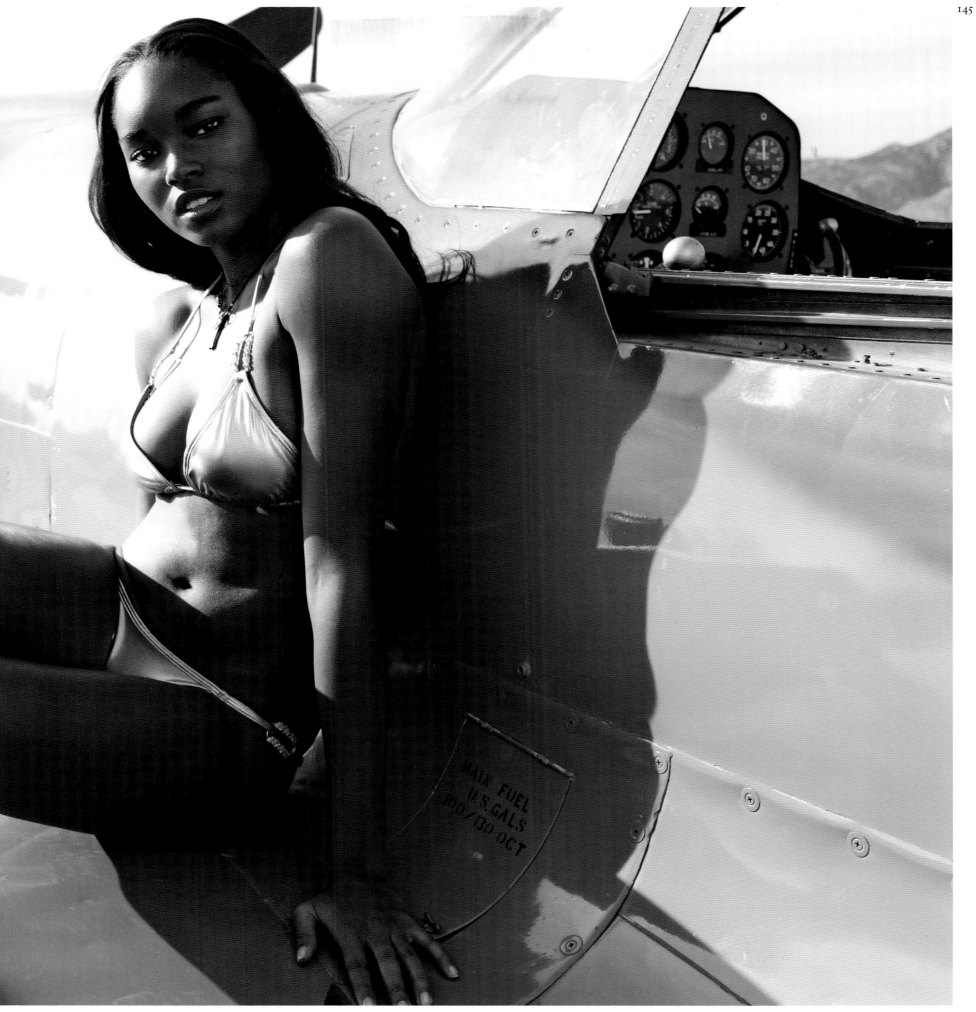

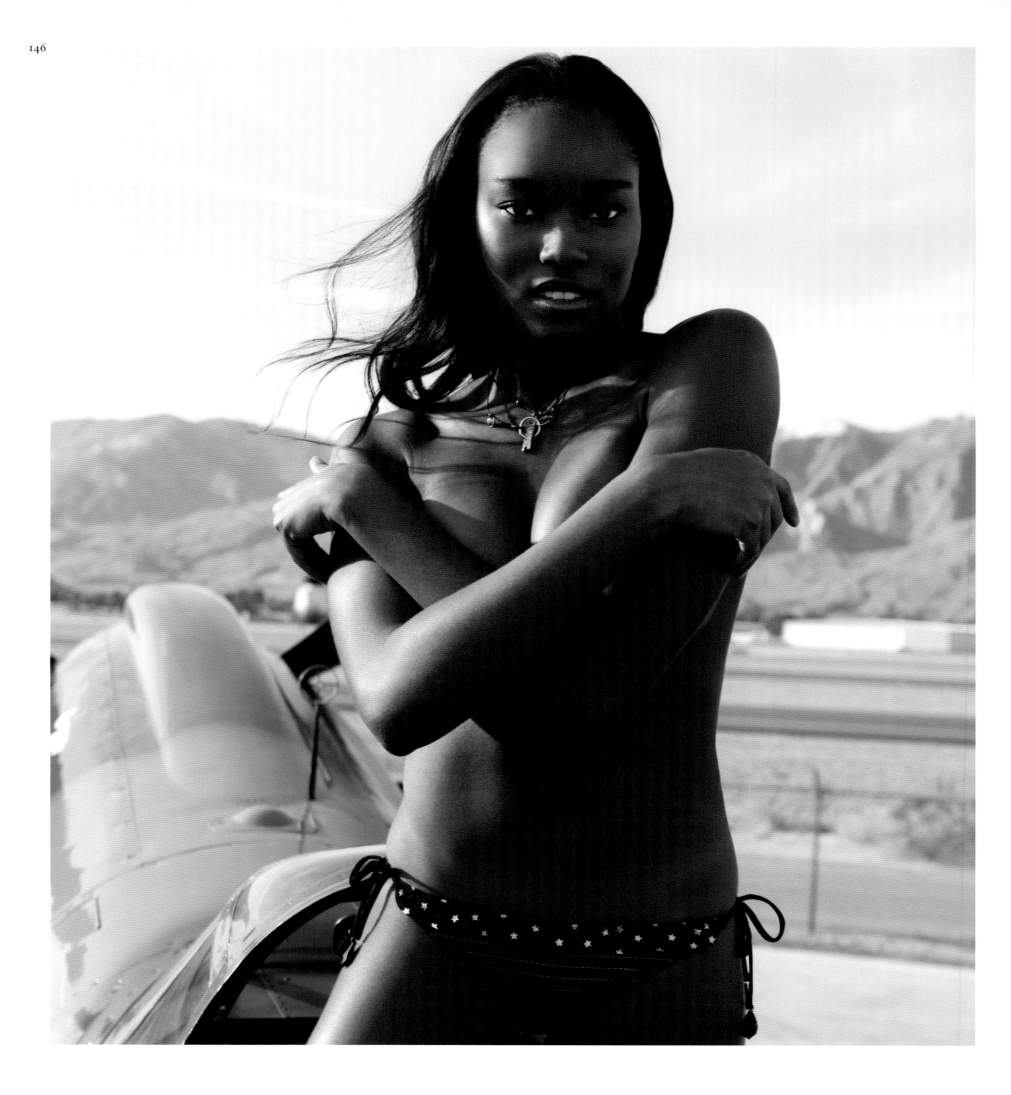

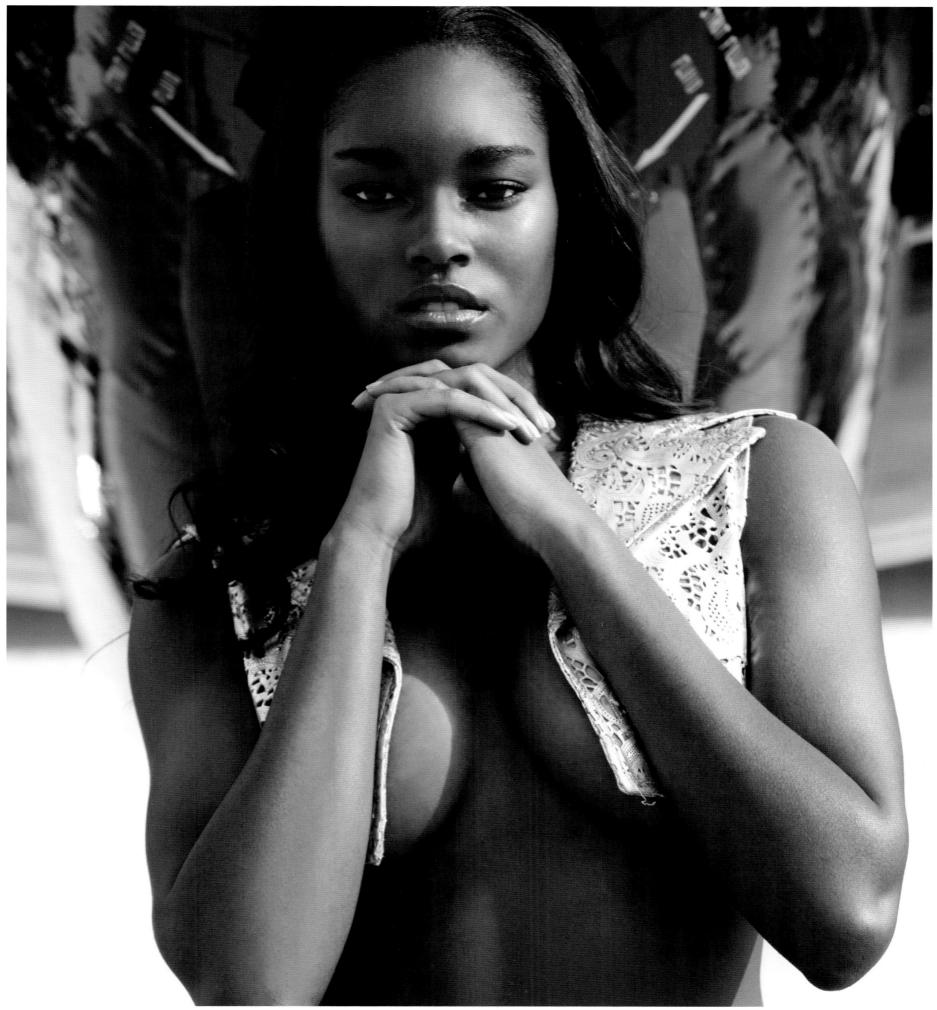

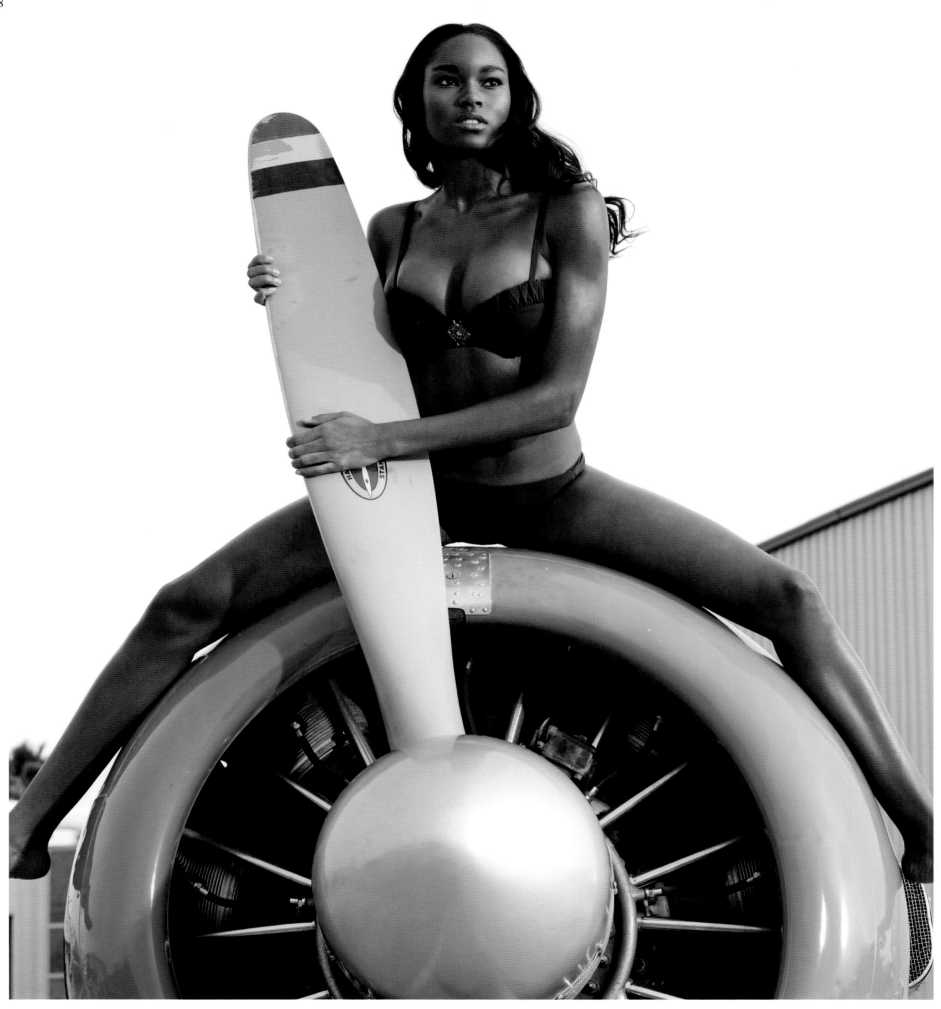

"I loved shooting with Walter Chin; there was no hesitation on any of the shots. If the plane wing worked to shoot on, fine. If it didn't, it didn't. One of my favorite shots is the one of me straddling the propeller. It's not every day someone tells you to climb up the wing and onto the nose of a fighter jet. When I got up there I felt as if it was just me and Walter, nobody else. Which made it easier for me not to think about falling off the plane and breaking every bone in my body."

—Damaris Lewis

BEHIND-THE-SCENES PHOTOS BY DARCIE BAUM

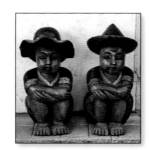

CINTIA DICKER | LISBON, PORTUGAL

CINTIA

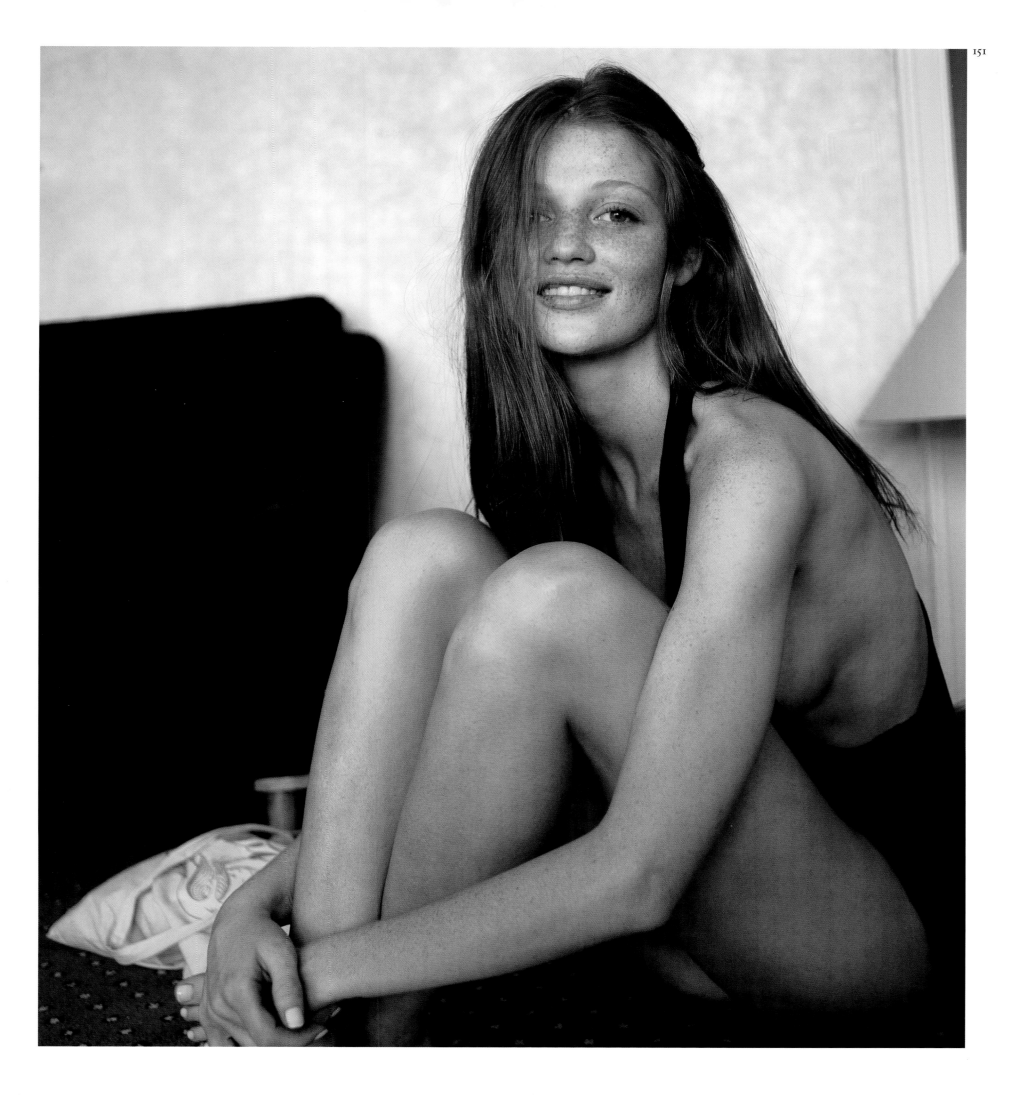

PORTFOLIO PHOTOGRAPHED ON LOCATION IN PORTUGAL BY

STEWART SHINING

"Cintia is Brazilian, but when you meet her, completely redheaded with all those freckles and fair skin, you expect her to break out into an Irish brogue. Cintia is shy and soft-spoken, which pulled me into a whole other direction with her pictures because there was a kind of intimacy when I was shooting her. I forgot everyone else was around; it felt as if I was just sitting there with her. She's like a lightbulb. She has this crazy energy but it starts inside of her and then pulls you into the picture. We did some shots in a vineyard and the sun was coming through her hair, and I thought, 'Wow, she looks like an angel.' Shyness can be supersexy because a girl doesn't just give it away. You have to go in there and earn it and find it."

— STEWART SHINING

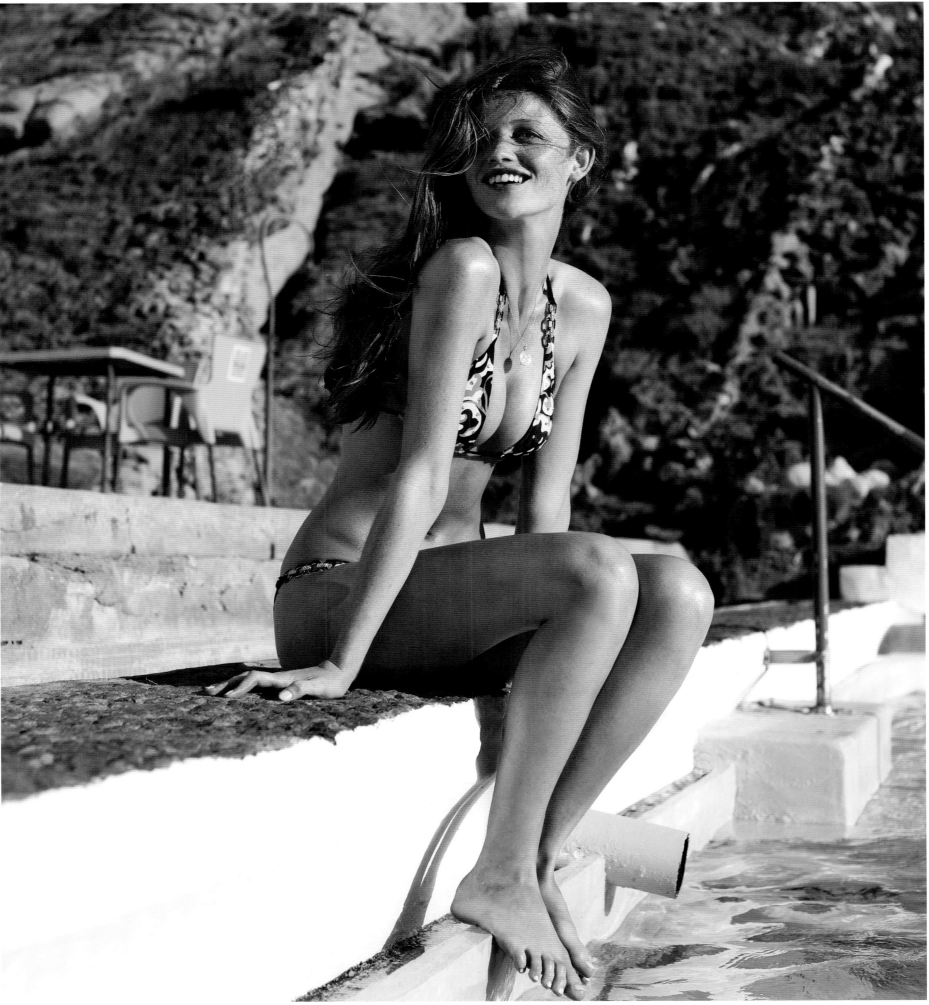

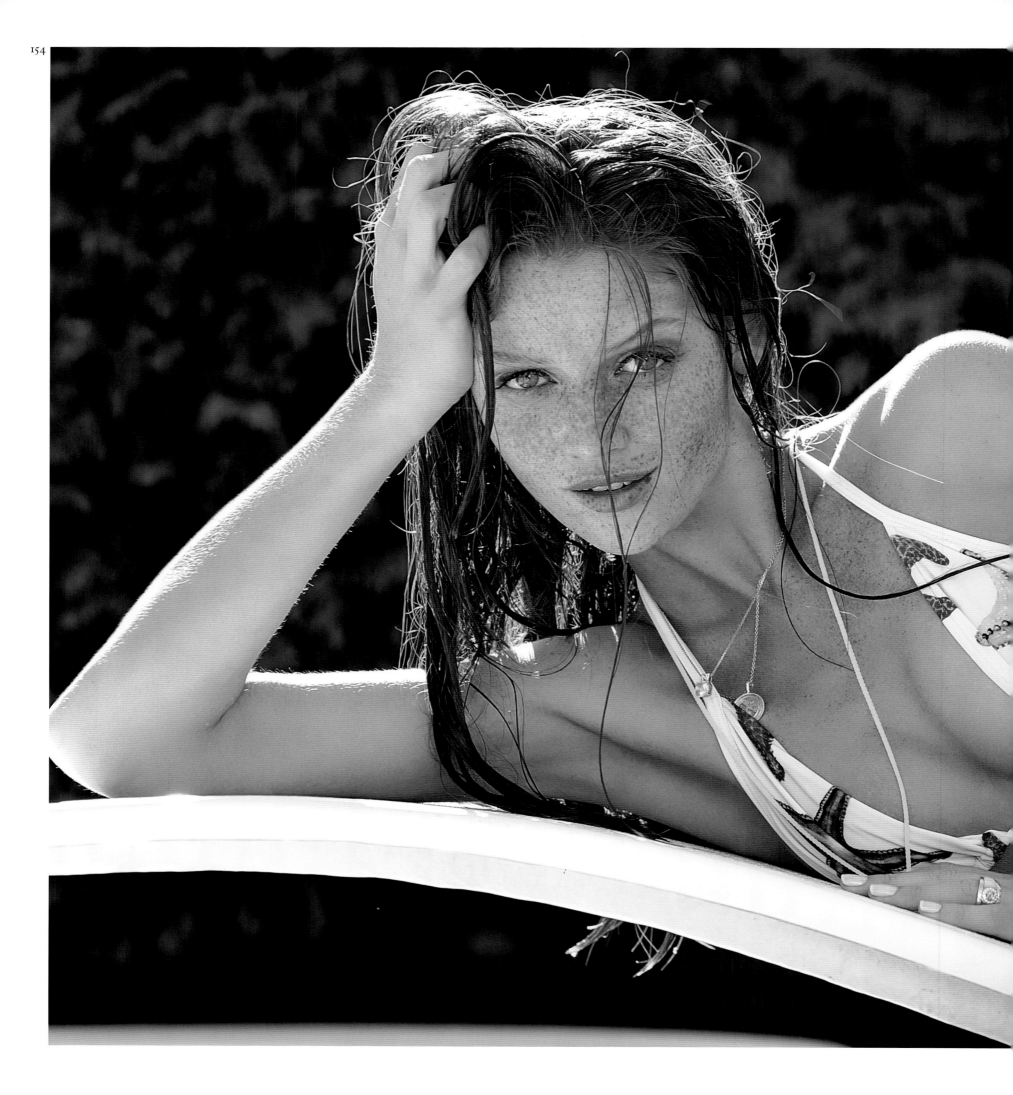

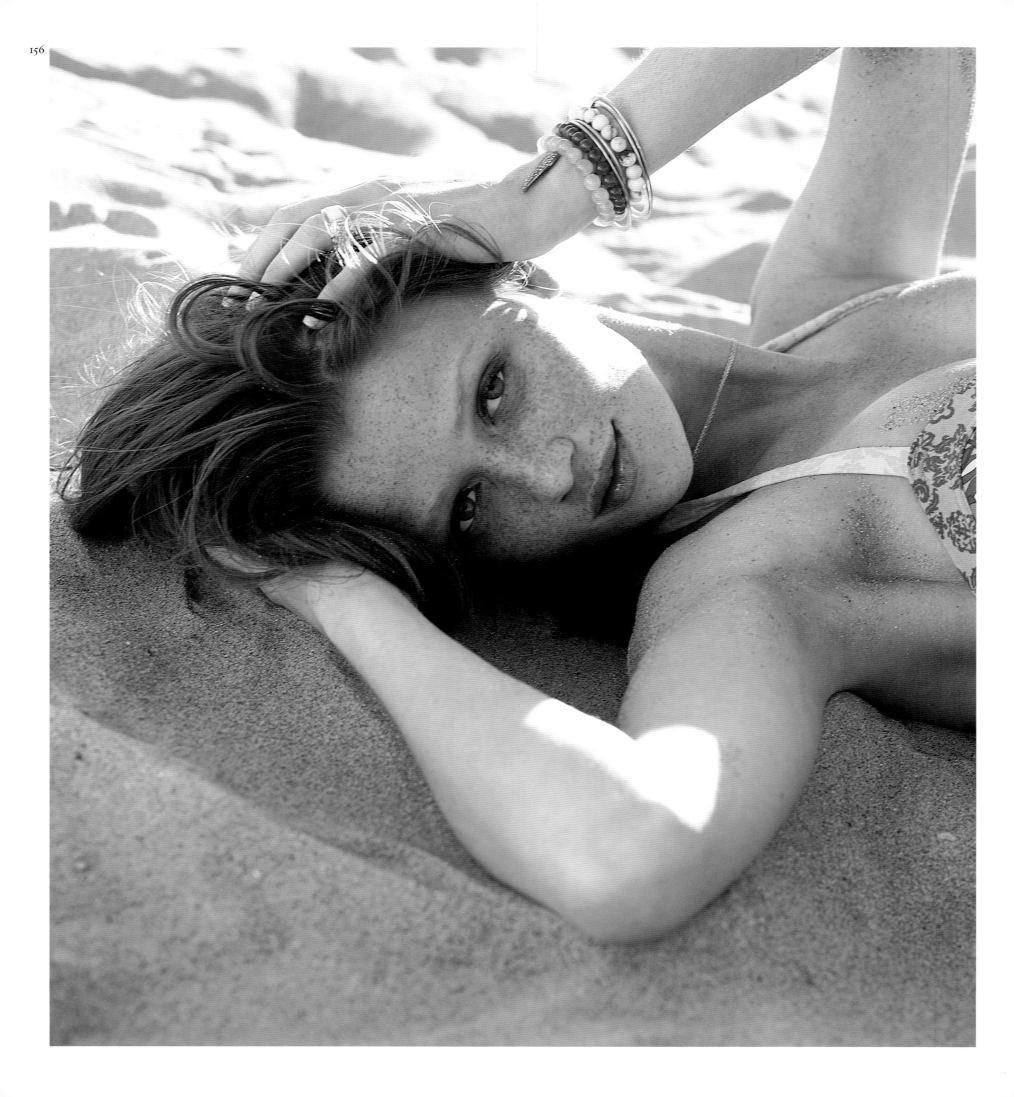

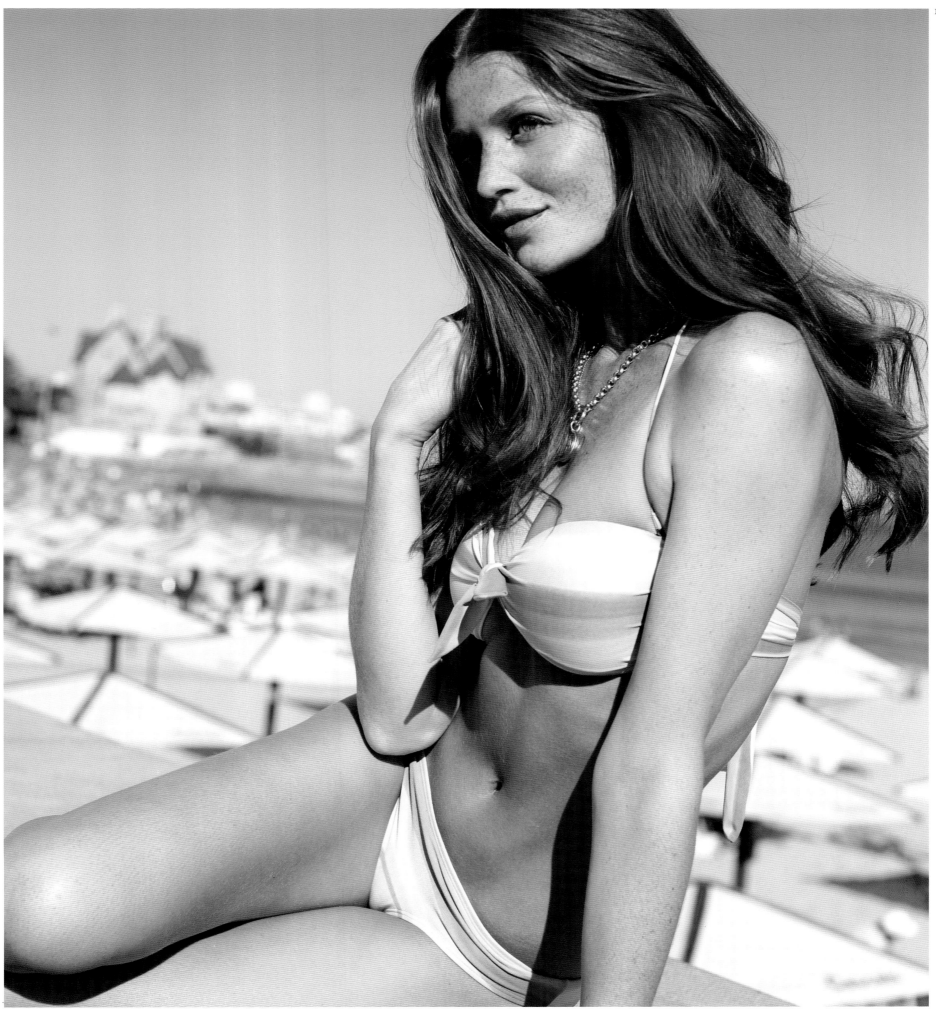

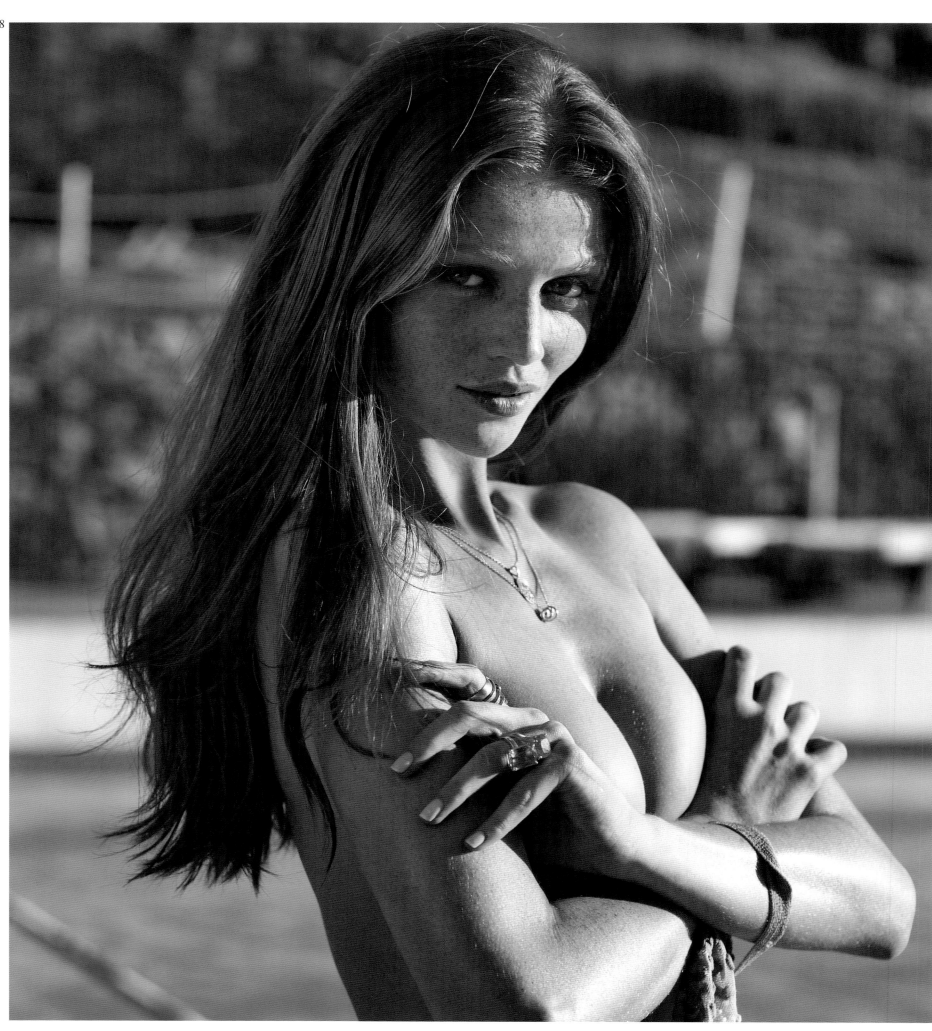

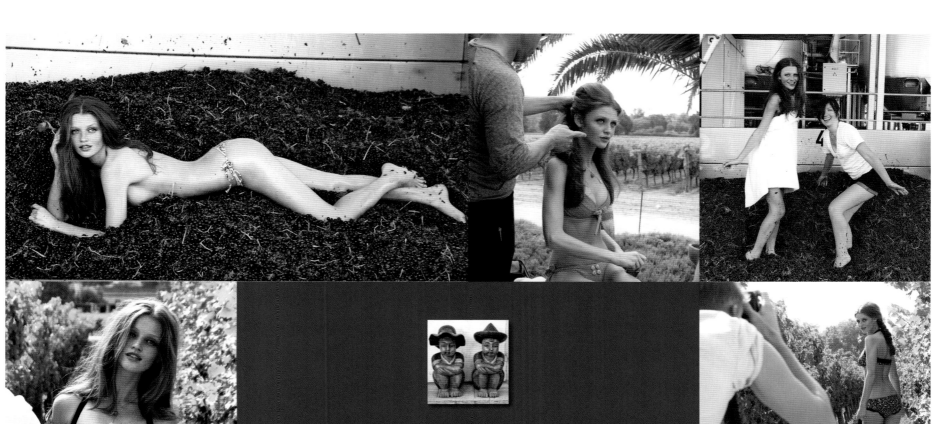

"One day we went to shoot at a winery. It was really interesting to see the process—I never imagined I'd be inside the room where they actually make the wine. There I was lying down with grapes all around me. It was really funny, really good for my skin, ha ha. That was my favorite photo of all—lots of fun, good energy, good people and a fabulous location. You can't go wrong with those things going for you. Plus, Stewart Shining can make anyone look beautiful naturally."

—CINTIA DICKER

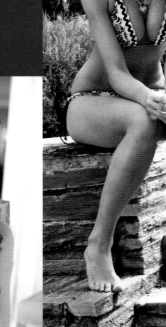

ZOE DUCHESNE | SAN PEDRO DE ATACAMA, CHILE

ZOE

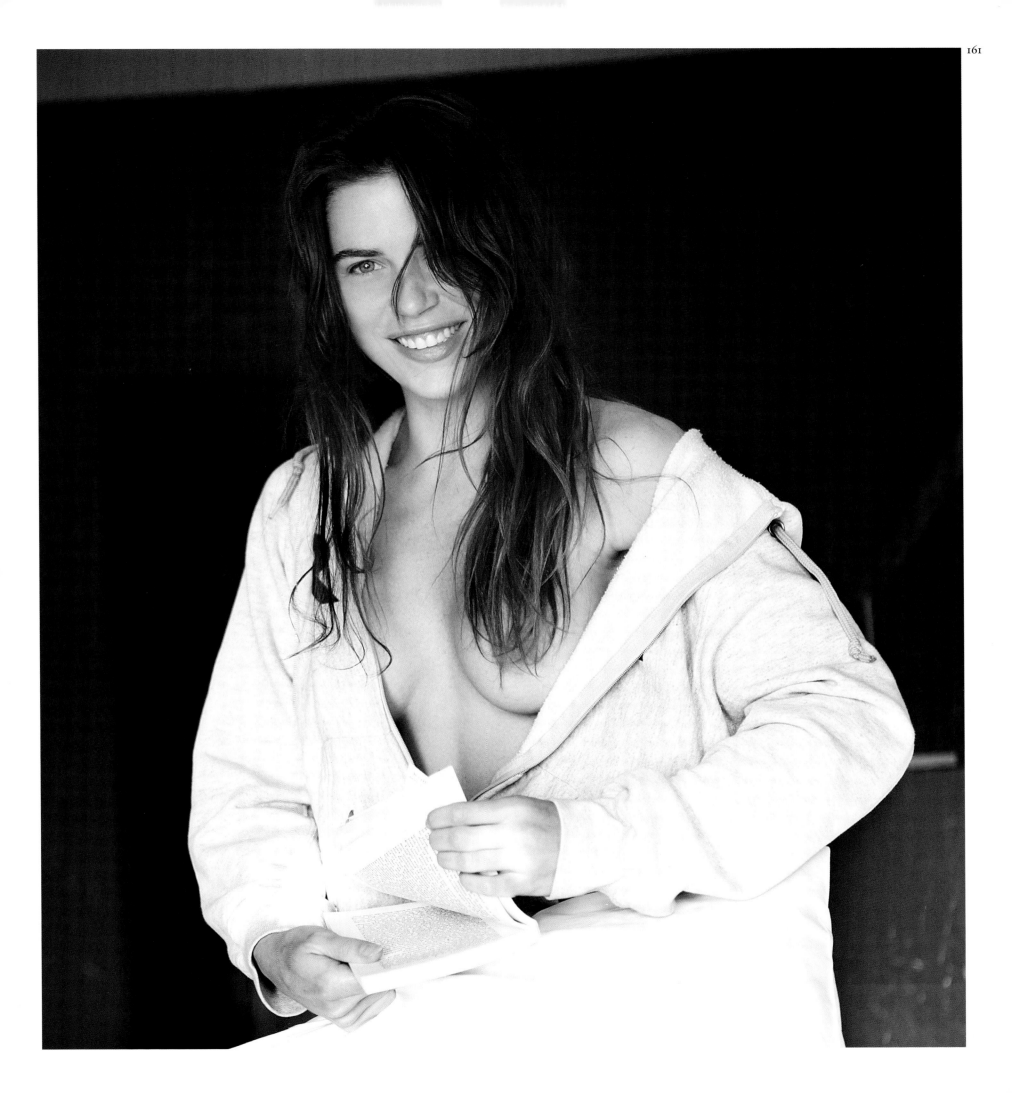

PORTFOLIO PHOTOGRAPHED ON LOCATION IN CHILE BY

RAPHAEL MAZZUCCO

*"Zoe and I are both Canadian—she's from Montreal and
I'm from Vancouver—and we've known each other for
a long time. The first time I photographed her was 10 years
ago in Costa Rica. She was very young, but from the first
moment I knew she would be a star. Her face is probably
one of the most incredible I have ever seen; it's simply timeless.
Zoe can be very funny, completely hilarious. She just
loves to joke around. That makes it easy to take pictures,
especially when you are traveling in the middle of nowhere
for a couple of days. I feel that Zoe is one of those girls
whose looks could translate well onto film. She could be
an old-time movie star. She just has style."*

—Raphael Mazzucco

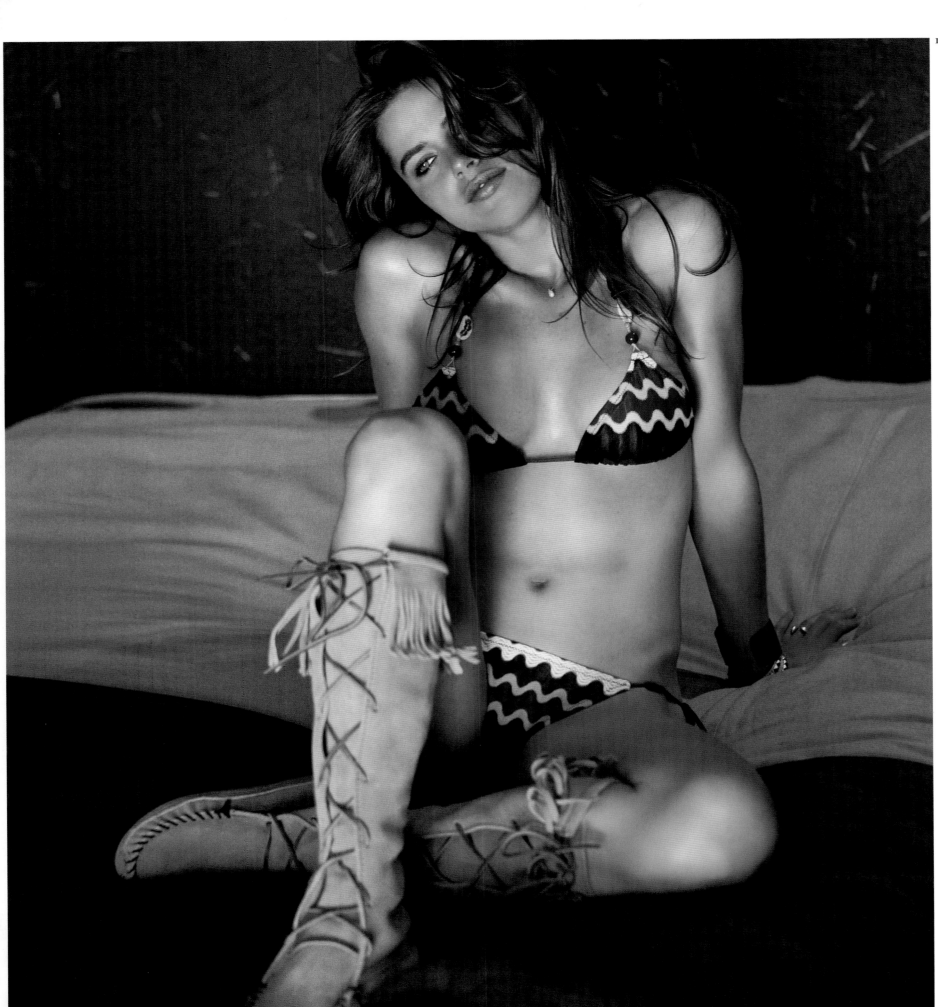

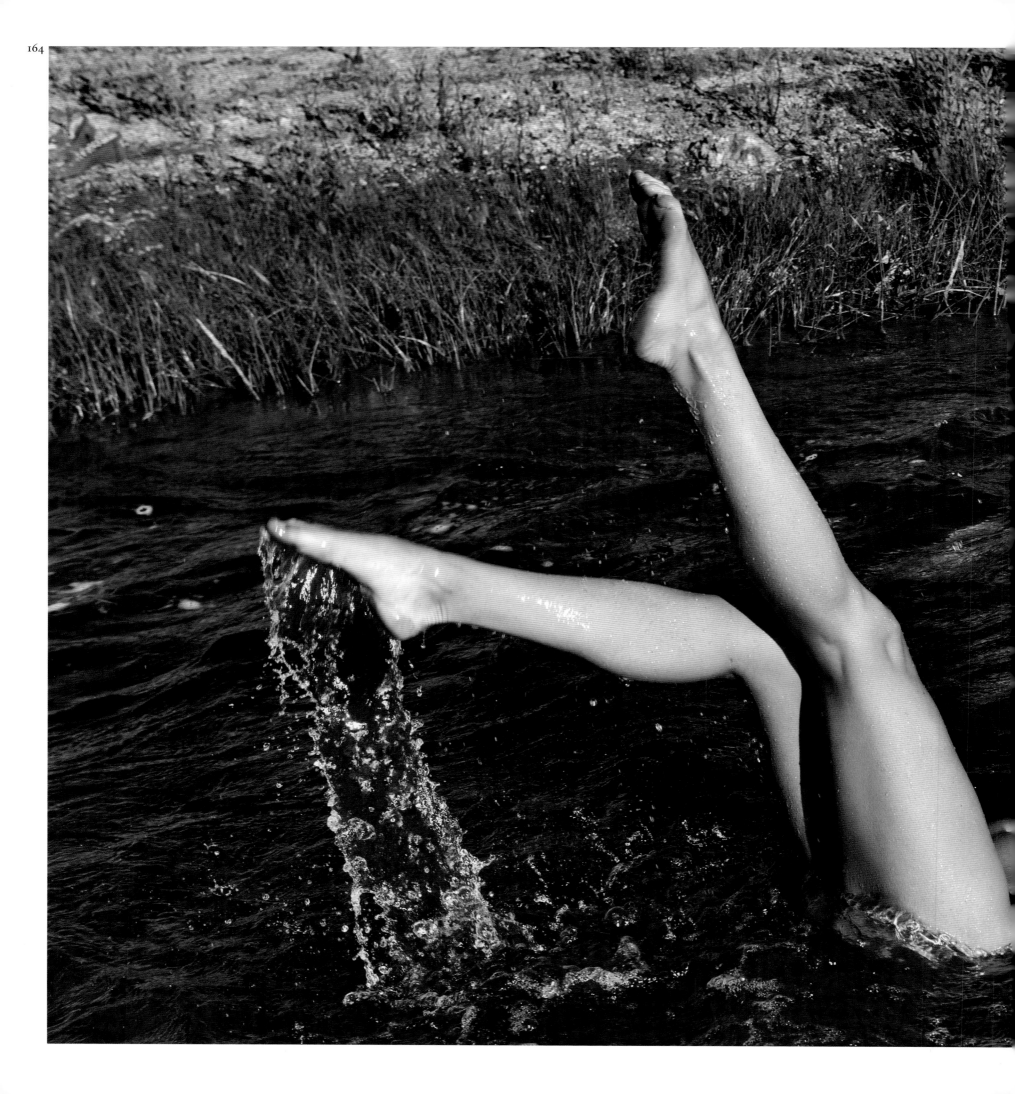

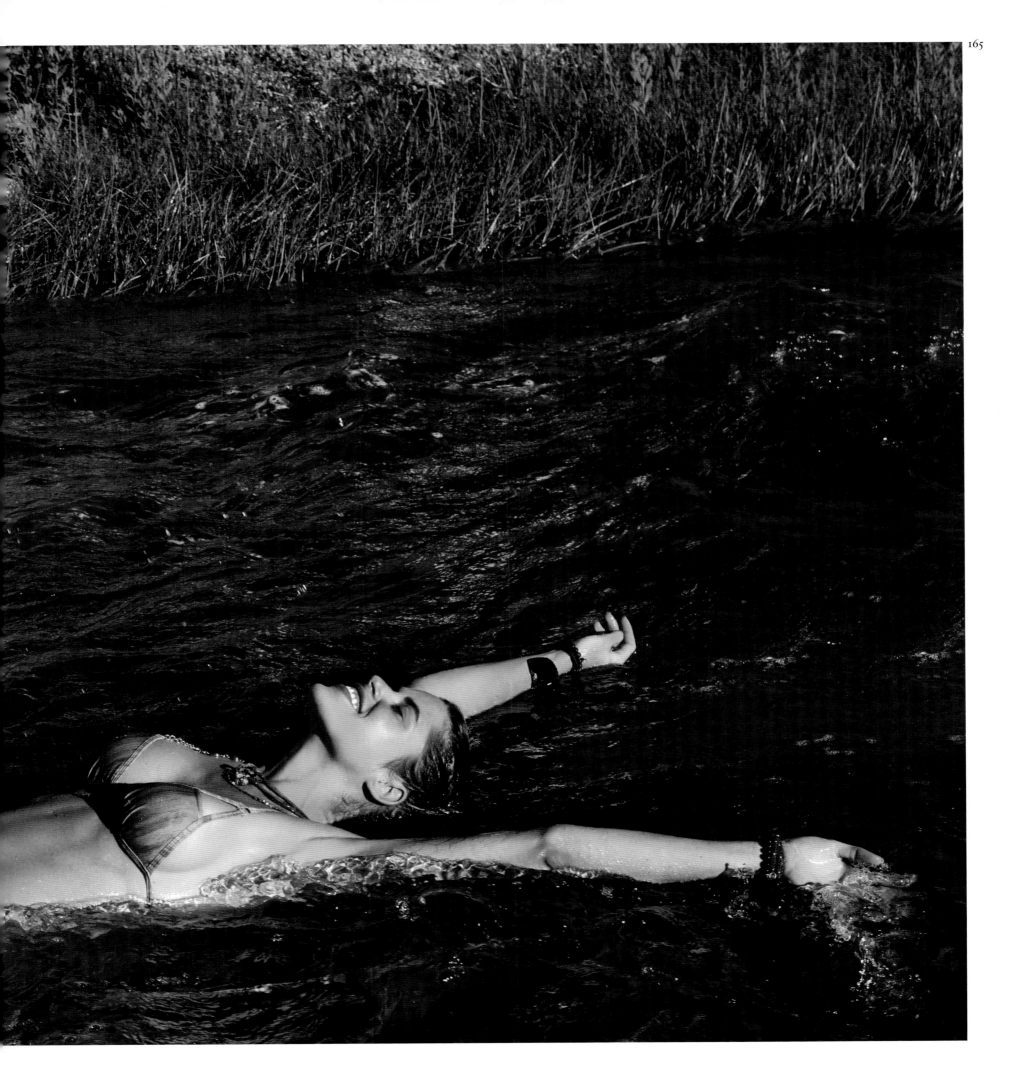

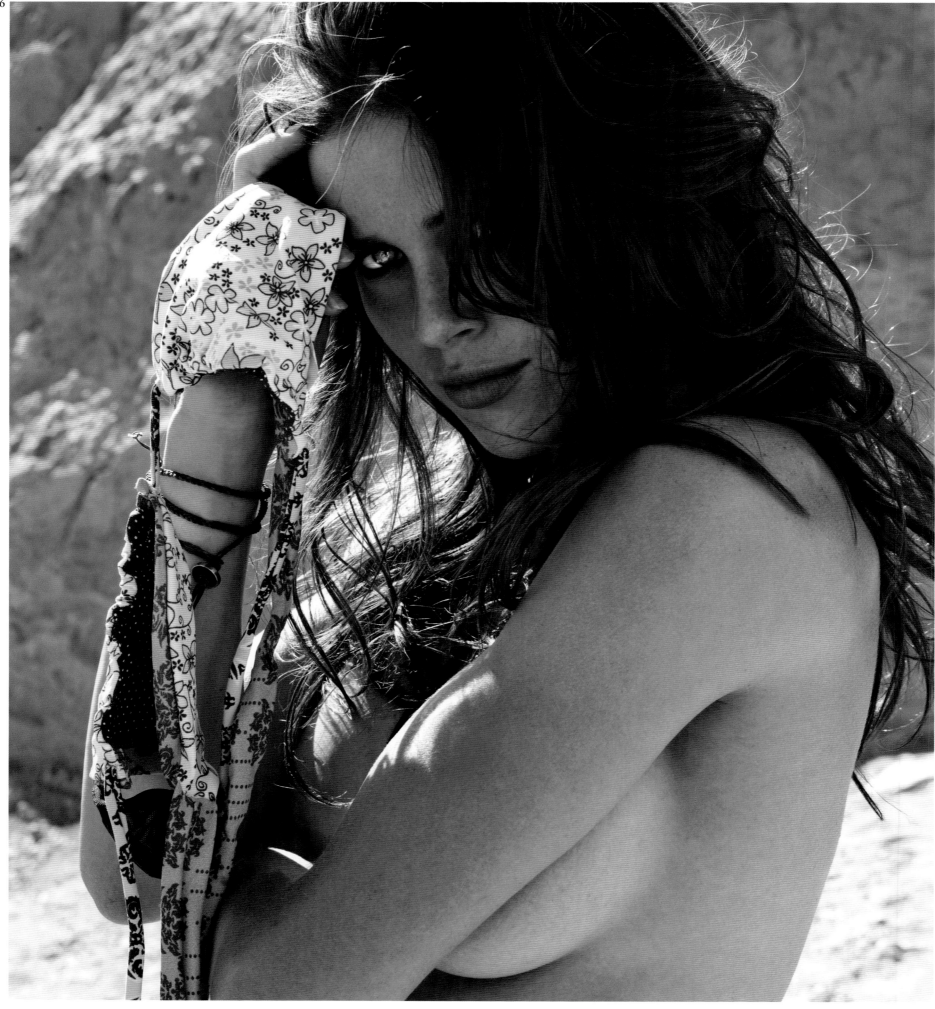

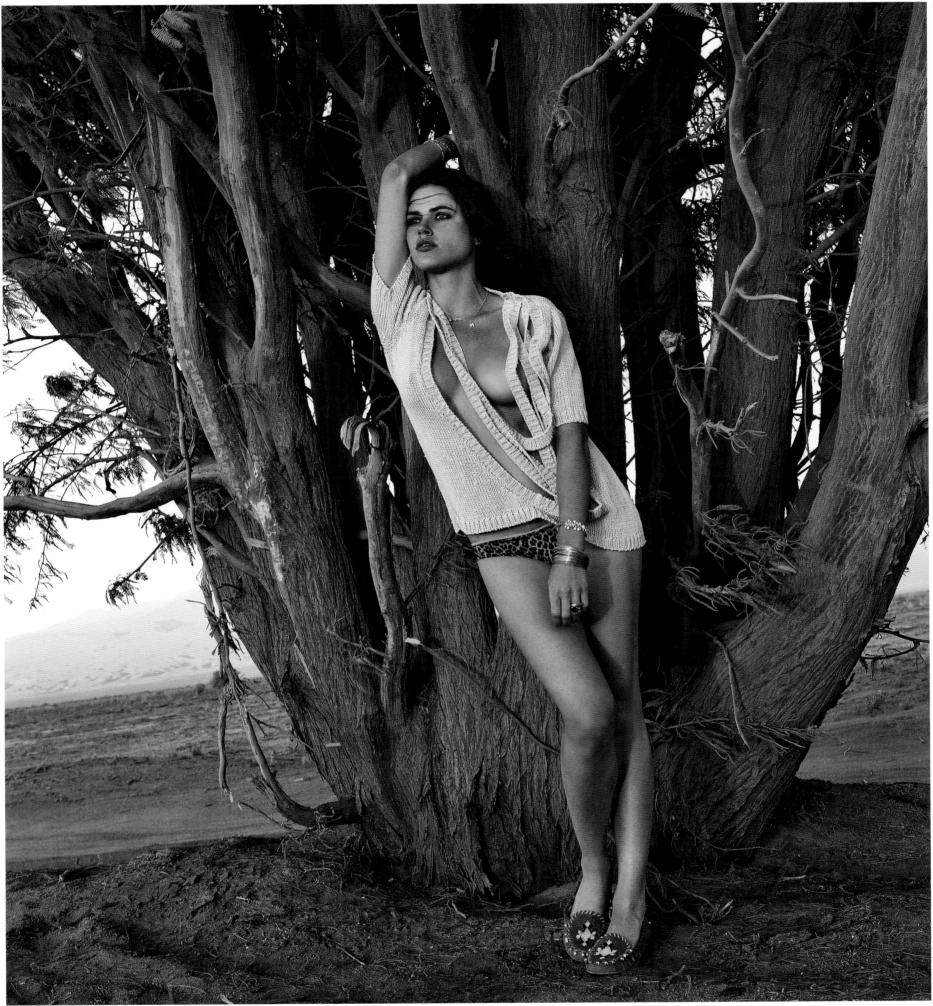

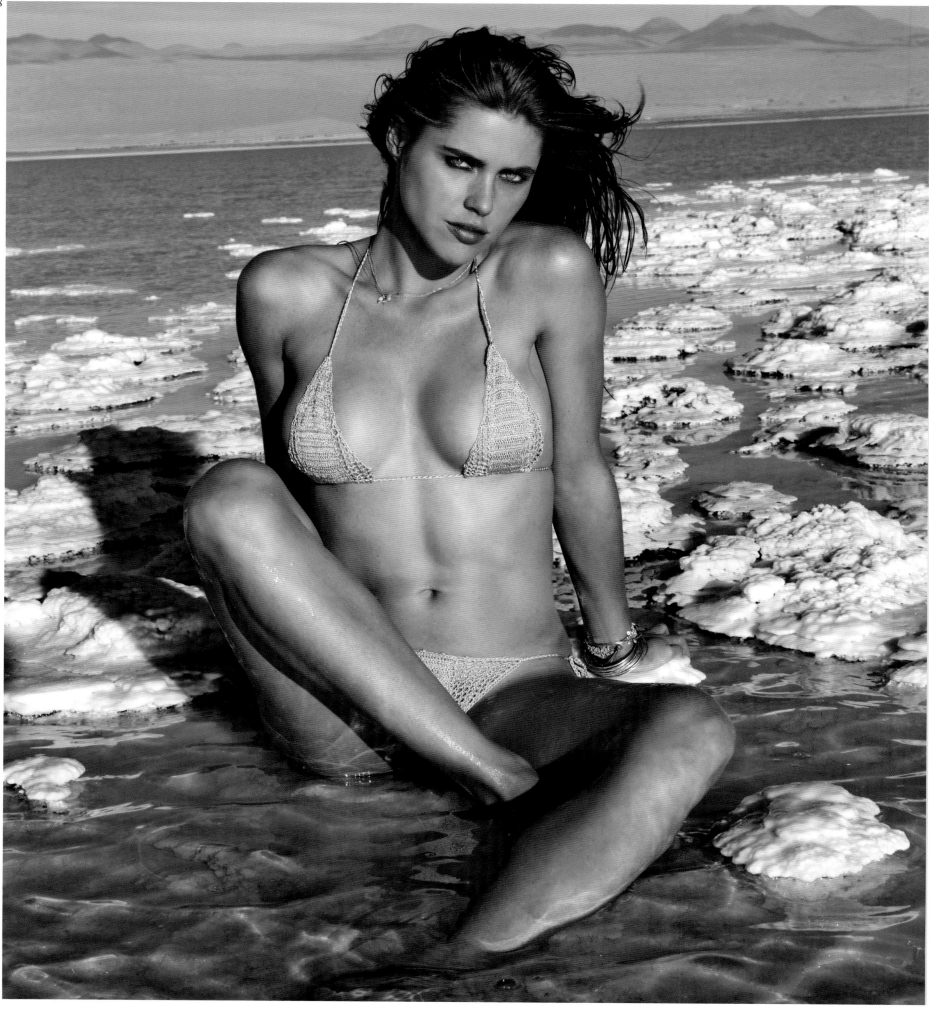

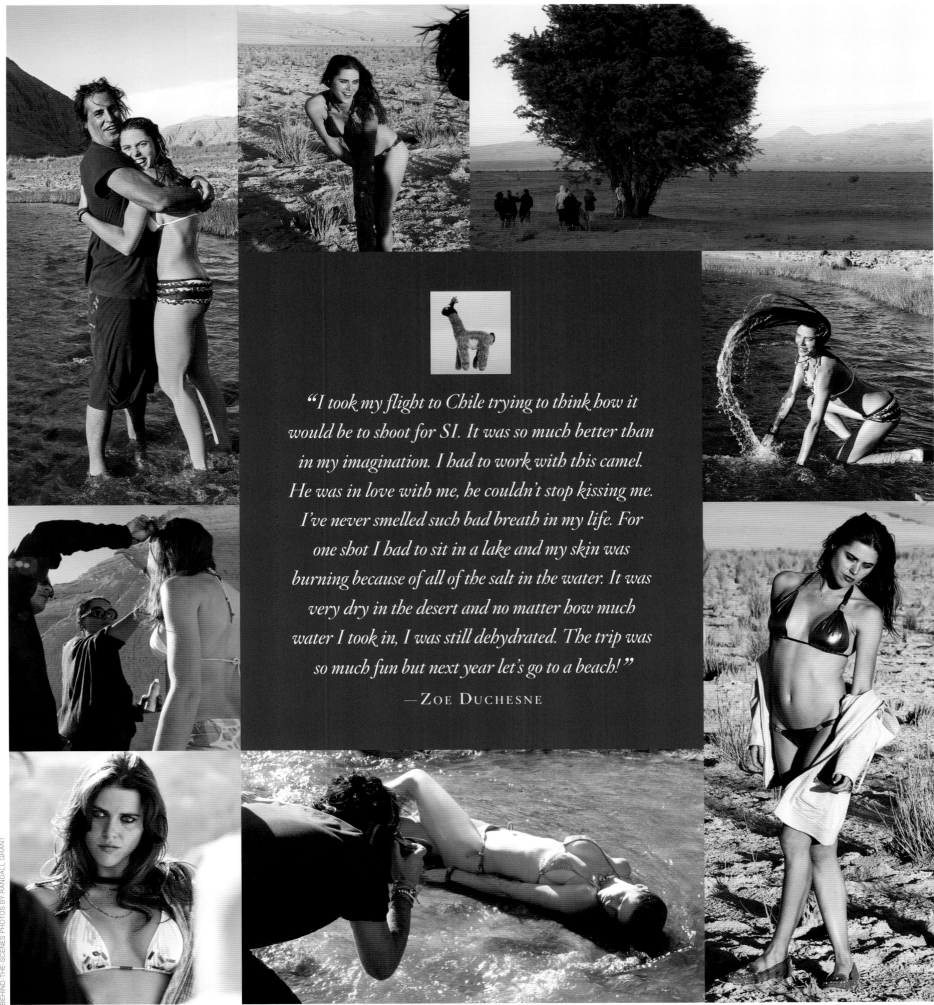

"*I took my flight to Chile trying to think how it would be to shoot for SI. It was so much better than in my imagination. I had to work with this camel. He was in love with me, he couldn't stop kissing me. I've never smelled such bad breath in my life. For one shot I had to sit in a lake and my skin was burning because of all of the salt in the water. It was very dry in the desert and no matter how much water I took in, I was still dehydrated. The trip was so much fun but next year let's go to a beach!*"

—ZOE DUCHESNE

BEHIND-THE-SCENES PHOTOS BY RANDALL GRANT

JULIE ORDON | RAJASTHAN, INDIA

JULIE

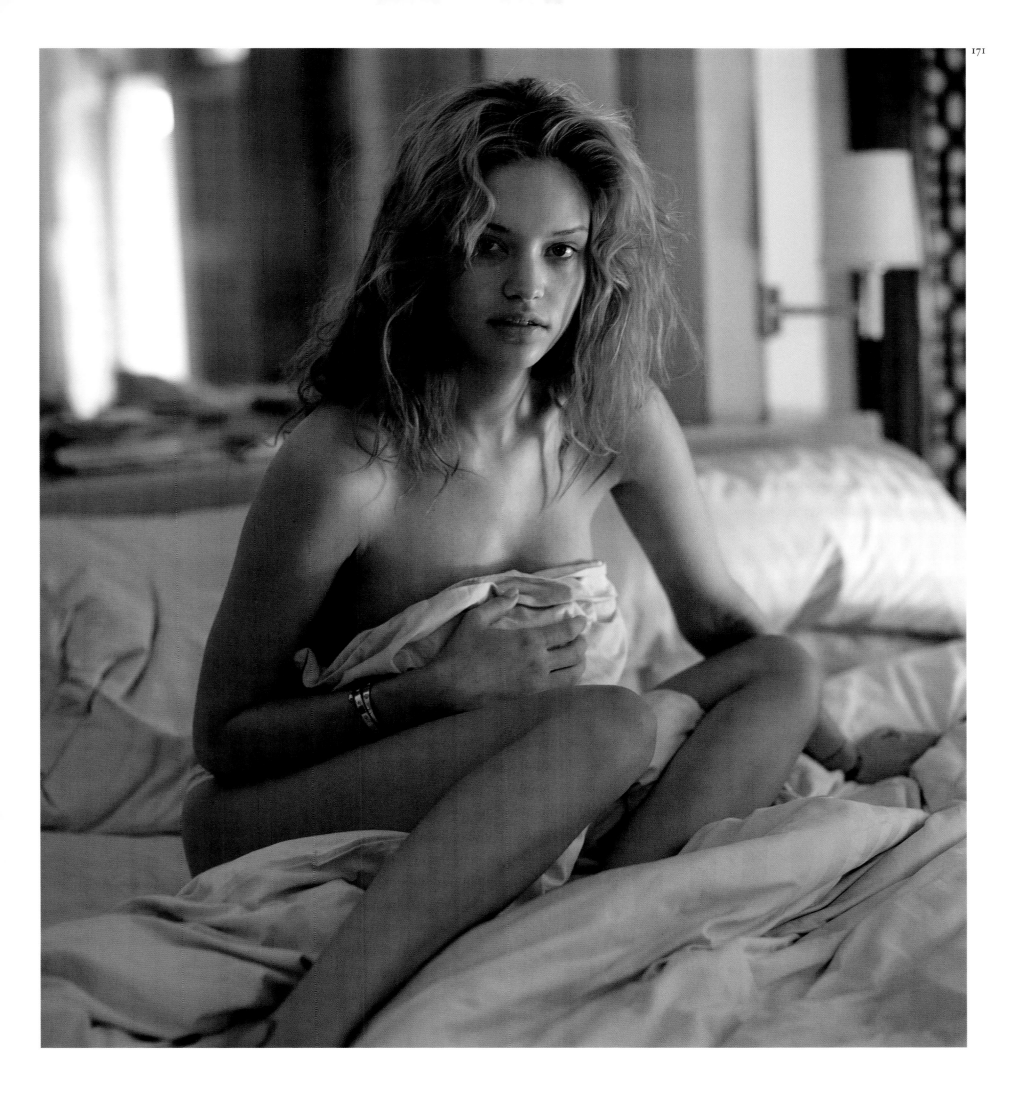

PORTFOLIO PHOTOGRAPHED ON LOCATION IN INDIA BY

RICCARDO TINELLI

" Julie is a really interesting piece of girl. She knows what she wants and she is in control of any situation. She went to the casting of the Swimsuit Issue pregnant. I mean, there are millions of girls who want this job and she got it after going to the casting pregnant. After she delivered her daughter, she got her body back really fast. Our shoot was in, like, two months. There is only one Julie Ordon in the world, I can assure you. Only one. She makes things happen around her. She is always relaxed but she gets what she needs. People say she reminds them of Brigitte Bardot and I agree. She just has The Face. She has presence in the camera. Some people stumble on the lens but Julie goes through it. "

—RICCARDO TINELLI

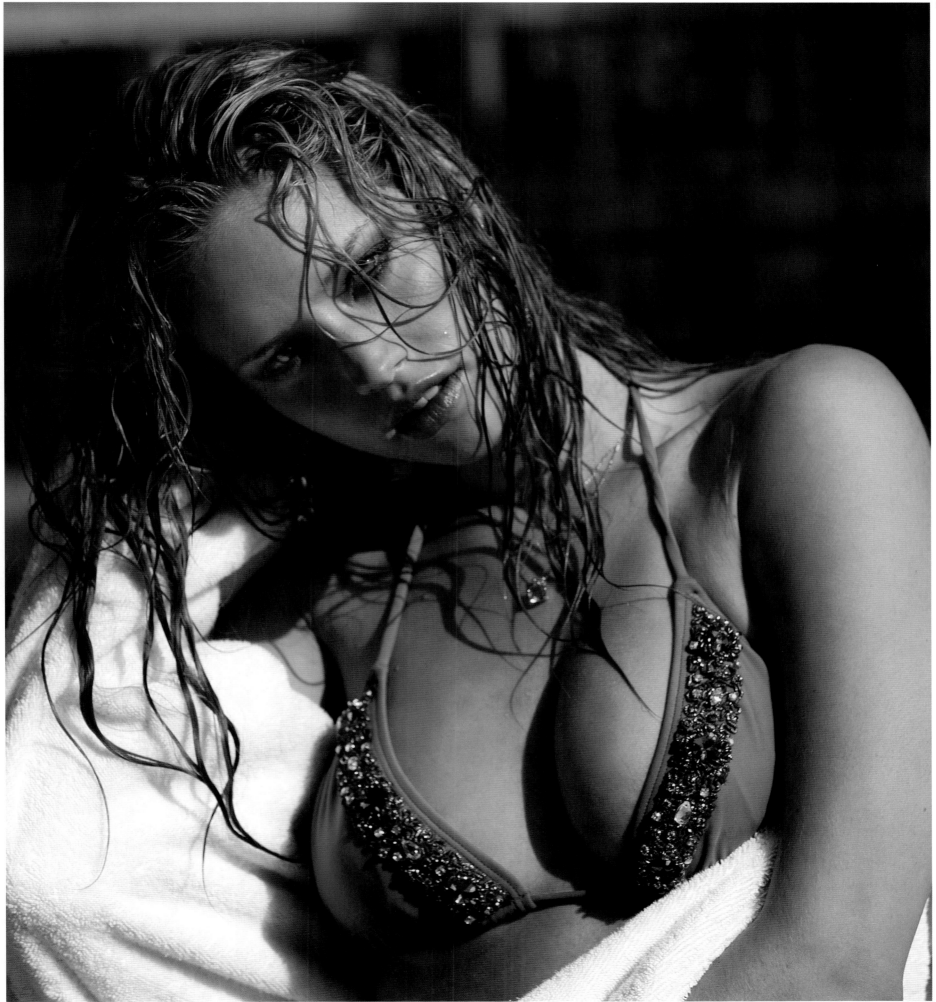

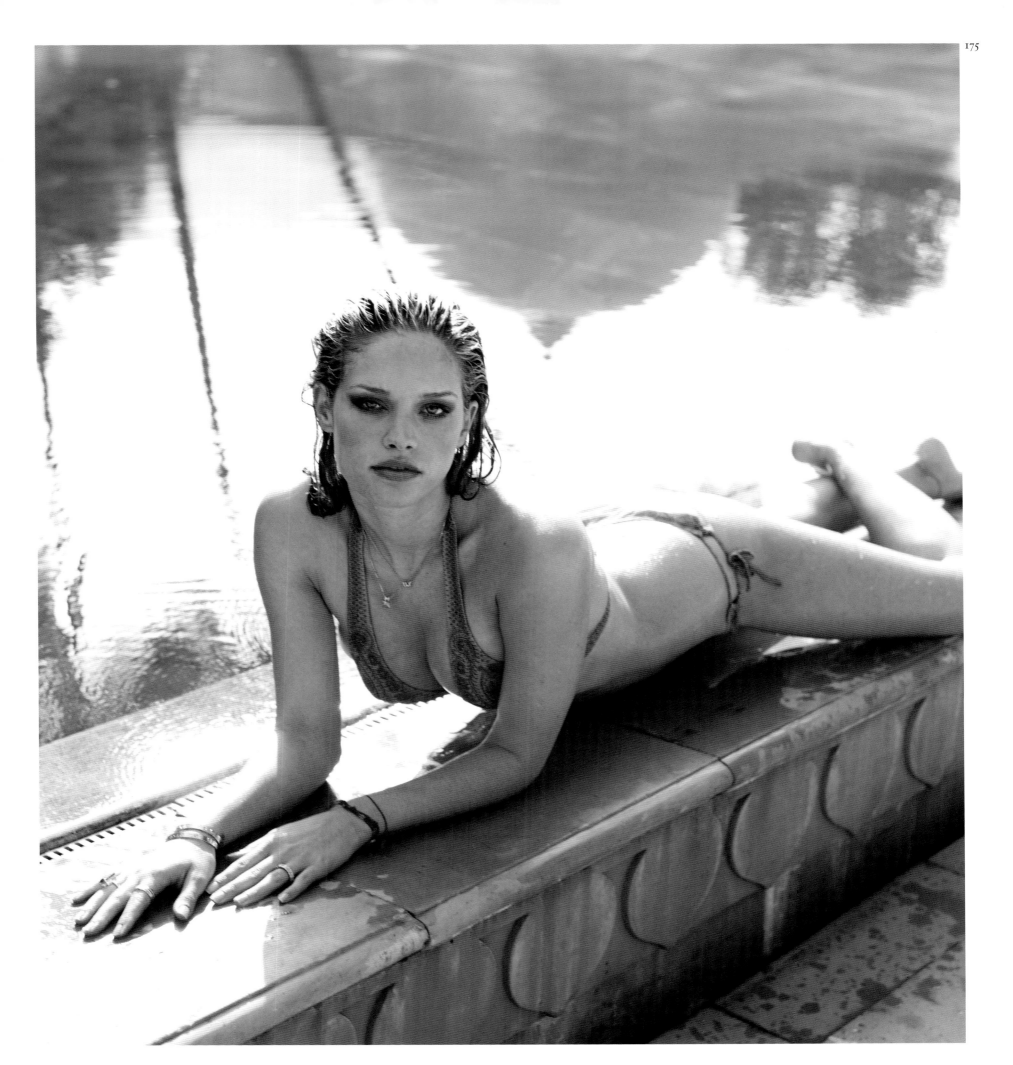

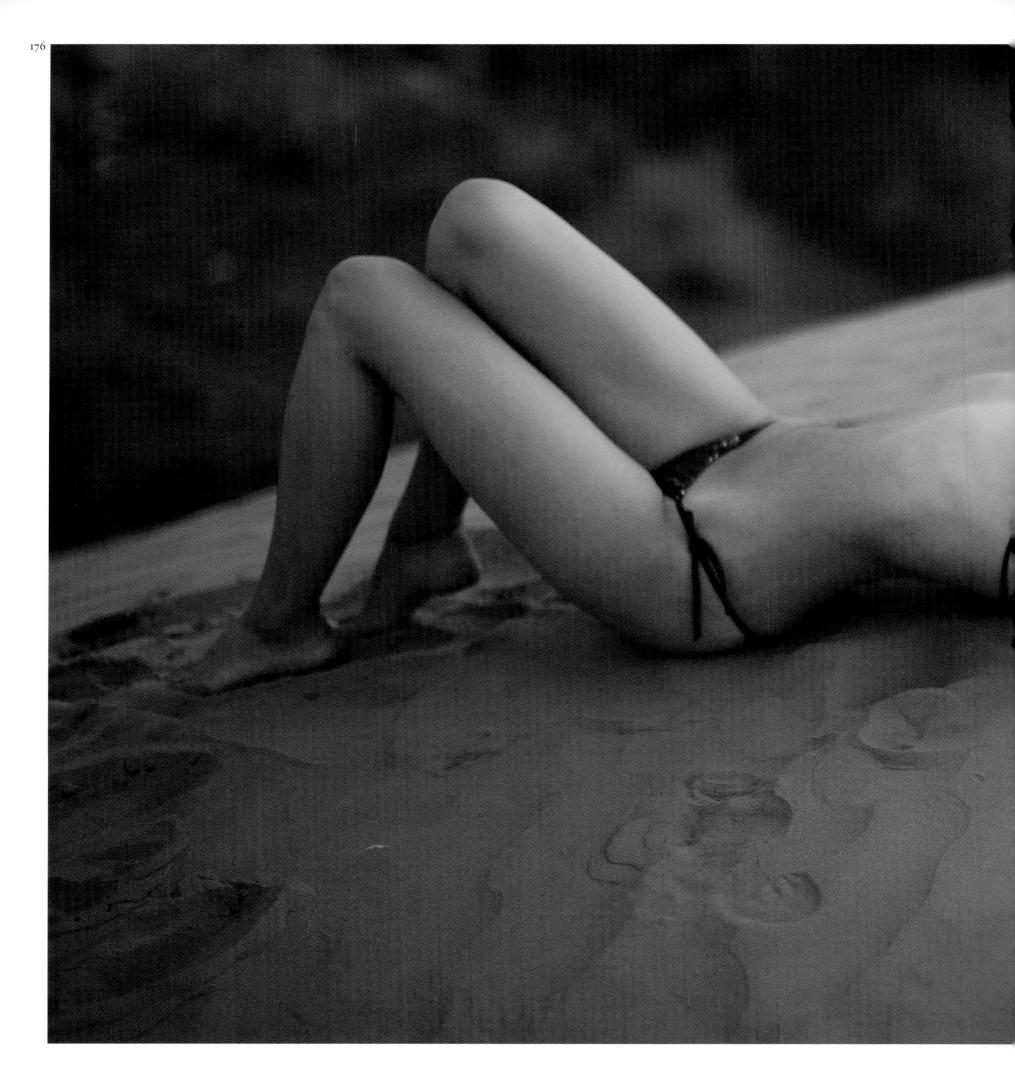

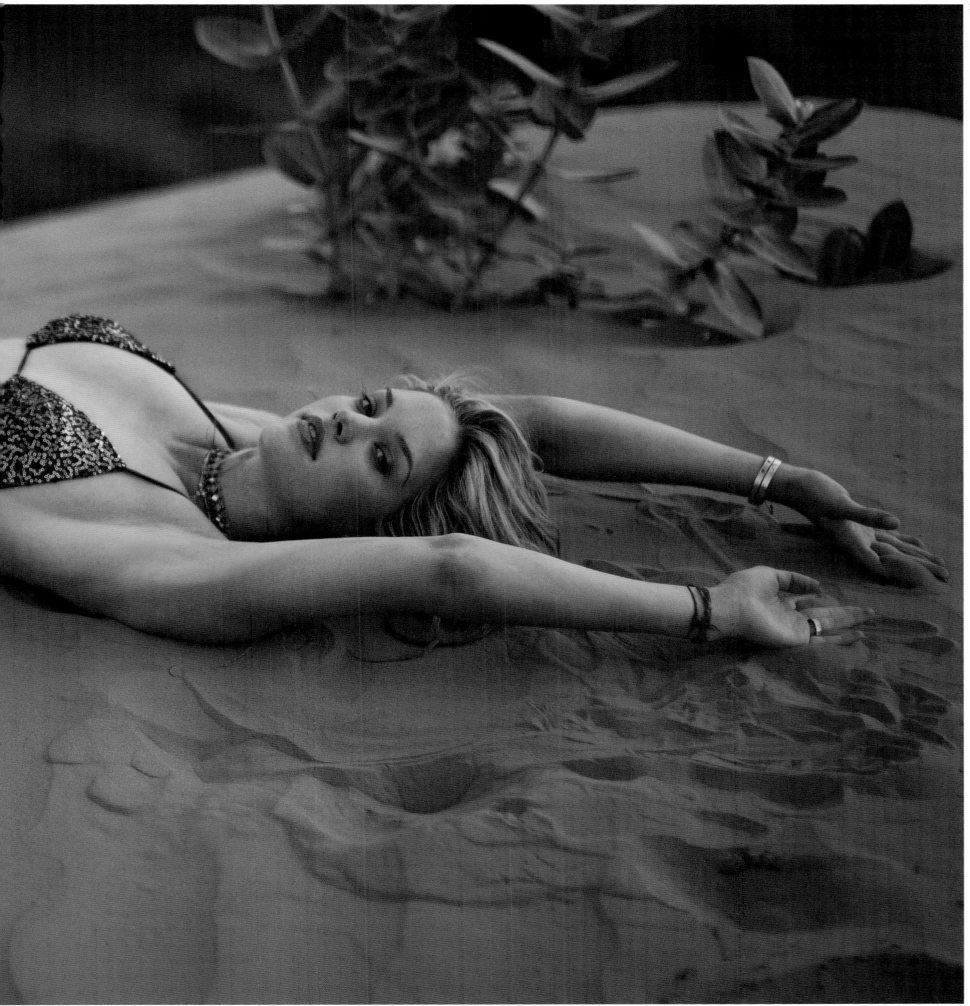

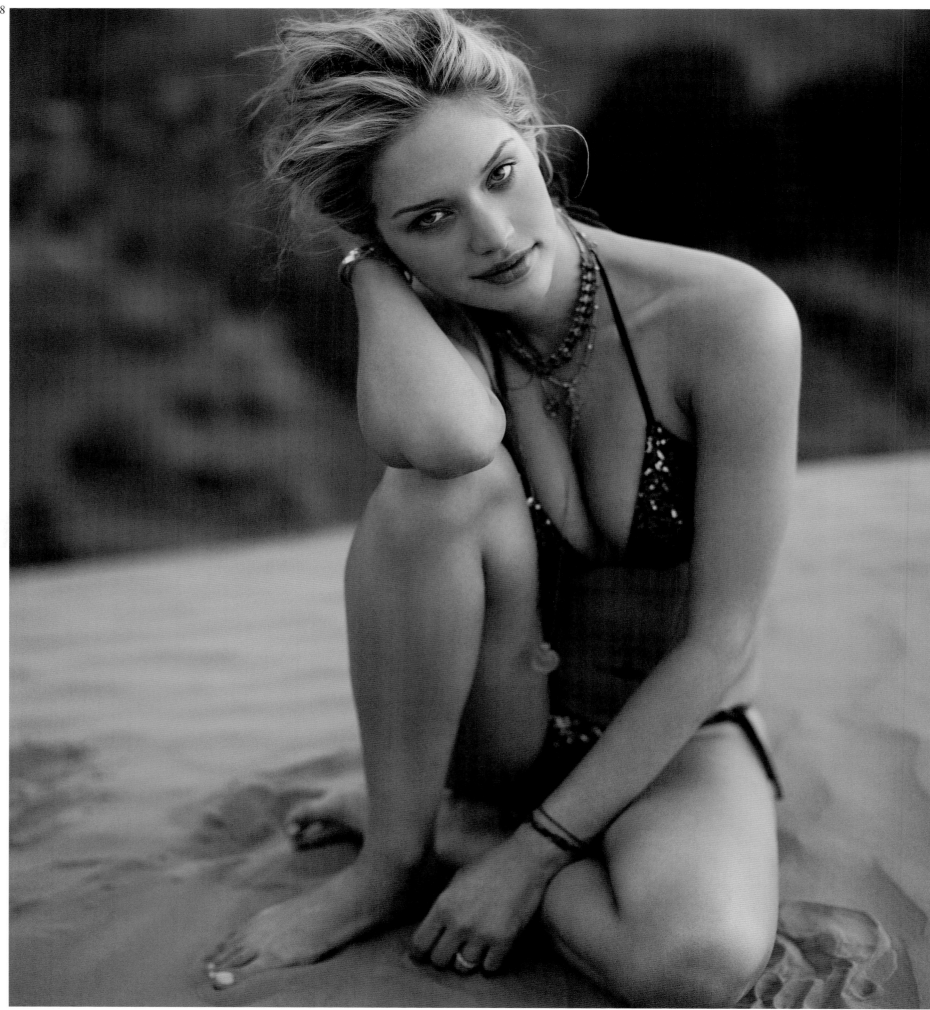

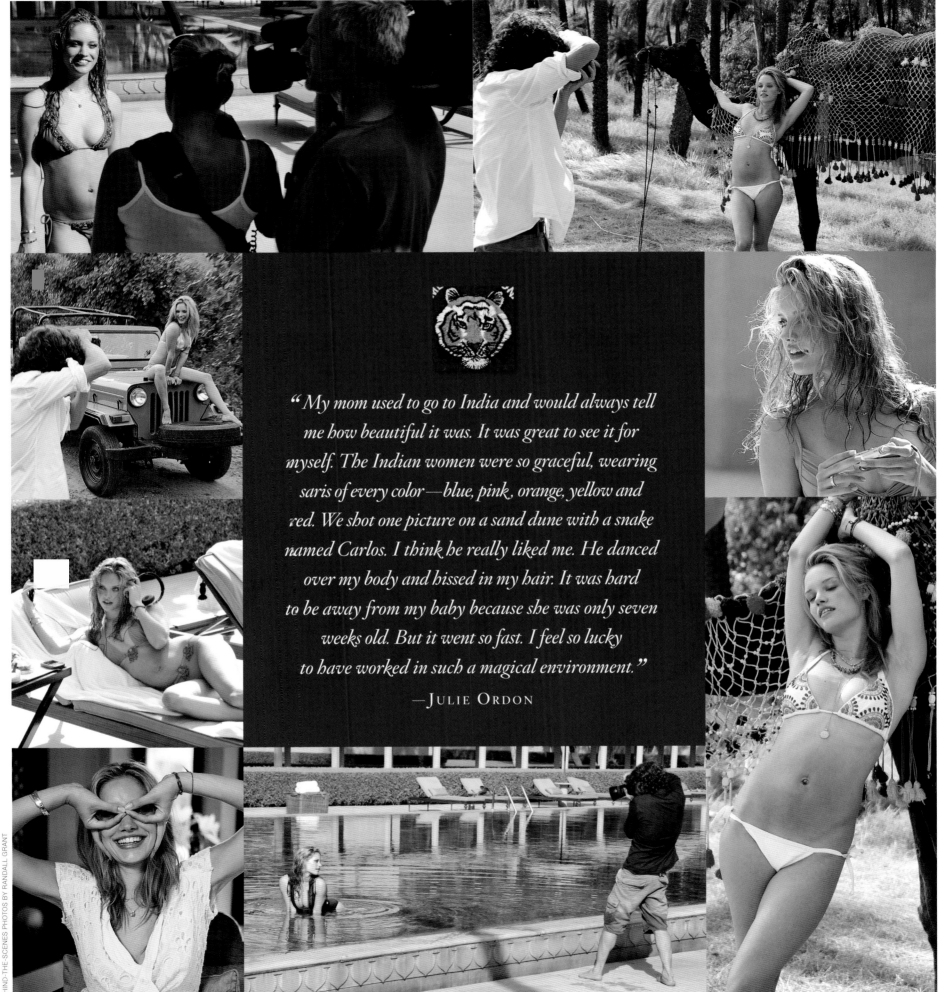

"*My mom used to go to India and would always tell me how beautiful it was. It was great to see it for myself. The Indian women were so graceful, wearing saris of every color—blue, pink, orange, yellow and red. We shot one picture on a sand dune with a snake named Carlos. I think he really liked me. He danced over my body and hissed in my hair. It was hard to be away from my baby because she was only seven weeks old. But it went so fast. I feel so lucky to have worked in such a magical environment.*"

—Julie Ordon

BEHIND-THE-SCENES PHOTOS BY RANDALL GRANT

BROOKLYN DECKER | SOUTH MALÉ ATOLL, MALDIVES

BROOKLYN

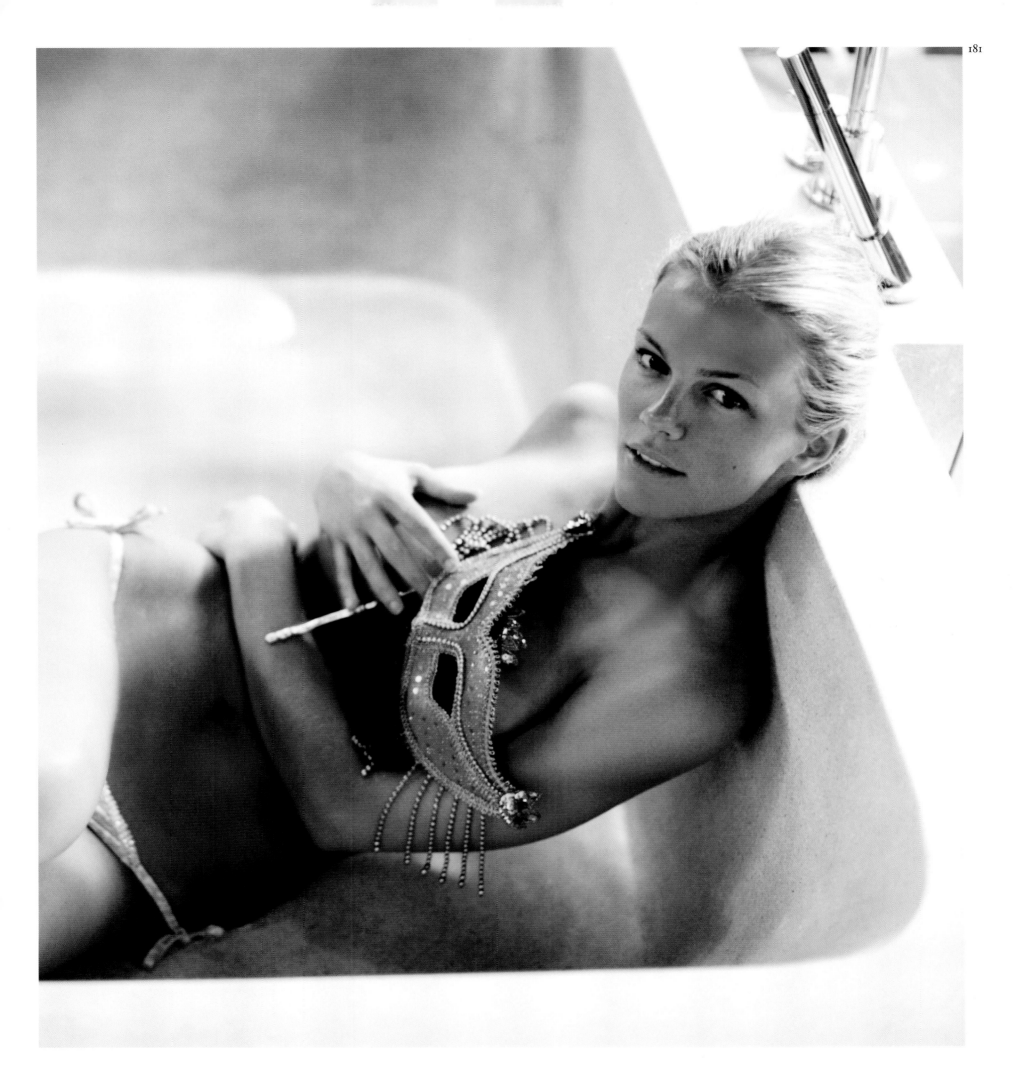

PORTFOLIO PHOTOGRAPHED ON LOCATION IN THE MALDIVES BY

WALTER IOOSS JR.

" I always say Brooklyn Decker is the real deal. If Brooklyn looked like Janet Reno, you would still love her. She's fun. She has so much going on. She's just a gorgeous girl with a great spirit. She was nervous on the shoot because she knew this was her year. She just sensed it. There was this little tiny island we nicknamed Cover Try Island. We went out there twice with Brooklyn, but it turned out the best shots came when we weren't thinking about the cover. The cover actually came out of the second shoot on the first day. Brooklyn is like Magic Johnson. As great as an athlete as he was, it was his personality that made him so interesting. He was so charismatic. It's the same with Brooklyn."

—WALTER IOOSS JR.

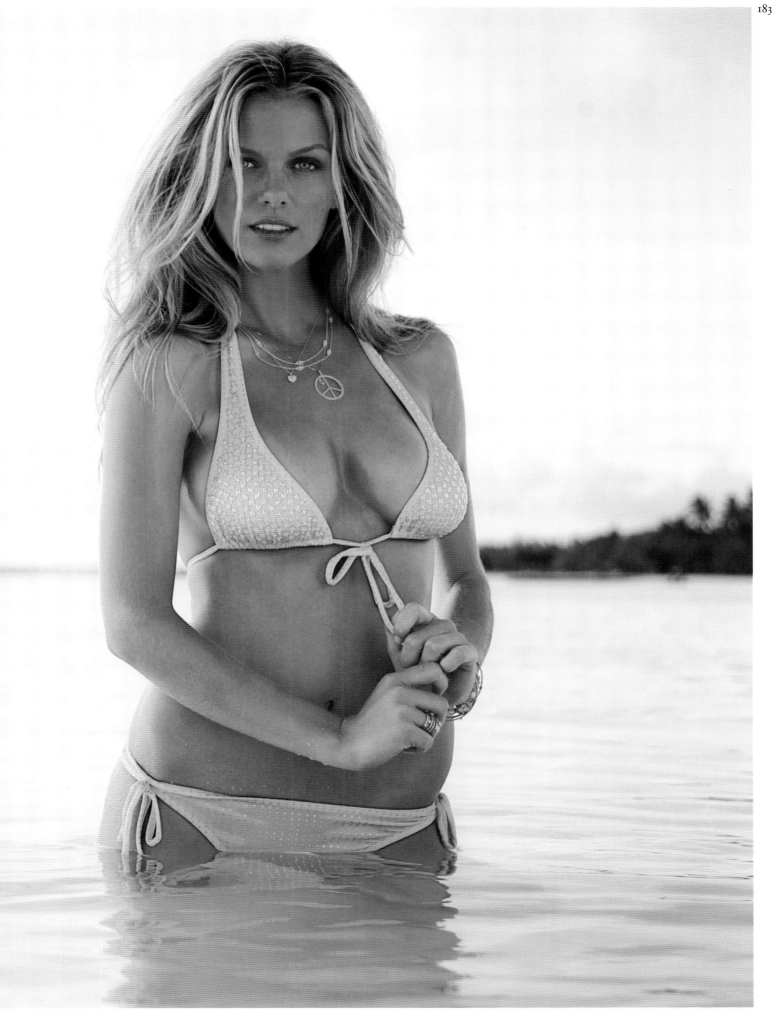

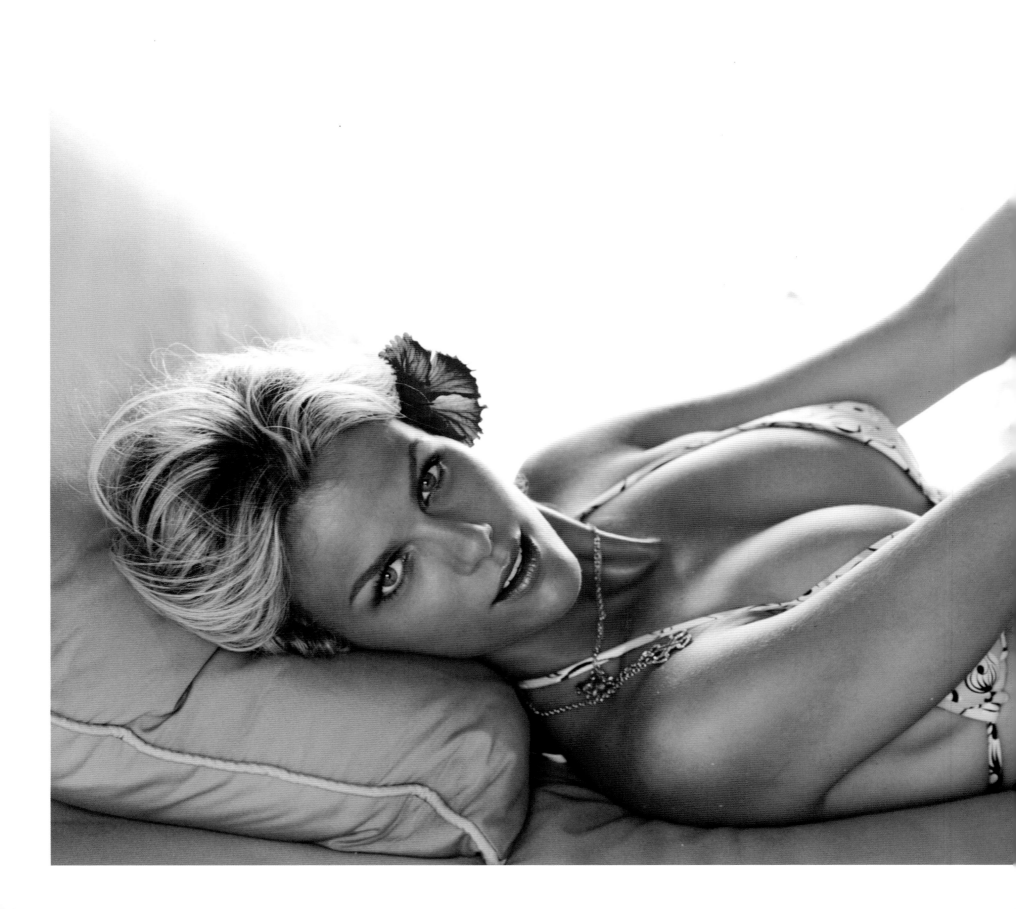

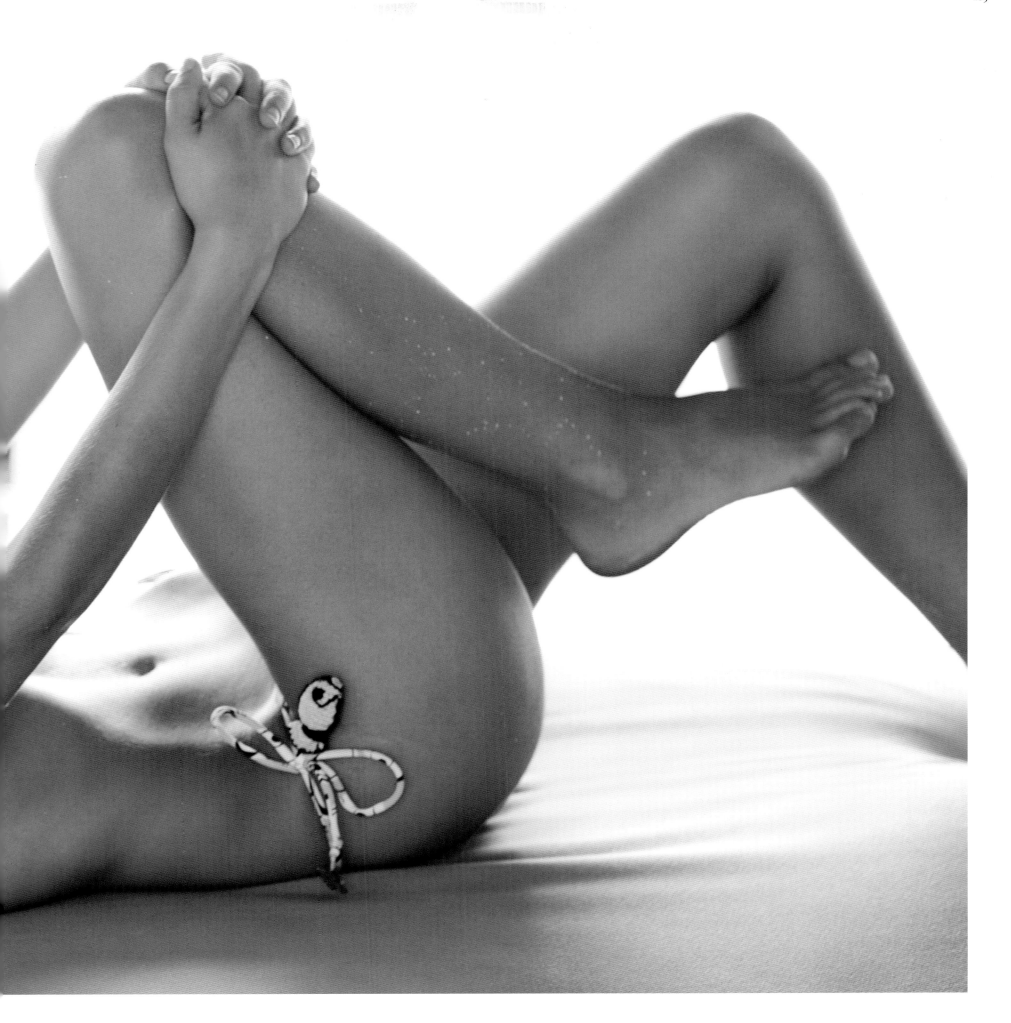

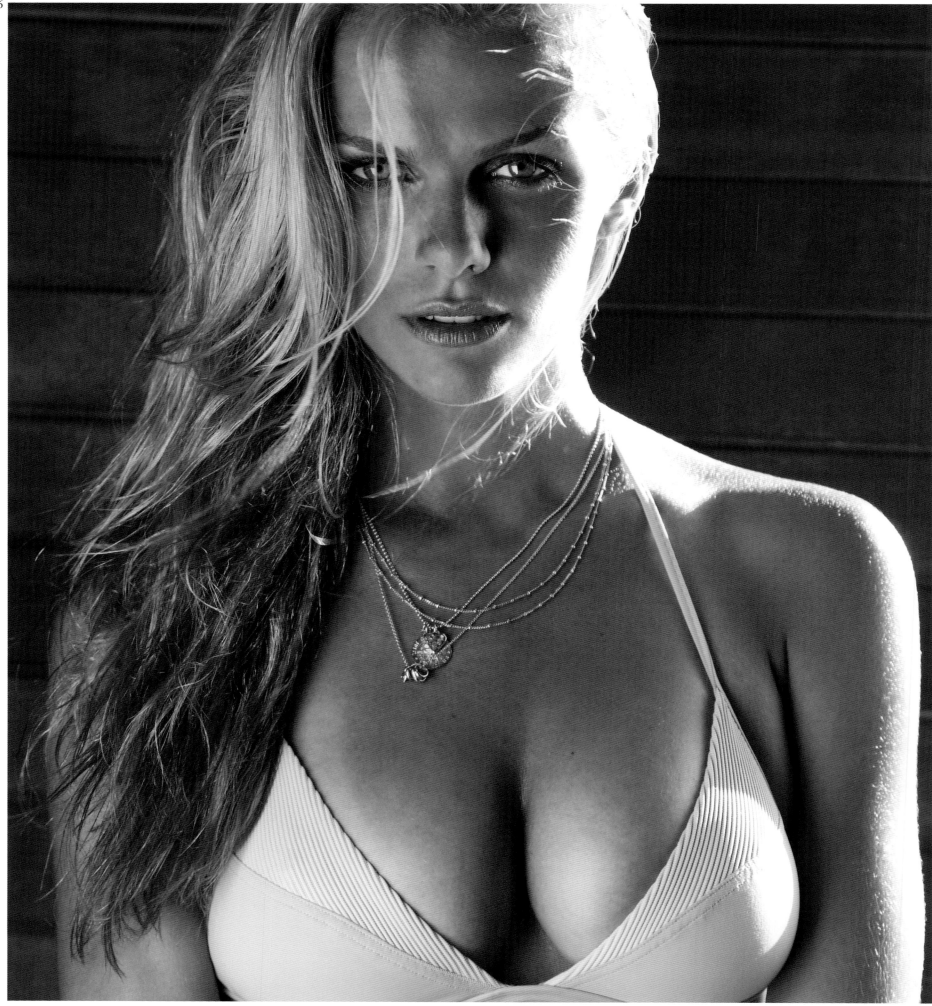

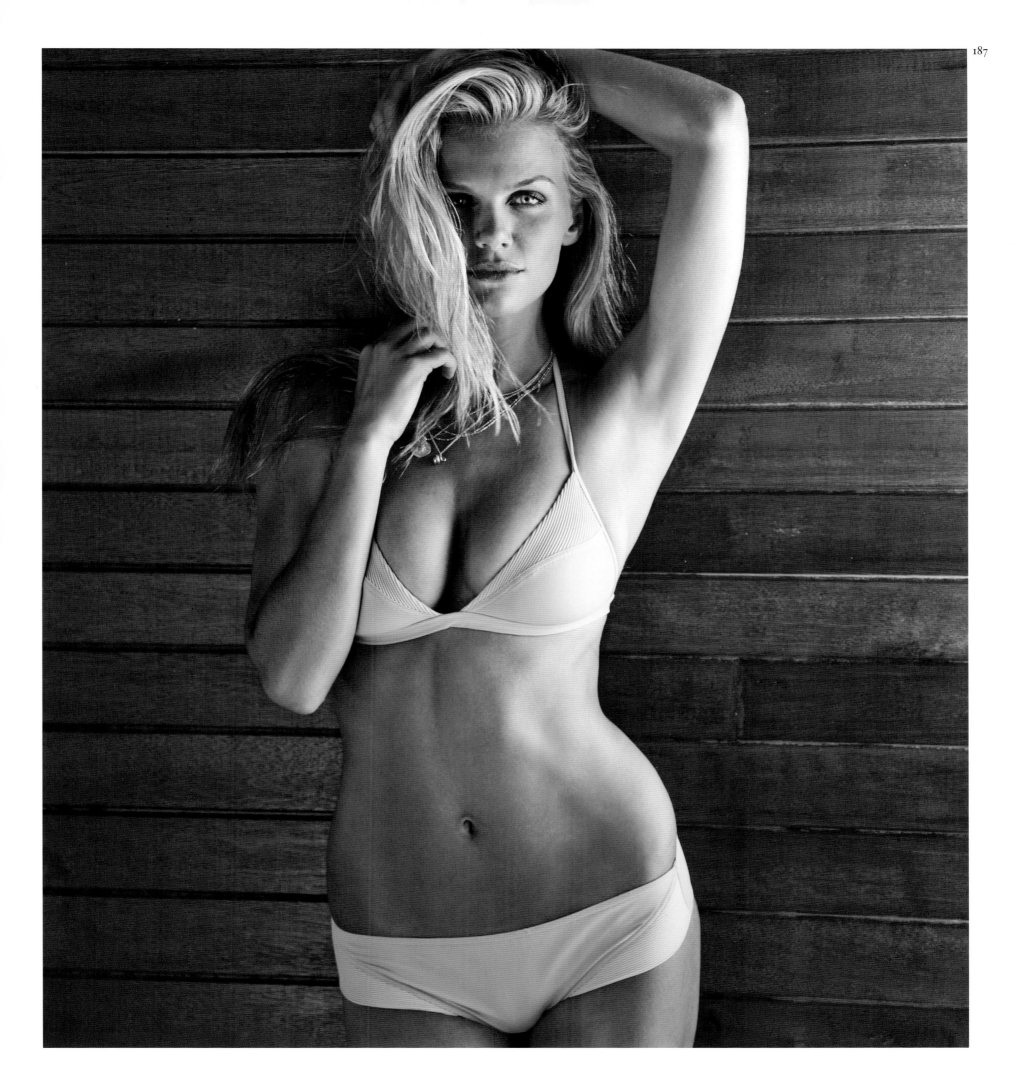

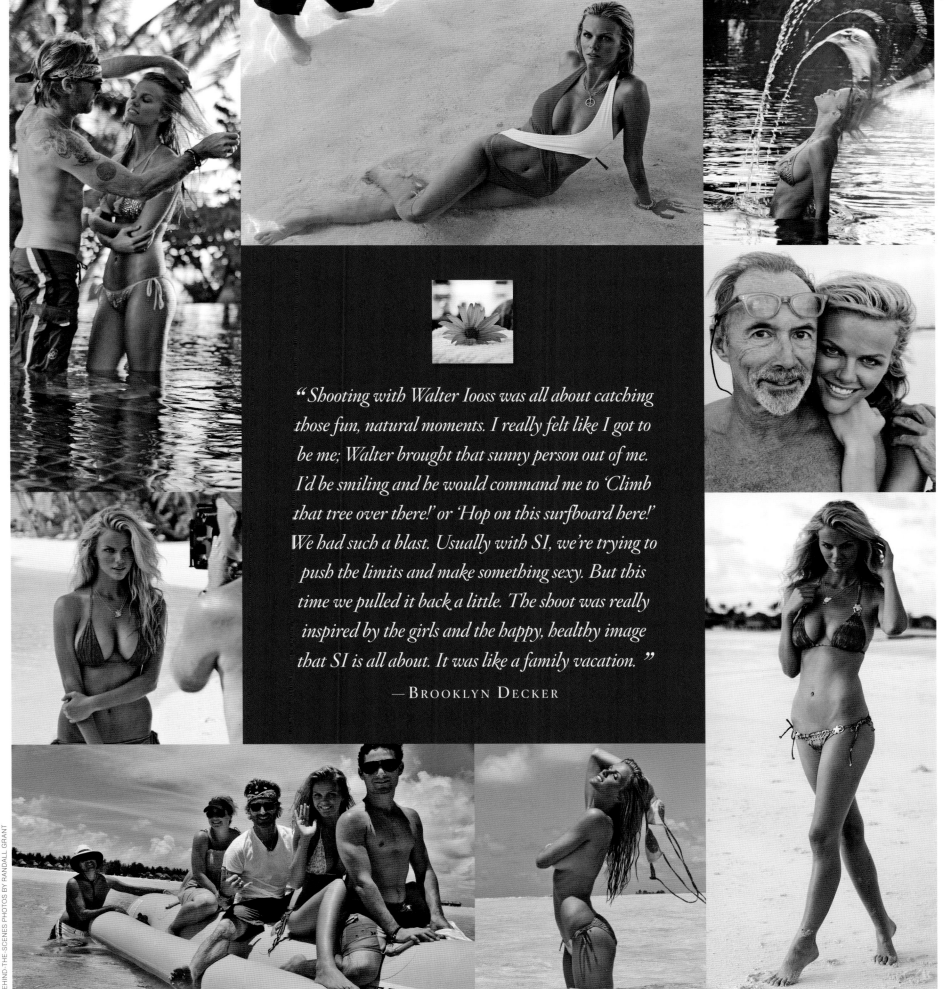

"Shooting with Walter Iooss was all about catching those fun, natural moments. I really felt like I got to be me; Walter brought that sunny person out of me. I'd be smiling and he would command me to 'Climb that tree over there!' or 'Hop on this surfboard here!' We had such a blast. Usually with SI, we're trying to push the limits and make something sexy. But this time we pulled it back a little. The shoot was really inspired by the girls and the happy, healthy image that SI is all about. It was like a family vacation."

— BROOKLYN DECKER

BEHIND-THE-SCENES PHOTOS BY RANDALL GRANT

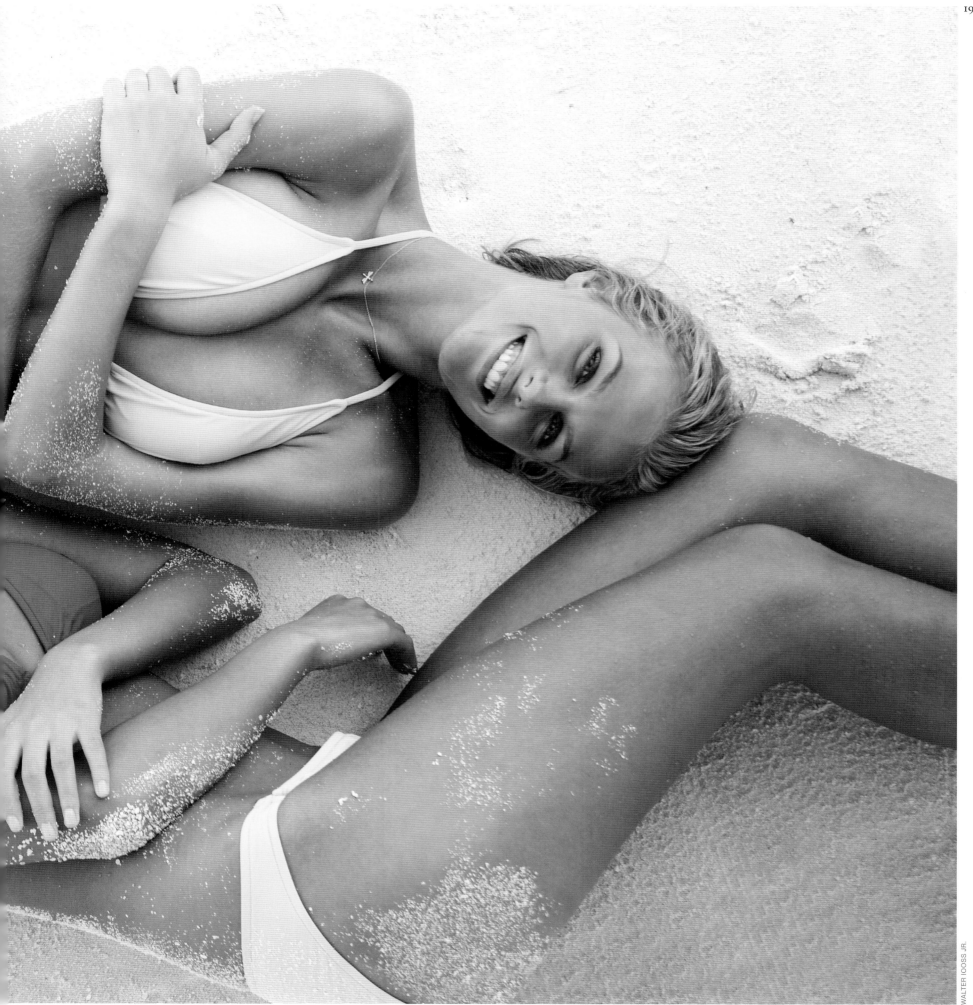

WALTER IOOSS JR.

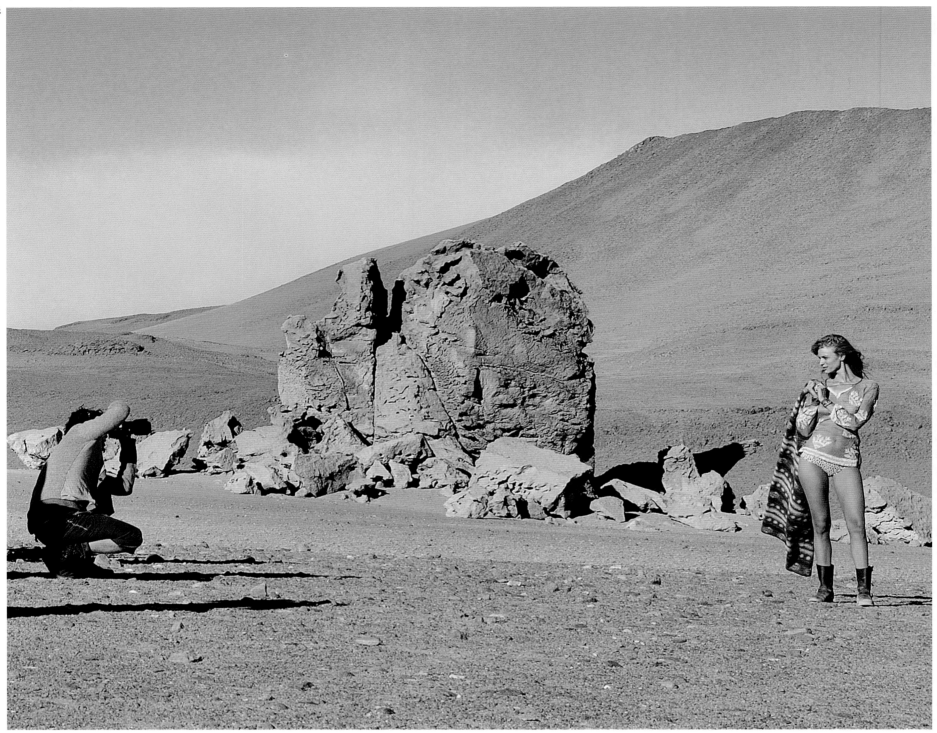

WE GRATEFULLY ACKNOWLEDGE THE FOLLOWING FOR THEIR ASSISTANCE IN THIS PROJECT: STYLISTS MAYIA ALLEAUME, PETER BUTLER, PATRICE DELAROCHE, ERIC GABRIEL, GIANNANDREA, ZAIYA LATT, GLENN MARZIALI, TRACY MURPHY, PAIGE SMITHERMAN AND VICKY STECKEL; PRODUCTION GURUS KRISTINA SCHRECK, TURISMO DE LISBOA, PAOLO GUIDOTTI AND FIBI THIND OF MISWAKI SOLUTIONS AND THE PALM SPRINGS AIR MUSEUM; CRISTINA SCALET, RANDALL GRANT, CHRIS HERCIK, CHRIS STONE, JOSH DENKIN, ERICK RASCO, KAREN CARPENTER, JANINE BEREY, GEOFF MICHAUD, DAN LARKIN, BOB THOMPSON AND, OF COURSE, SI GROUP EDITOR TERRY McDONELL

PHOTOGRAPHER PORTRAITS CREDITS: JUSTIN HUDEPOHL (SHINING), BJORN IOOSS (IOOSS, MAZZUCCO), HARRY KONG (CHIN) AND RICCARDO TINELLI (TINELLI)

TIME HOME ENTERTAINMENT RICHARD FRAIMAN, PUBLISHER STEVEN SANDONATO, GENERAL MANAGER CAROL PITTARD, EXECUTIVE DIRECTOR, MARKETING SERVICES TOM MIFSUD, DIRECTOR, RETAIL & SPECIAL SALES PETER HARPER, DIRECTOR, NEW PRODUCT DEVELOPMENT LAURA ADAM, DIRECTOR, BOOKAZINE DEVELOPMENT & MARKETING JOY BUTTS, PUBLISHING DIRECTOR, BRAND MARKETING HELEN WAN, ASSOCIATE GENERAL COUNSEL ANNE-MICHELLE GALLERO, DESIGN & PREPRESS MANAGER SUSAN CHODAKIEWICZ, BOOK PRODUCTION MANAGER ALLISON PARKER, ASSOCIATE BRAND MANAGER ALEX VOZNESENSKIY, ASSOCIATE PREPRESS MANAGER SPECIAL THANKS TO CHRISTINE AUSTIN, JEREMY BILOON, GLENN BUONOCORE, JIM CHILDS, ROSE CIRRINCIONE, JACQUELINE FITZGERALD, CARRIE FRAZIER, LAUREN HALL, SUZANNE JANSO, BRYNN JOYCE, MONA LI, ROBERT MARASCO, AMY MIGLIACCIO, KIMBERLY POSA, BROOKE REGER, DAVE ROZZELLE, ILENE SCHREIDER, ADRIANA TIERNO AND SYDNEY WEBBER

COPYRIGHT ® 2010 TIME HOME ENTERTAINMENT INC. PUBLISHED BY SPORTS ILLUSTRATED BOOKS, AN IMPRINT OF TIME HOME ENTERTAINMENT INC. 135 WEST 50TH STREET, NEW YORK, N.Y. 10020 ALL RIGHTS RESERVED. NO PART OF THIS BOOK MAY BE REPRODUCED IN ANY FORM OR BY ANY ELECTRONIC OR MECHANICAL MEANS, INCLUDING INFORMATION STORAGE AND RETRIEVAL SYSTEMS, WITHOUT PERMISSION IN WRITING FROM THE PUBLISHER, EXCEPT BY A REVIEWER, WHO MAY QUOTE BRIEF PASSAGES IN A REVIEW. SPORTS ILLUSTRATED IS A TRADEMARK OF TIME INC. ISBN 10: 1-60320-153-X ISBN 13: 978-1-60320-153-7 LIBRARY OF CONGRESS NUMBER: 2010925782. PRINTED IN CHINA

RANDALL GRANT